艾未未

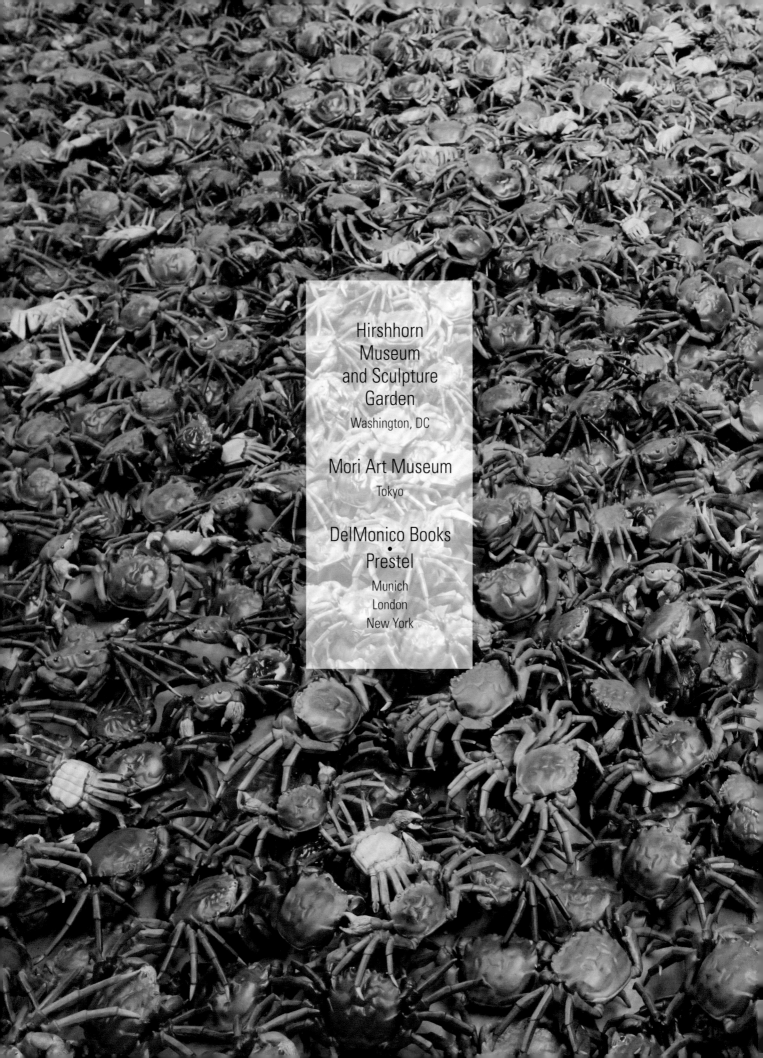

Hirshhorn
Museum
and Sculpture
Garden
Washington, DC

Mori Art Museum

Tokyo

DelMonico Books
·
Prestel

Munich
London
New York

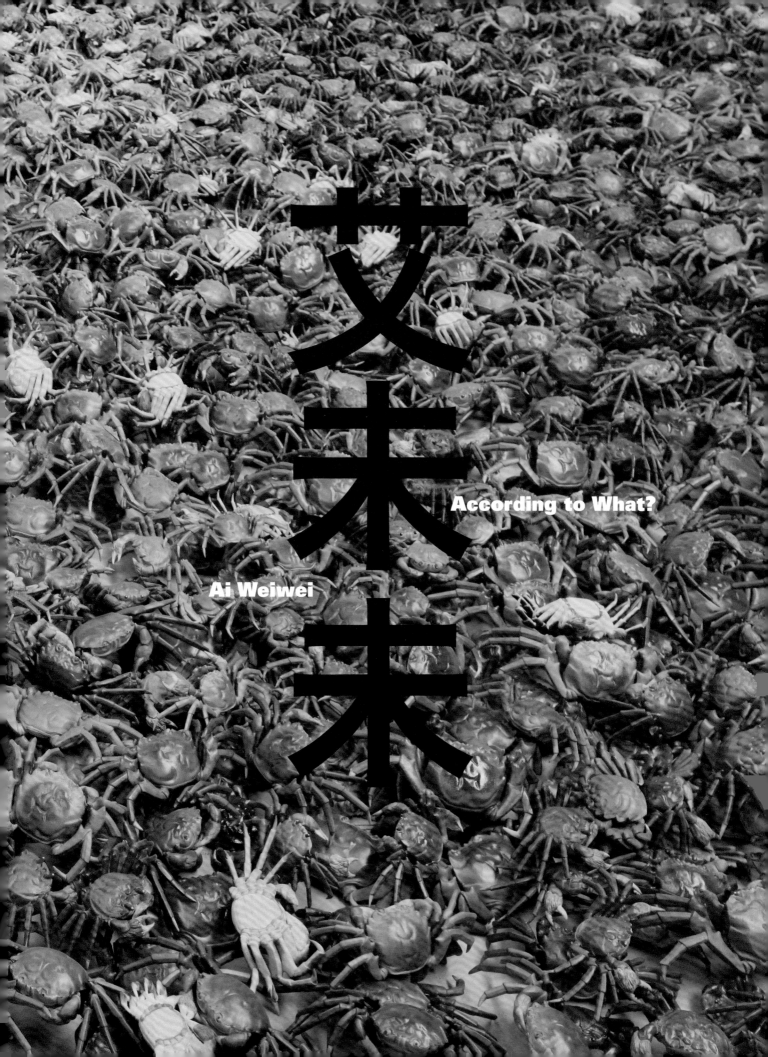

艾未未

According to What?

Ai Weiwei

This catalogue is published in conjunction with the exhibition *Ai Weiwei: According to What?*, organized by the Mori Art Museum, Tokyo, in association with the Hirshhorn Museum and Sculpture Garden, Smithsonian Institution, Washington, DC.

Hirshhorn Museum and Sculpture Garden
Washington, DC
October 7, 2012–February 24, 2013

Indianapolis Museum of Art
Indianapolis, Indiana
April 5–July 28, 2013

Art Gallery of Ontario
Toronto, Ontario
August 31–October 27, 2013

Pérez Art Museum Miami
Miami, Florida
November 28, 2013–March 16, 2014

Brooklyn Museum
Brooklyn, New York
April 18–August 10, 2014

COVER

China Log, 2005
Tieli wood (iron wood) from dismantled temples of the Qing Dynasty (1644–1911)
$22\,7/16 \times 137\,13/16 \times 22\,7/16$ in. (57 × 350 × 57 cm)
Collection of Honus Tandijono

PAGES 2–3

He Xie (detail), 2010–
3,000 porcelain crabs
Dimensions variable
Collection of the Artist

PAGE 6

Colored Vases (detail), 2007–10
16 Han Dynasty (206 BCE–220 CE) vases and industrial paint
Dimensions variable
Collection of the Artist

BACK COVER

(hardcover only)
Surveillance Camera, 2010
Marble
$15\,3/4 \times 15\,3/4 \times 7\,7/8$ in. (40 × 40 × 20 cm)
Collection of Daniel Sallick and Elizabeth Miller, Washington, DC

The exhibition is made possible by major support from the Yuz Foundation.

Additional generous support is provided by André Stockamp and Christopher Tsai, Tsai Capital Corporation; members of the Committee for the Artist's Voice; the Holenia Trust Fund, in memory of Joseph H. Hirshhorn; and the Hirshhorn's Board of Trustees.

Major support for the catalogue is provided by Mary Boone Gallery, Haines Gallery, Lisson Gallery, Galerie Urs Meile, Beijing-Lucerne.

ISBN 978-3-7913-5240-4 (hardcover)
ISBN 978-3-7913-6443-8 (magazine)

Editor: Deborah E. Horowitz
Designer: Hal Kugeler Ltd.
Production Manager: Karen Farquhar
Editorial Assistance: Rhys Conlon and Kathrin V. Halpern

Printed in Hong Kong.

Second printing 2013

Published by Hirshhorn Museum and Sculpture Garden, the Mori Art Museum,

and

DelMonico Books, an imprint of Prestel, a member of Verlagsgruppe Random House GmbH.

Prestel Verlag
Neumarkter Strasse 28
81673 Munich
Germany
tel 49 89 4136 0
fax 49 89 4136 2335
www.prestel.de

Prestel Publishing Ltd.
4 Bloomsbury Place
London WC1A 2QA
United Kingdom
tel 44 20 7323 5004
fax 44 20 7636 8004

Prestel Publishing
900 Broadway, Suite 603
New York, NY 10003
tel 212 995 2720
fax 212 995 2733
sales@prestel-usa.com
www.prestel.com

Image Credits

We would like to thank all those who gave their kind permission to reproduce material. Individual images appearing in this book may be protected by copyright in the United States of America or elsewhere and may not be reproduced in any form without the permission of the copyright holders. All reasonable efforts have been made to obtain permission. The publisher apologizes for any inadvertent errors or omissions.

Unless otherwise indicated, all images © Ai Weiwei.

Page 11: Art © Jasper Johns/Licensed by VAGA, New York, NY. Photo courtesy and © SuperStock; Page 12 (top): © 2012 Artists Rights Society (ARS), New York / ADAGP, Paris / Succession Marcel Duchamp. Photo © The Metropolitan Museum of Art, New York. Image source: Art Resource, NY; Pages 12 (bottom), 46–51: From the exhibition *Ai Weiwei: New York Photographs 1983–1993* at the Three Shadows Photography Art Center, January to April 2009, Courtesy Ai Weiwei and the Three Shadows Photography Art Centre, Beijing; Page 24: Courtesy AW ASIA, New York; Page 25: © The Hirshhorn Museum and Sculpture Garden, Washington, DC. Photo by Cathy M. Carver; Pages 40–41: Photo by Eric Gregory Powell; Page 57: Courtesy Ai Weiwei and Galerie Urs Meile, Beijing-Lucerne; Pages 58–59 (top), 62–63, 69 (top), 78, 80–81, 96–97, 122–23: Including installation views at Mori Art Museum, Tokyo, 2009, Courtesy Mori Art Museum. Photos by Watanabe Osamu; Page 100–01: Courtesy Mori Art Museum, Tokyo. Photo by Wang Chao; Pages 108–15: For the *Fairytale* project images, Erlenmeyer Stiftung, Switzerland; Leister Foundation, Switzerland; and Urs Meile Galerie, Beijing-Lucerne; Pages 124–25: Photo © Mathieu Wellner; Page 136 and Back Cover: Courtesy the artist and Lisson Gallery, London.

Contents

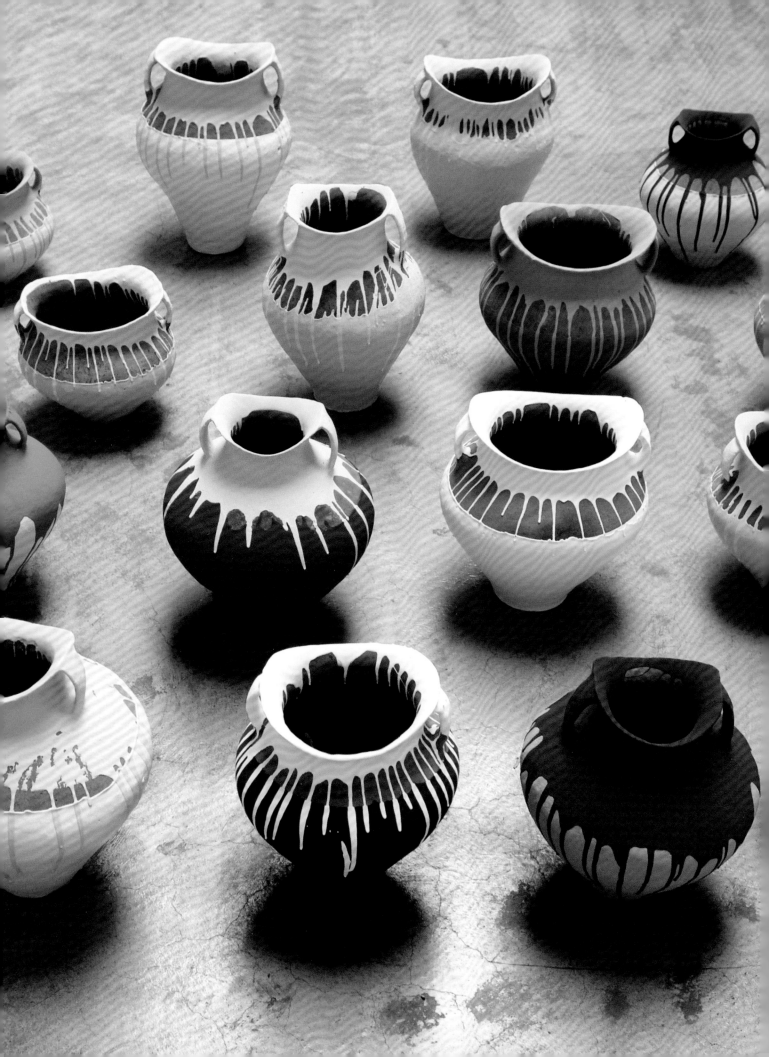

Directors' Foreword

Much has happened since the Mori and the Hirshhorn began discussions about bringing *Ai Weiwei: According to What?* to North America. When the Mori opened its exhibition in Tokyo in July 2009, both institutions agreed that it was important to offer audiences in the West the opportunity to become familiar with the artist's work as Ai had become one of the most influential contemporary artists in China since his return to Beijing in 1993 after spending more than a decade in the United States. In the intervening three years, Ai's life and art have taken dramatic turns that have made him an instantly recognizable figure around the world and put him at the center of a global conversation about freedom of expression and the role of art and artists in effecting social change.

Despite being beaten and detained by Chinese officials in his hotel room in 2009, which resulted in a head injury that ultimately required emergency surgery, as well as his arrest and confinement for eighty-one days in 2011, the artist remains through his art and actions an advocate for open dialogue and human rights issues. In his artwork, he continues to raise crucial questions about the right to express and conduct oneself freely, about accountability, and about the value of individual lives.

This exhibition, the first-ever North American tour of Ai Weiwei's work, has been substantially updated to present the full spectrum of the artist's work, as well as several new pieces. Included among the more than thirty-five artworks in the show are early photographs taken when the artist lived in New York; selections from his series of colored vases and re-purposed furniture that explore and challenge definitions of artistic, cultural, and historical value; major sculptural installations made from found remnants of ancient temples and structures or everyday objects like bicycles; and photographic and video documentation of several of his most well-known projects, including *Fairytale,* for which he took a-thousand-and-one Chinese citizens to Kassel, Germany, in 2007 as part of Documenta 12, and his collaboration with Herzog & de Meuron on the "bird's nest" stadium for the 2008 Beijing Olympics. More recent works address his ongoing investigation of the aftermath of the Sichuan earthquake, as well as his responses to his detention and continual surveillance by Chinese authorities.

As institutions committed to providing a platform for the artist's voice and presenting the most notable and thought-provoking art of our time, the Mori and the Hirshhorn are pleased to have collaborated on this important exhibition and catalogue. Moreover, as Ai Weiwei's art and his activism resonate far beyond the art world and encourage an expanded dialogue on crucial social, cultural, and political issues of the day, we welcome the chance to engage audiences who might not otherwise be drawn to contemporary art.

The realization of this complex exhibition and catalogue has required the dedication of many individuals. Mami Kataoka, the Mori's Chief Curator and curator of this show, has ably shepherded this exhibition from the beginning. She worked closely with the artist and his studio, as well as with the staff at the Hirshhorn, including the Museum's coordinating curators for this presentation, Deputy Director and Chief Curator Kerry Brougher and Assistant Curator Mika Yoshitake. We are also grateful to the entire staffs at both the Mori and the Hirshhorn for their expertise and skill in overseeing all details of the coordination of the exhibition and this catalogue, and to Smithsonian Secretary Wayne Clough and Undersecretary for History, Art, and Culture Richard Kurin for their support. In addition, we would like to extend our thanks to the museums in North America who have become our enthusiastic partners in this tour, as well as the lenders who made their works available for this important exhibition: Mr. Joseph Chen, Faurschou Foundation, Mr. Honus Tandijono, the Tiroche De Leon Collection & Art Vantage Ltd., the Stockamp Tsai Collection, Daniel Sallick and Elizabeth Miller, and other private collectors.

The Hirshhorn and the Mori, both institutions founded thanks to the drive, passion, and public spirit of a single individual—Joseph Hirshhorn and Minoru Mori—would like to recognize those who also share a commitment to making the work of today's most important artists available to the public, first and foremost Budi Tek, along with André Stockamp and Christopher Tsai, Mary Boone Gallery, Haines Gallery, Lisson Gallery, Galerie Urs Meile, and members of the Committee for the Artist's Voice.

Most of all, we would like to express our gratitude and admiration for Ai Weiwei. Every aspect of this project has been developed in close collaboration with the artist and his studio, and we are grateful to him for his vision and commitment to making this project a reality.

Fumio Nanjo
Director
Mori Art Museum,
Tokyo

Richard Koshalek
Director
Hirshhorn Museum
and Sculpture Garden,
Washington, DC

The world is changing. This is the fact. Artists work hard hoping to change it according to their own aspirations.[1]

Art allows us to ask the right questions through our visual perception or feeling. By doing that, we are able to question the essential elements, our mental processes.[2]

— Ai Weiwei

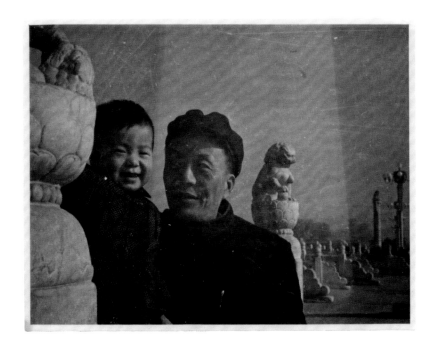

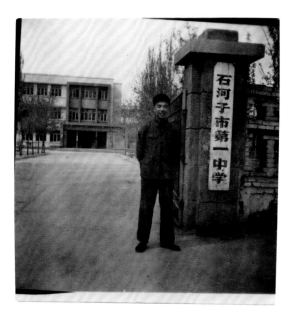

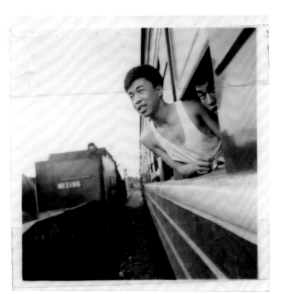

According to What?—
A Questioning Attitude

Mami Kataoka

Who and what am I? Why do I do what I do? Where did I come from and where am I going?

The more deeply we consider the artist Ai Weiwei, the more we find ourselves facing these fundamental questions concerning human existence—related questions that underlie Ai's richly varied creative activities. Truly a "Renaissance man," Ai works not only in the visual arts, but also in the fields of architecture, design, publishing, and exhibition planning. In addition, often with the aid of technology, his activities have become more overtly connected with the events of politics, society, and everyday life and now reach a wider public.

Ai took the international contemporary art world by storm with *Fairytale*, 2007, a project for Documenta 12 for which he invited 1,001 Chinese citizens to Kassel for the exhibition, and he gained worldwide recognition through his collaboration with the Swiss architects Herzog & de Meuron on the design for the National Olympic Stadium—or "bird's nest"—that was built for the 2008 Olympic Games in Beijing.

More recently, from around the time he began listing on a blog the names of children killed in collapsed school buildings during the May 2008 Sichuan earthquake, Ai's direction has shifted dramatically. He has since demonstrated his determination to ask fundamental questions about the value of human life. He has greatly reduced his involvement in time-consuming architectural projects and intensified his efforts as a human rights activist in relation to the Sichuan earthquake, endeavors clearly reflected in his recent artworks. Concurrently, his international and social status have risen to an unprecedented level. This shift has been paralleled by a deterioration of his relationship with the Chinese authorities, which originally took the form of clashes about his online activities and has gradually extended in a very real way into his life.

After the opening of the exhibition *Ai Weiwei: According to What?* at the Mori Art Museum in July 2009, surveillance by plainclothes police escalated into a physical attack on Ai Weiwei at a hotel in Chengdu, Sichuan province. Ai—who had gone to Chengdu to attend the trial of Tan Zuoren, a fellow campaigner in the Sichuan earthquake Citizens' Investigation project—was beaten about the head by police. Later, while on a plane bound for Munich to install an exhibition at the Haus der Kunst, Ai suffered severe headaches, and immediately upon his arrival, he underwent emergency brain surgery for a cerebral hemorrhage. Ai posted photographs of himself in the hospital online, and his exhibition garnered widespread international coverage, turning Ai into a notable figure well beyond the confines of the contemporary art world.

Once Ai entered into the spotlight, Chinese authorities responded to his frank statements regarding the human rights issues by shutting down his blog. On April 3, 2011, Ai was detained on charges of tax evasion and held in detention for eighty-one days. Even after his release on bail, he was restricted from leaving Beijing for one year. Ironically, it can be argued that these restrictions have further strengthened his position within contemporary society, both in China and around the world. Ai's statement that "This so-called contemporary art is not a form but a philosophy of society"[3] is a perfect expression of his current approach to living.

Ai has also become a leading figure among the Chinese artists of his generation. He bridges the conventional alternatives of adopting modern and contemporary Western

**OPPOSITE,
CLOCKWISE FROM TOP**
Early black and white photos of Ai Weiwei, 1958–75: Ai Weiwei, 1 year old, with father Ai Qing in Beijing, 1958; In front of Shihezi First Middle School, Xinjiang, 1974; Ai Weiwei, age 4, with his mother Gao Ying in Xinjiang, 1961; Ai Weiwei on a train to Beijing, 1975

artistic styles or Asian forms and traditional techniques. He also does much more than address reactions to the dramatic changes occurring in China. By focusing on the fundamental question of the nature of human existence, Ai's work exhibits a dynamism and power due to its universal context. Simultaneously, Ai's broad-ranging creative practice forces us to reconsider the modern analytic approach to cultural or artistic activities, an approach based on parsing differences and making clear-cut distinctions: between such genres as fine art and architecture, or such modes of artistic expression as sculpture and painting, between East and West, or between differing political ideologies. Instead, Ai brings our minds and our very being back to a fundamental way of thinking. As Ai puts it: "We can't just learn from Western art, but also need to examine and criticize our daily experience and our own thought. This is the nature of intellect as well as art, to question the basic foundation of being and our state of mind."[4]

With the specter of a growing cultural homogeneity produced by globalization, many are awakening to the necessity of cultivating a deeper understanding of the cultural and historical backgrounds of others. But when, for example, a Chinese person and a Japanese person engage in a conversation, they are quite likely to use English as a common language. In the same way, when we discuss art today, the common language that links Western and non-Western cultures is the context of modern art history as it unfolded, primarily, in Europe and the United States. Ai has said that "Duchamp and Minimalism are already cultural Readymades,"[5] and the shared task of those of us living in the world today is to relate our own cultural, social, and political contexts as broadly as possible to the other cultures of the world using those cultural Readymades as a foundation or a medium. And that, indeed, leads us to question the very nature of our being, to ask "Who am I?" and to cultivate respect for others who are different from us.

The title of this exhibition, *According to What?*, is derived from the name of a Jasper Johns painting. Before moving to the United States in the early 1980s, a family friend gave Ai a number of art books, including a publication on Johns, which the artist remembers having thrown away. Ai, who was then in his twenties, notes that at the time he was uncertain as to how depictions of flags, targets, or beer cans could be considered art. It was only after arriving in New York that Ai came into contact with Johns' work and writings, which directed his art interests along a path that led to Marcel Duchamp, Andy Warhol, and John Cage, among others. In this sense, Johns served as Ai's point of entry to contemporary art.

Today, some thirty years later, through his own contemporary art practice, Ai continues to question his social and

political environment, and one common thread running through his work is that it forces us to face the basic, existential question of "According to what?" Throughout this process, Ai continually references the political and historical context of China, a country in the international spotlight for its economic growth. He seems to be asking us not to observe China from a distance as the "other" but to consider the country from our own context, and in so doing, seek universal values that connect China and the rest of the world at a fundamental level. In a way, we need to change how we interpret contemporary art, approaching it as *contextual* art in the most general sense, rather than solely as conceptual art. In order to understand fully Ai Weiwei's work, it is essential to examine in greater detail the role of the artist's personal and social background and the art historical contexts that have shaped his ideas.

Three Periods: Xinjiang Region, New York, Beijing

Ai Weiwei's life can be divided into three periods—his years in the Xinjiang Region, in New York, and in Beijing. Ai was born in 1957 in Beijing. His father, Ai Qing, was a renowned poet.[6] Soon after Ai Weiwei's birth, his father was denounced as a "rightist" (that is, antisocialist with bourgeois tendencies), and the family was exiled to the Xinjiang Region in northwest China. The artist spent the first sixteen years of his life in the regional capital of Urumchi, in Shihezi, and other nearby cities.

In the midst of the Cultural Revolution, from 1967 to early 1972, Ai Qing, like other intellectuals of the day, was subjected to forced labor. Records show that this work consisted of "trimming trees, cleaning lavatories, and performing other menial tasks. The normal workload was more than a dozen lavatories a day."[7] Yet Ai Qing "was the first to appear at meetings, and the first to leave for work each morning. He was a sincere and honest poet of good character, a skilled teller of jokes, and a very intelligent and learned man."[8] Though their lifestyle was primitive, "he created a lot of mental space for us. It was another world,"[9] recalls Ai Weiwei, clearly testifying to his father's significant influence on him. At the same time, reflecting on his childhood, Ai said: "I know what subsistence living is. I also learned the influence the natural world has on ordinary people's lives, and the message hidden inside nature."[10] This extremely simple life must have awakened Ai to the world of thought and ideas, and undoubtedly played a part in his becoming a conceptual artist.

In 1978, two years after Ai returned with his family to Beijing, he entered the Beijing Film Academy. Among those studying there at the time were Zhang Yimou and Chen Kaige. During this period, Ai felt the force of political power and authority beyond anything he had

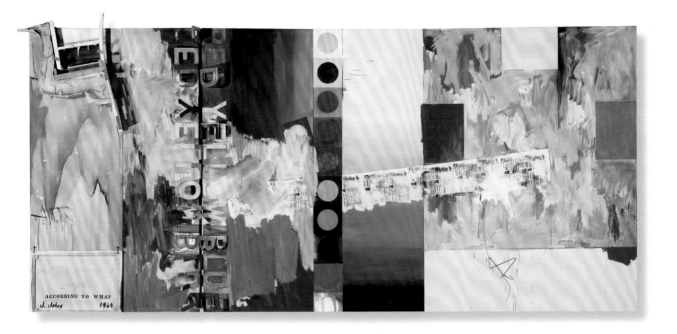

imagined growing up in Xinjiang, a region situated far from China's central nexus of power. The following year, Ai participated in an exhibition by The Stars, China's first group of avant-garde artists, and he took part in the group's subsequent 1980 exhibition as well before moving to the United States in 1981.

After living in California and Philadelphia, Ai arrived in New York. He entered the Parsons School of Design, where he studied while supporting himself with various odd jobs—carpentry, picture framing, babysitting, portrait sketching, and he even appeared as an extra in Metropolitan Opera productions. During this period of freedom from any rigorous schedule, he walked around the city capturing interesting moments in daily life with his camera, almost as if to confirm his own existence. These photographs from his time in New York record the presence of such individuals as the now-acclaimed film director Chen Kaige, composer Tan Dun, Taiwanese artist Tehching Hsieh, and poet Allen Ginsberg. He also photographed notable events, such as the 1988 riots that broke out in Tompkins Square Park when police tried to remove the homeless encamped there. These photographs capture the diversity and political activism of the New York scene during the period, as well as such intensifying social problems as AIDS and homelessness.

In the 1980s, contemporary art was still a predominantly centralized affair, and New York was one of its global centers. The New Painting of such artists as Julian Schnabel and David Salle, appropriation art using images and elements from existing works, and such movements as Neo-Geo and Simulationism dominated the art scene.

Elisabeth Sussman wrote in the 1993 Whitney Biennial catalogue: "I do not mean to characterize the art of the last two years by sociological analysis, but to recognize that art production springs up from a relation of cultures and identities (in the plural). It is their rich interrelations that make up the social reality which underlies the art of this Biennial."[11] Society was becoming more aware of cultural diversity and complexity, and this development was beginning to influence the art world by the end of the 1980s.

Jasper Johns' *According to What*, 1964, which recalls Duchamp's last oil painting, *Tu m'*, 1918, is a kind of digest or compendium of all the motifs that Johns had employed up to that time. Johns quotes many motifs from Western art history from a modernist position of questioning the meaning and existence of avant-garde art, an approach that clearly distinguishes him from the postmodern appropriation of the 1980s. Ai has explained his interest in Johns as the appeal of "a certain emotional detachment or indifference"[12] in his work, adding that having grown up in a totalitarian state, "we wanted to be logical and able to think rationally. It was such a relief."[13]

Rather than being strongly influenced by the latest trends of the 1980s, Ai's New York photographs reveal a deeper sympathy with the more direct expression of Johns and Warhol or such early twentieth-century art movements as Dadaism and Surrealism, which took the definition of art itself and the social systems that supported it as their subjects and examined the world from scientific, cultural, and political perspectives. Johns' *According to What* is a horizontal painting with a tracing

Jasper Johns
According to What, 1964
Oil on canvas with objects, six panels, 88 × 192 in. (223.5 × 487.7 cm), overall
Private Collection
Art © Jasper Johns/ Licensed by VAGA, New York, NY

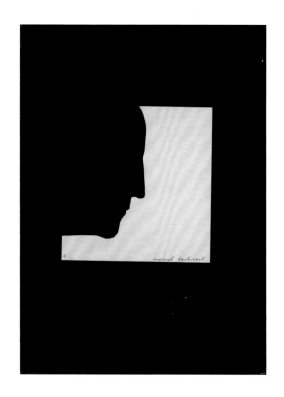

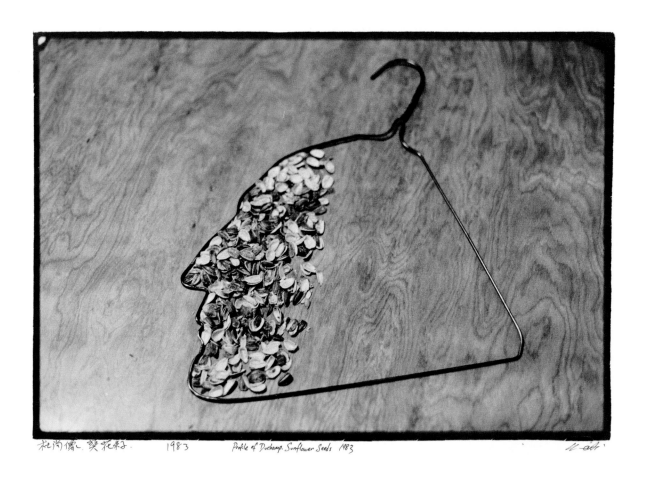

杜尚像。葵花籽. 1983 *Profile of Duchamp. Sunflower Seeds 1983*

of Duchamp's *Self-Portrait in Profile,* 1957, Duchamp's initials in the lower left-hand corner attached by a pair of hinges. As seen in *According to What* and Johns' earlier work *Coat Hanger,* 1959, coat hangers are a frequent motif for Johns. Ai also elicits Duchamp's silhouette using a coat hanger in *Hanging Man: Homage to Duchamp,* 1983.

One of Ai's New York photographs, *Profile of Duchamp, Sunflower Seeds* shows this likeness with sunflower seeds placed along the outline of the face. Sunflower seeds, according to Ai, "are not only a favorite snack for Chinese people, but during the Cultural Revolution it was often said that Mao Zedong is the sun and the Chinese people are like sunflowers turning toward him."[14] In 2010, Ai employed this sunflower seed motif in the Turbine Hall at London's Tate Modern, an installation comprising 100 million porcelain seeds produced individually in porcelain kilns in the Chinese city of Jingdezhen.

Leather shoes, a motif employed by both Johns and Ai, were "a luxury item" for Ai, "available only to the highest party officials, yet my mother found a special way to send me a pair when I was in America."[15] His works of this early period already show what was to become one of his characteristic traits—incorporating motifs employed by others (in this case, Johns) into his own distinctive cultural and social context and making art available not just to society's elite but to ordinary citizens.

In 1993, after his father fell ill, Ai Weiwei returned to China. Following The Stars' exhibitions in 1979 and 1980, avant-garde art movements such as the '85 New Wave Movement emerged, but in 1989 the *China/Avant-garde* exhibition at the National Art Museum of China and the Tiananmen Square incident put an end to many groups and movements in the country. From that point on, Chinese artists have tended to focus on individual endeavors. Moreover, since the late 1980s, most of Ai's contemporaries, the generation of Chinese artists born in the 1950s, have shifted their activities overseas.[16]

The economic reforms and liberalization introduced after the Cultural Revolution produced a growing disparity in income and social position within Chinese society and contributed to a rise in corruption. A movement for greater equality and democracy arose in protest, reaching its apogee at Tiananmen Square in 1989. Following this event, democratic activism declined, while China's shift to a market economy—as symbolized by Deng Xiaoping's 1992 Southern Tour, during which he made many important statements about the future of China's economy—gained even greater momentum. In other words, Ai returned home to China at a time when the country was undergoing major changes and emerging in a new incarnation that prioritized economic development over freedom and democracy.

Since the late 1990s, the expansion of the Chinese economy has been accompanied by a rising international interest in contemporary Chinese art. For instance, twenty Chinese artists were invited by Harold Szeemann to the Venice Biennale in 1999, Cai Guo-Qiang winning the Golden Lion Prize. Around the same time, numerous exhibitions of contemporary Chinese art were held around the globe, including *Inside Out* at the Asia Society in New York in 1998 and *Alors, La Chine?* at the Centre Pompidou in Paris in 2003. Back in 1993, however, when Ai returned to Beijing, painting and sculpture dominated the local art scene, and the notion of conceptual art had not really penetrated the Chinese art world.

In 1994, while making his own works as an artist, Ai collaborated with Xu Bing and Zeng Xiaojun to publish a book titled *Black Cover Book,* which introduced the experimental artistic practices of young Chinese artists as well as translations of texts by such leading Western art figures as Duchamp and Warhol. They distributed more than 3,000 copies in an underground edition that exerted a powerful influence on the Chinese art world. Ai continued these publication activities with *White Cover Book* in 1995 and *Grey Cover Book* in 1997. He founded the China Art Archives and Warehouse (CAAW) in 1997, and, in 2000, in conjunction with the third Shanghai Biennale, he acted as co-curator with Feng Boyi on the *Fuck Off* exhibition at Eastlink Gallery, Shanghai, providing young Chinese artists with various opportunities to show their work. These activities made a substantial contribution to raising awareness of and building an infrastructure for contemporary Chinese art, and, simultaneously, they established the foundation for Ai's continued artistic practice in China.

In 1999, he designed his own studio and residence, Ai Weiwei Studio, in the Caochangdi district near the Beijing Capital International Airport. His first architectural design, the studio has become the base of operations for the myriad projects that he has since pursued.

Fundamental Forms and Volumes

Many of Ai Weiwei's works are created using a very simple form and systematic method reminiscent of the conceptual and Minimal art of such artists as Sol LeWitt and Donald Judd. The extreme regularity of the forms and volumes of these works delimits their visual concreteness, and as a result, the viewer must focus on the context, meaning, and the nature of the materials of each work.

The standardized unit of one meter that is a defining characteristic of several of Ai's works, including *Bowls of Pearls,* 2006 (pages 54–55); *Ton of Tea,* 2006; *Cubic Meter Tables,* 2009; *Cube in Ebony,* 2009 (pages 60–61), among other works, is reminiscent of the mathematical measures and methods in the work of Sol LeWitt. The three-dimensional nature of Ai's works, however, evokes Donald Judd's *specific objects,* and the elimination of hierarchy and structure from sculptural objects readily

suggests Minimalist forms. It is even possible to trace this approach back to the Suprematism of Kazimir Malevich or the Constructivism of Vladimir Tatlin. *Cubic Meter Tables* nevertheless do retain their actual function as tables; the material for *Ton of Tea* is Pu'er tea from Yunnan Prefecture, fermented and aged according to traditional methods; and the decorative patterns on the surface of *Cube in Ebony* are taken from a small wooden box Ai inherited from his father. These works each take the form of a Minimalist sculpture, but also possess cultural resonances that are deeply ingrained in Chinese history and customs, and thus the works exist between formalist and contextual methodologies.[18]

The truncated icosahedrons of *Untitled*, 2006 and 2011 (pages 58–59), though inspired by one of Ai's cat's rubber toys, are reminiscent of a diagram sketched by Leonardo da Vinci for the mathematician Luca Pacioli's 1509 treatise *De Divina Proportione* [The Divine Proportion]. Leonardo, with his strong interest in geometrical forms, contributed to the mathematical theory of polyhedra, and surely it is no accident that Ai, who also has a strong interest in mathematical regularity, was attracted to this shape. Ai created his icosahedrons using traditional Chinese joinery techniques, without nails. He has said that the calculations necessary to create the three-dimensional forms were far more complicated than Leonardo's drawing.

This preference for basic shapes and volumes can also be seen in his design for his studio and residence. Ai is essentially self-taught as an architect, and, for his studio project, the starting point for his subsequent activities in this arena, his only reference was Stonborough House, designed by philosopher Ludwig Wittgenstein—also a self-taught architect—for his sister Margaret. In his clear-cut and precise sense of space, Ai follows Wittgenstein, but he also evokes the primitive underground home in which he lived as a child in Xinjiang: "We dug out a square belowground area, making bookshelves by digging out spaces in the walls and a bed by creating a raised flat area, and when the ceiling was too low, we just dug the floor deeper."[19] This spatial sensibility has now been realized in more than seventy architectural and urban design projects, as well as in installations on an architectural scale.

Teahouse, 2011 (pages 62–63), which was created for this exhibition, is an updated version of a work of the same title unveiled at Ai's 2009 solo exhibition at the Mori Art Museum consisting of twenty-centimeter square bricks of Pu'er tea stacked in the shape of a house. The new *Teahouse* for the US tour was made with the same materials, but unlike the other versions, it is made from a solid block of tea molded into the shape of a house. This giant "building block" house is an imaginary tea room, which cannot be entered. In form, these pieces recall

Judd's Minimalist sculptures, but while Judd's works avoided all feeling and meaning as well as the anthropomorphism and abstraction of European art, Ai's basic sense of form and volume is visually minimal while at the same time it exudes a sense of the life, customs, and humanity of the Chinese people—a "warm" Minimalism.

Ai's interest in mathematical units extends to his video works. He has produced four videos focusing on Beijing's gridded layout and encompassing ring roads. *Chang'an Boulevard*, 2004 (pages 64–65), follows this boulevard from east to west as it bisects the city center from one point on the circumference of Sixth Ring Road to a point on the opposite side of its arc. Ai shot one minute of video for every fifty meters of the forty-five kilometer distance over a month in the winter of 2004, eventually creating a video ten hours and thirteen minutes in length. The video opens with a small outlying village, then traverses the business area, the city center with its government buildings, the old city, and eventually, it reaches the outskirts on the opposite side.

The Capital Steel Corporation captured in the video was once a symbol of China's national industries; today, eight years later, it no longer exists. By filming according to a measured, mechanized method that precludes interpretation by the artist, the sights of the city are presented objectively. Ai says of the work: "It's not being used as evidence or testimony for anything, but rather to materialize our physical life, its condition in the moment,"[20] in which visual fragments capturing individual instances reveal various aspects of the essence of the city.

Ai has filmed three other video works depicting Beijing,[21] all of them accumulations of visual fragments capturing specific moments or the routine of daily life. The images unfold before our eyes in a homogeneous flow, as if to suggest the repetition, and perhaps monotony, of life.

Structure and Craftsmanship

Ai has noted that if we push the boundaries of craftsmanship and artisanship to include more than mechanical skills, we will be able to explore the very nature of the materials employed. It is this challenging and questioning of wood, stone, and other materials that "changes our perspective."[22] Judd used industrial materials such as metal, concrete, and plywood in order to exclude traditional craftsmanship and the artist's own hand, leaving the construction of his works to subcontractors. Ai also employs others to realize his ideas, but he turns to classical Chinese craftsmen to do so. Moreover, Ai uses traditional craft materials such as wood, ceramics, and stone, which are the components of classical sculpture. Although the artist's hand may not be directly apparent, the creativity required to solve problems involved in

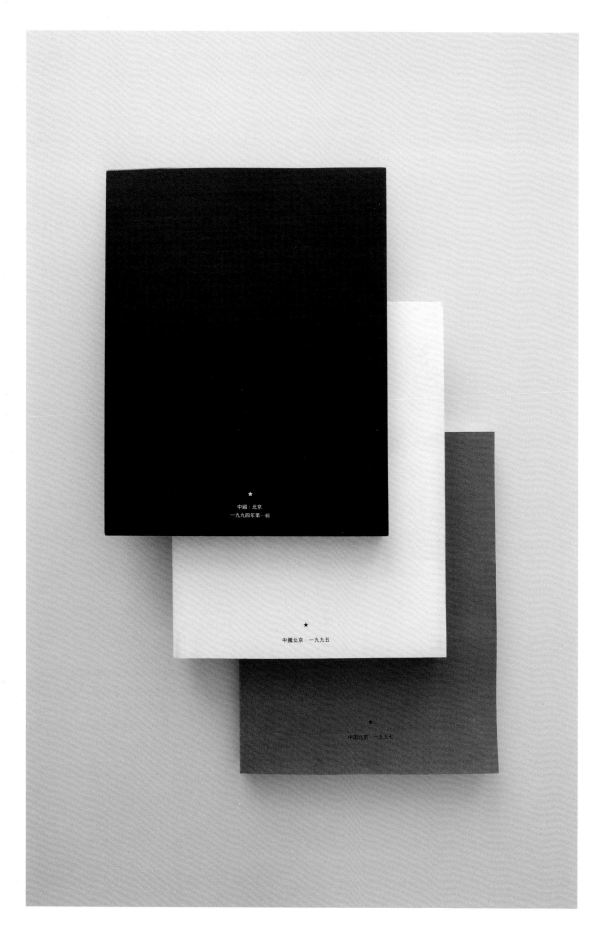

Black Cover Book, 1994
Artist's book
9 × 7³⁄₁₆ × ⅜ in.
(22.9 × 18.2 × 1 cm)

White Cover Book, 1995
Artist's book
9 × 7³⁄₁₆ × ½ in.
(22.9 × 18.2 × 1.2 cm)

Grey Cover Book, 1997
Artist's book
9 × 7 × ⁷⁄₁₆ in.
(22.8 × 17.8 × 1.1 cm)

realizing his concepts and the reverence for the skills of the craftsmen are evident. Ai conveys his respect by heightening the viewer's awareness of the original structure and meaning of an object. Frequently he does this by removing or liberating an object from its familiar context, thereby forcing us to confront our ideas about it.

Through commissioning others to make the works of art, Ai follows an art historical tradition. Nearly 100 years ago, Duchamp with his Readymades challenged the notion that an artist's originality and authority depends upon his producing a piece. And in terms of others' images, the Dadaists' collages and assemblages, Pop Art's dependence on mass media images, appropriation in art of the 1980s, and the widespread use of printed materials and online images all make it clear that we have entered an age of remix and reassembly. The craftsmanship of the artist has likewise been challenged from such diverse perspectives as the industrial, mechanized, inorganic aesthetic of Constructivism, the English Arts and Crafts Movement, the Bauhaus, and Soetsu Yanagi's assertion of "the beauty of function." In other words, today, the aura of art has been dispelled, not only in photography and cinema, as Walter Benjamin anticipated in his famous 1936 essay on the subject, but in all media. The emphasis on the artist's "originality" and hand has diminished.

In Ai's case, the subject of his artistic practice is not his own authority or identity as the creator, but the physical nature of the materials he employs—the wood, stone, ceramics, and tea—or the immaterial and intangible values of the skills and efforts of the executing craftsmen. Ai's collaborations with craftsmen can be also seen as akin to his relationship with the carpenters and artisans who build his architectural works. Speaking of *Kippe,* 2006 (pages 72–75), he notes: "When I was a child, we had to pile up wood for the winter. Every house had a woodpile by the front door. Our woodpile was very tight and orderly, without any gaps. The people in the neighborhood used to comment on it. During the Cultural Revolution, every school had a set of parallel bars and a basketball hoop in the schoolyard. We all competed to see what we could do with this piece of equipment that was basically just two metal bars."[23] This remark displays Ai's aesthetic preoccupation with daily activities and the process of giving them artistic form, as well as his focus on eliciting the creative value in ordinary objects.

The *Furniture* series that Ai Weiwei has been creating since 1997 is perhaps most representative of his interest in structure and craftsmanship (pages 76–77). The evolution of Chinese furniture reached an apogee during the Ming and Qing Dynasties (1368–1911). One reason for this ascension was the active seafaring trade with Southeast Asia that Chinese merchants engaged in during the Ming Dynasty, and the import of beautifully grained hardwoods such as rosewood and Chinese quince [*huali*] from those regions. Ai's *Furniture* series employs some of these antiques. The artist disassembles and reassembles the originals to form new works, still emphasizing simple, clean designs and the purity of the lines. As in *Untitled,* 2006 and 2011, he relies on traditional joinery techniques. He effects a transformation of the originals by eliminating their function and value, thereby giving them a new meaning and *raison d'être* as art objects.

Traditional techniques are also employed in *Map of China,* 2008 (pages 68–69), and *China Log,* 2005 (pages 70–71), this time with beams and pillars of demolished Qing Dynasty temples. In *Map of China,* various wood parts have been painstakingly assembled. The task of shaping and joining these pieces by hand and the craftsman's mindset and sensibility are both important. At the same time, according to the artist, "Not only in regard to China but rather more generally, it is about the concept of unity and form"[24] and "The map is just the shape that happens to result from this assemblage of pieces."[25] Moreover, in rendering the two-dimensional image of the map of China in three dimensions, he adds "depth" to the depiction, suggesting the accumulation of many layers of history and time in the makeup of the nation's foundation.

Moon Chest, 2008 (pages 78–81), employs the same techniques in Chinese quince [*huali*]. These works represent not only Ai's interest in craftsmanship and structure but also unite art, architecture, and design with an underlying conceptual approach. There are eighty-one chests in this series, and each has a round hole in its upper and lower halves, front and back. The placement of the openings is different in every piece, calculated to represent, in their juxtaposition, the varying phases of the moon when the chests are viewed from the front. These openings render the pieces nonfunctional, and they become sculpture. In this exhibition, seven of them, ten feet in height, are arranged in a row. Walking around *Moon Chest,* the spectator observes the various shapes of the moon during an eclipse. Ai has said:

> I make the useful become not useful; they combine the practical with change and illusion. They open up a perspective so that we can have an understanding of the material or an understanding of space. It is a basis for dealing with perception and when you think about how people use an object, you're also using so-called knowledge in the sense that "useful" has a meaning. The meaning is the use. And that plays a great role in human understanding and culture.[26]

Reforming and Inheriting Tradition

"History is always the missing part of the puzzle in everything we do. I think that they only have a momentary truth, that's the fragment: those momentary pieces."[27] "Fragment" for Ai is an instant in the long millennia of human history or the existence of a single individual among the 1.3 billion Chinese or 6.7 billion human beings on the planet. Focusing on fragments is, for Ai, a manifestation of the objective awareness of history, time, society, and reality. A fragment is a piece of the structure of a whole, which at the same time expresses Ai's worldview, and, like a single pearl or sunflower seed, does not lose sight of the most elementary unit.

Ai stands in the very midst of the torrent of political and cultural change that China is experiencing and questions the meaning of individual existence. With China's long and venerable history, what should be preserved and what reformed?

Ai's interest in ancient Chinese art deepened after his return from the United States in 1993. While visiting antique markets with his younger brother, he became intrigued by the differing forms, colors, designs, and scripts favored during the different Chinese dynasties. The first work to arise from this interest was *Han Dynasty Urn with Coca-Cola Logo,* 1994 (see page 83). As Ai notes, "the actual form of the script, the brushstroke seemed to follow very closely the shape and form of the vase itself,"[28] although the designs and scripts Ai explored in relation to the vessel's form were not those of ancient China but the logo for Coca-Cola—a symbol of America's mass consumer society of the 1960s that Andy Warhol also employed as a motif. "What's great about this country is that America started the tradition where the richest consumers buy essentially the same things as the poorest.... A Coke is a Coke, and no amount of money can get you a better Coke than the one the bum on the corner is drinking."[29] Warhol speaks of Coca-Cola as a symbol of American democracy. In 1978, the Coca-Cola company was the first American firm to enter the Chinese market, and, now, China is its fourth-highest global consumer. Ai's urn combines a 2,000 year-old Chinese style with the tastes of Americans in the 1960s and Chinese today.

Dropping a Han Dynasty Urn, 1995/2009 (pages 88–89), from the same period, more strongly emphasizes Ai's iconoclastic approach to traditional values, as well as cultural and political authority and power. The act of dropping a two-millenia-old urn challenges values cloaked in tradition and offers a confrontational testament. At the same time, this statement underscores the presence of iconoclasm in contemporary art.

The shock-value of dropping or painting over an authentic artwork is clear, and in many ways, this process of destruction or manipulation can be seen to augment a piece's worth. Ai asserts that the market for questionable antiquities or reproductions has resulted in highly developed techniques for re-creating glaze colors, vessel forms, designs, and inscriptions, and that the tradition is in effect being preserved through the practice of forgery. He poses the question:

> So-called creative behaviors always accompany the issue of "authentic" and "original." It may be the most important core question whether a work is original or authentic. And this issue may well be the main point for our contemporary fine art. People are looking for something new. But what on earth is something new? And what is the method of making something new? . . . Can it be fake and at the same time authentic?[30]

The notion of preserving the spiritual and aesthetic qualities underlying craft and discovering in them an eternal element, are also an integral part of Ai's sensibility. In *Forever,* 2003 (pages 91–93), both the title and form of the piece suggest the notion of eternity. Ai arranges Forever-brand bicycles in a circle. Since the company's establishment in 1940, these bicycles have become the most iconic brand in China. The use of the bicycle as an art object recalls Duchamp's Readymade *Bicycle Wheel,* 1913, as well as Ai's frequent tactic of retaining the structure of an object while eliminating its original function and reformulating it into something new. Here, the artist retains the external form of the bicycle, formerly China's most widespread mode of transportation, while eliminating its function, just as the bicycle's *raison d'être* is being made obsolete by the automobile in Chinese society. This monumental sculpture of bicycles interlinked in a circle elicits questions of harmony, eternity, and equality in a rapidly changing society.

Fragments, 2005 (pages 95–97), uses leftover wood from other works—such as those in the *Furniture* series, *China Log,* and *Map of China*—which were constructed from the pillars and beams of demolished Qing Dynasty temples. Like the shift from bicycles to cars, the fact that such quantities of antique lumber are available in the market, makes one aware that in parts of China, whole towns are being transformed into high rise buildings, and ancient structures like temples are no longer required. Moreover, when seen from above, this installation resembles a map of China, suggesting that the nation is composed of the fragments of the spirituality, memories, and history, of its people. Ai's methods of re-use and re-assembly express his belief that every moment in history and every aspect of culture bears the stamp of its predecessors. He notes:

Fragments is a metaphor, not a value judgment of these objects; it's like deciphering the DNA of an animal from a single hair. The title *Fragments* alludes to a previous condition or to the original situation. We are witnessing dramatic historical movement, you can call it social change; a simultaneous big transformation that we are all in together. It has a destructive, and at the same time, creative nature.[33]

A historical property has morals and ethics of the society that created it, and it can be revived. What I mean is that we can discover new possibilities from the process of dismantling, transforming, and re-creating.[34]

This description also pertains to the process that took place in Beijing as the Olympics approached, with many historical buildings being destroyed to make way for new construction.

Provisional Landscapes, 2002–08 (pages 98–101), a series of photographs more directly conveying unease with this process of modernization, captures the "void spaces" in the cityscape, where historical buildings and districts have been demolished to make room for new development. Since the People's Republic of China took power in 1949, almost all land has been deemed State land. Construction projects are relatively easily decided upon by the government, and huge tracts of land can be made available for redevelopment in a very short time, resulting in large open spaces in the midst of an urban environment. These spaces are symbols of the end of one era, with all its history and tradition, and the beginning of a completely new one. Yet this new age will also reach its end one day. Is this the continuity of historical time or just a series of discontinuous segments? The numerous sites captured in *Provisional Landscapes* are temporary landscapes that exist in the gap between past and future, fragments of the present moment.

Valuing Each and Every Individual Life

What or who am I? Why am I doing what I'm doing? Where did I come from and where am I going? These questions about the meaning of existence posed at the start of this essay can be reformulated as Ai's conception of the social responsibility of the artist:

For artists and intellectuals today, what is most needed is to be clear about social responsibility, because that's what most people automatically give up. Just to protect yourself as an individual is very political. You don't have to march on Tiananmen, but you have to be clear-minded, to find your own way of expression.[35]

Speaking of the Olympic Stadium, which he collaborated on with architects Herzog & de Meuron, Ai has observed:

The shape of the "bird's nest" is also important, but the essential point is that it needs to not only be a permanent part of the city but also give people the impression of freedom and openness in terms of its function and feeling. The first thing I pursued when designing the stadium was a sense of equity and fairness. I tried to create a space where everything is applied equally, like we feel fairness is at a round table. The second one was freedom. I tried to make everything look equal no matter what. The third one was uniformity. I designed it to be easily recognizable by anyone with the most basic and simple compositions.[36]

Ai kept a meticulous account of the construction of the stadium, which began in 2005 and continued through 2008 (pages 102–07). Very few people appear in his photographs, which primarily show the building process continuing day and night through all four seasons, subtly reminding viewers of the contributions made by countless anonymous hourly workers.

This notion of the "hidden self" in large-scale projects was the central theme of *Fairytale* (pages 108–15), for which, in 2007, Ai brought 1,001 Chinese citizens to the German city of Kassel for Documenta 12. This project—which was a kind of dream come true for the diverse individuals, ranging from art students to those who had never left their villages, much less traveled overseas—was only realized after overcoming incredible obstacles. The documentary Ai made only features the stories of a small percentage of those involved. In one of these stories, a participant from one of China's ethnic minorities could not apply for a passport because she did not have a name; so for her, the process had to begin with the fundamental step of selecting her name.

The extra "1" in "1,001" represents the individual, in contrast to the mass represented by "1,000"; this reference reflects Ai's emphasis on the relationship between the whole and the individual, a theme also underlying his use of the terms "fragment" and "puzzle." *Fairytale* is not one large project but a compilation of 1,001 distinct and unique fairytales, each infused with the environment, situation, feelings, and life of a particular individual. In the project touched on earlier in which the floor of the Turbine Hall at the Tate Modern was covered with 100

million sunflower seeds, each one of those seeds was made by hand, and so, although the seeds may look homogenous when grouped together, each is unique. Ai's concept behind *Sunflower Seeds,* 2010 (pages 40–41), underscores the fact that every one of China's 1.3 billion people has a life of his or her own.

For Ai Weiwei, the Sichuan earthquake of May 12, 2008 demanded stronger advocacy to ensure the importance and value of each and every individual life. More than 5,000 children lost their lives in this earthquake when shoddily constructed ferroconcrete schoolhouses collapsed, including Beichuan Middle School, while most of the surrounding buildings remained standing. Ai, who visited the stricken region in the immediate aftermath of the earthquake, saw a number of schoolchildren's backpacks lying scattered about. He chose this common element of school life as the essential component of *Snake Ceiling,* 2009 (pages 120–23), which is suspended from the ceiling in a serpentine curve evocative of how students might proceed if walking to school together holding hands, and *Remembering,* 2009, which covered the façade at the Haus der Kunst in Munich during his 2009 exhibition there. Ai felt outrage toward the injustices that the earthquake revealed and demonstrated his innate sense of duty with his response: "These people have cried a lifetime's worth of tears. In their hearts, they know that the precious lives they gave everything to protect are no longer."[37]

In *Wenchuan Steel Rebar,* 2008–12 (pages 128–29), a new work for this exhibition, Ai uses reinforced steel rebar recovered from the rubble of the collapsed schoolhouses, much of which he bought at markets where it was sold as scrap iron. For a while, the steel rebar lay in a disorderly, twisted heap outside his studio in the suburbs of Beijing, a clear reminder of the destruction. Over time, the rebar was heated and worked on by craftsmen employed by Ai, and eventually the bars were restored to their original straight condition. In fact, the Beichuan Middle School was reconstructed in August 2011 as a vast institution with a combined floor space of 72,000 square meters. Ai's work can be interpreted as a statement of protest not at the earthquake as a natural disaster, but at the absurdity of a society that can start afresh "almost as if nothing had happened."

One can view *Wenchuan Steel Rebar* as a critical response to the government's neglect. There were no efforts to uncover the truth behind the collapsed schoolhouses, and those responsible for building them were never questioned. Moreover, the work is designed to commemorate the lost souls in danger of being intentionally forgotten with a monumental piece of substantial physical mass. At a glance, the reinforcing rods, which are arranged in an orderly manner, call to mind a Minimalist aesthetic,

but the large divide running through the center of the piece is reminiscent of both a fissure in the ground and of the chasm between different agendas. And when we consider that this artwork is made from steel rebar from the actual site, even those of us who live far from Sichuan are affected because of our shared experiences and sense of the value of human life.

Ai's personal outrage at this incident, focus on the individual, and his strong determination to defend fundamental human rights has been conveyed most directly in the various texts he has published online. In his blog, he has even referenced the US Declaration of Independence (perhaps enhancing his desire to have Washington, DC, be the first venue for the US tour of this exhibition):

> Lines from that document penned on July 4, 1776, can still be used to exorcise demons. One of humanity's universally recognized fundamental values is that viewpoints cannot be glossed over, and likewise one must not yield his or her principles. The tragic reality of today is reflected in the true plight of our spiritual existence: we are spineless, and cannot stand straight.[38]

At other moments, he has asserted:

> Silence please. No clamor. Let the dust settle, let the dead rest.

> Extending a hand to those caught in trouble, rescuing the dying, and helping the injured is a form of humanitarianism, unrelated to love of country or people. Do not belittle the value of life; it commands a broader, more equal dignity.[39]

> Feel sad! Suffer! Feel it in the recesses of your heart, in the unpeopled night, in all those places without light. We mourn only because death is a part of life, because those dead from the quake are a part of us. But the dead are gone. Only when the living go on living with dignity can the departed rest with dignity.[40]

In addition to blogging, Ai used the Internet to recruit volunteers who assisted him with the Citizens' Investigation project for which he compiled a list of the children who died in the collapsed schoolhouses. Aside from names, the list includes other personal data such as the gender, birth year, and class for each victim. So far, this list—which is posted on the wall of Ai Weiwei's studio—includes over 5,000 names. For this exhibition, the names are printed in ink on white paper that is displayed on the gallery walls. The power of this list gains

even greater potency in Washington, DC, as it recalls the names of the near 60,000 war victims inscribed on the black granite Memorial Wall of the Vietnam Veterans Memorial, thus underscoring the significance of the act of listing individual names. The following words of Ai's offer further insight into his feelings regarding "names":

A name is the first and final marker of individual rights, one fixed part of the ever-changing human world. A name is the most primitive characteristic of our human rights: no matter how poor or how rich, all living people have a name, and it is endowed with good wishes, the expectant blessings of kindness and virtue.[41]

Ai has employed various methods to communicate his thoughts regarding the importance of each and every individual life. For example, in his sound piece *Remembrance*, 2010 (pages 126–27), he used the Internet to invite people from around the world to read the names of the Sichuan earthquake victims. In *4851*, 2010, however, he conveyed this same idea but placed a notebook computer displaying the children's names on a school desk installed next to an empty chair.

In *He Xie*, 2010– (pages 2–3; 134–35), a new work, Ai points out metaphorically the current situation in Chinese society, where individual expression and freedom of speech are restricted. *He xie* literally means "river crab," but because it is a homophone for the Chinese word for "harmonious" in the Chinese Communist Party slogan, "the realization of a harmonious society," it has come to be used as an Internet term to refer to online censorship and the removal of antiestablishment views and information. In November 2010, Ai planned a party to mark the imminent demolition of his newly constructed studio in Shanghai, calling for support via Twitter and inviting attendees to feast on 10,000 river crabs in protest of the government's control of information. Ai himself, however, was unable to attend, having been placed under house arrest as a result of his actions. As with *Sunflower Seeds*, the river crabs were made in Jingdezhen from porcelain, and they too allude to a series of events. Furthermore, both the crabs and the sunflower seeds are realistic-looking artificial objects made to encourage viewers to think about such things as the meaning of truth and the existence of individuals within a mass.

In the present-day society in which Ai Weiwei finds himself, what can he personally do as an artist? Undaunted by the likely consequences, he continues to pursue truth and justice by documenting events and presenting the results to the public. His movements, including his work on the various projects relating to the Sichuan earthquake, are now constantly recorded with surveillance cameras, and meanwhile, Ai himself has continued to record his everyday activities for documentary purposes. The means of this observation, the surveillance camera, has itself become part of his art, and he subsequently crafted a marble sculpture in its shape (page 136) and called the device "an important object of our time."

In an interview, Ai once said:

To learn how to rearrange different historical backgrounds and life experiences and use them to build one's character, to find in these the meaning of one's own existence, and to work out how to maintain the kind of relationship with one's surroundings that one desires are all extremely difficult things.[42]

When asked about how he maintains an attitude of inquiry in the face of adversity, Ai has spoken of his childhood experiences, of the difficult lives his parents' generation faced during the Cultural Revolution, and of the many lives that were lost during that period. According to Ai, when one senses that things are clearly heading in the wrong direction, one must act. When repeated attempts at rectification are unsuccessful, and many people might lose their fighting spirit, Ai is consistently moved to take up the challenge once again.

In what circumstances would it be possible for Ai to become a victor of sorts by maintaining such a questioning attitude? Ai responds to this question with a laugh. "The best circumstances as far as becoming a victor is concerned would be to disappear from society altogether. In such circumstances one wouldn't have to put up a fight. Perhaps then I'd finally be able to become the kind of artist who deals with the form, color, and texture of things."[43]

Translated by Jeffrey Hunter/Miki Associates

1 Ai Weiwei with Charles Merewether, "Changing Perspective," in *Ai Weiwei Works: Beijing 1993–2003* (Beijing: Timezone 8, 2003), 30.

2 Ibid., 34.

3 Ibid., 46.

4 Ai Weiwei with Chin-Chin Yap, "Conversations," in ibid., 48.

5 Author's interview with the artist, October 2008, Beijing.

6 Born in Zhejiang in 1910, Ai Qing was a leading modern Chinese poet. In 1928 he entered the National Hangzhou Xihu Art School in the painting department, and from 1929 to 1932, he studied in Paris. Shortly after returning to China, he was arrested for trying to overthrow the government and imprisoned until 1935. In 1933, while still behind bars, he published his first collection of poetry, *Da Jan River—My Babysitter*. Following his release from prison, he taught in the Chinese department at Chongqing YuCai University and other universities while continuing to write poetry. He knew Zhou Enlai and Mao Zedong, but was denounced in 1958 as a rightist, banned from publishing his writings, and exiled from Beijing. He spent the next sixteen years in Xinjiang. With the fall of the Gang of Four in 1976, he was reinstated, and in 1978, he was allowed to engage in literary activities again after a twenty-year hiatus. From that point on, Ai Qing was active around the world. He visited Japan in 1982, and he received the Commander of the Order of Arts and Letters, France's highest honor for arts and culture, in 1985. He died in 1996 at the age of 86.

7 Takashi Inada, "Yakusha Atogaki" [Translator's Afterword], in *Ai Chin Yaku Shishu: Ashi no Fue* [Ai Qing's Poems in Translation: A Reed Flute]. Translated by Takashi Inada (Tokyo: Keiso Shobo, 1987), 316–17.

8 Ibid.

9 Ai Weiwei, "Changing Perspective," 22.

10 Author's interview with the artist, October 2008, Beijing.

11 Elisabeth Sussman, "Coming Together Parts: Positive Power in the Art of the Nineties," in *1993 Biennial Exhibition*, exh. cat. (New York: Whitney Museum of American Art, 1993), 13–14.

12 Ai Weiwei, "Changing Perspective," 23–24.

13 Ibid.

14 Author's interview with the artist, October 2008, Beijing.

15 Ibid.

16 Examples include Cai Guo-Qiang (b. 1957), who after living in Japan from 1986 to 1995, moved to New York; Gu Wenda (b. 1955), who left for the United States in 1987; Xu Bing (b. 1962), who did so in 1990; Hong Yongping (b. 1962), who moved to Paris in 1989, when his work was included in the "Magiciens de la Terre" at the Centre Pompidou; and Yan Pei-Ming (b. 1960), who has lived in Paris since 1982.

17 Ai Qing, *Ai Qing Shixuan* [Selected Poems of Ai Qing] (Beijing: Renmin Wenxue Chubanshe,1979): Introduction.

18 The fact that Donald Judd's *specific objects* were created in reaction to European artists such as Malevich and Paul Klee, as an attempt to produce non-European or distinctly American art, is provocative when considering the relationship between the Eurocentric history of modern art and other currents of culturally specific history in non-Western regions in this time of multiculturalism.

19 Author's interview with the artist, October 2008, Beijing.

20 Cited in Adrian Blackwell, "Ai Weiwei: Fragments, Voids, Sections and Rings," conversation with Ai Weiwei. *Archinect* (December 5, 2006), available from http://www.archinect.com/features/article.php (accessed January 31, 2012).

21 A year before he made *Chang'an Boulevard*, 2004, Ai produced *Beijing: 2003*, filming 150 hours of video over 2,400 kilometers within Beijing's Fourth Ring Road. In 2005, he shot video along the Second and Third Ring Roads, one hour and six minutes and one hour and fifty minutes, respectively.

22 Ai Weiwei, "Changing Perspective," 30.

23 Author's interview with the artist, October 2008, Beijing.

24 Ai Weiwei, "Changing Perspective," 35.

25 Ibid.

26 Ai Weiwei and Jacques Herzog, "Concept and Fake," *Parkett*, no. 81 (2007): 131.

27 Nataline Colonnello, "Fragments Beijing," in *Fragments, Beijing 2006: Ai Weiwei*, exh. cat. (Beijing: Galerie Urs Meile, Timezone 8, 2006), 11.

28 Ai Weiwei, "Changing Perspective," 28.

29 Andy Warhol, *The Philosophy of Andy Warhol* (Orlando: Harcourt, 1975), 100–01.

30 Sae-mi Kim, "Feature Ai Weiwei: Realization of Fairy Tale, A Conversation with Ai Weiwei," *art in ASIA*, no. 5 (May/June 2008), 55–56.

31 Available from http://www.sengu.info/qanda02.html

32 Kenzo Tange, "Ise: Nihon no Kenkei" [Ise: The Origin of Japanese Architecture] in *Ise: Nihon Kenchiku no Genkei* [Ise: The Origin of Japanese Architecture] (Tokyo: Asahi Shimbunsha, 1962), 3.

33 Colonnello, "Fragments Beijing," 7.

34 Kim, "Realization of Fairy Tale," 55.

35 Ai Weiwei with Chin-Chin Yap, "Conversations," 51–52.

36 Kim, "Realization of Fairy Tale," 56.

37 Ai Weiwei, "Koe naki Saijitsu" [Silent Holiday] in *Gendaishi Techo* [Modern Poetry Handbook] (Shichosha, 2008), 87.

38 Ai Weiwei, "Shanzhai Ideals," posted on January 4, 2009. See *Ai Weiwei's Blog: Writings, Interviews, and Digital Rants, 2006–2009*. Edited and translated by Lee Ambrozy (Cambridge, MA: The MIT Press), 192.

39 Ai Weiwei, posted on May 22, 2008 and originally translated by Philip Tinari. See *Ai Weiwei's Blog: Writings, Interviews, and Digital Rants, 2006–2009*. Edited and translated by Lee Ambrozy (Cambridge, MA: The MIT Press), 149.

40 Ibid.

41 Ai Weiwei, "That Liu Yaling," posted on November 13, 2008. See *Ai Weiwei's Blog: Writings, Interviews, and Digital Rants, 2006–2009*. Edited and translated by Lee Ambrozy (Cambridge, MA: The MIT Press), 183.

42 Interview by Mami Kataoka, "Artist Interview," in *Bijutsu Techo* 61, no. 930 (November 2009): 163.

43 Ibid.

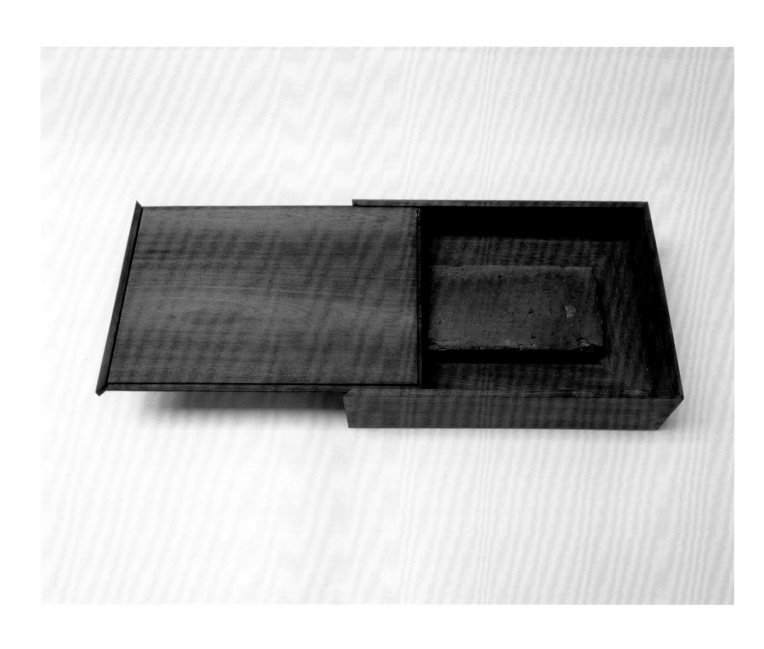

The House of the People:
Forms of Collaboration

Charles Merewether

Over the past few years, Ai Weiwei's work has demonstrated a deepening concern with civil society in China. The emergence of this focus can be traced back through his personal history as well as aspects of his artistic practice,[1] particularly his photo-based and video work produced since his 1993 return to Beijing after twelve years in the US: his 2007 project *Fairytale* at Documenta 12 in Kassel, Germany, and his collaboration with Herzog & de Meuron on the Olympic Stadium in Beijing in 2008. These works, as well as his activities related to the 2008 Yang Jia case and the aftermath of the 2008 Sichuan earthquake, demonstrate the artist's enduring and intensifying attention to Chinese policies and practices, and their social impact. Viewed in this manner, it becomes clear that Ai Weiwei's practice is no longer circumscribed by the art world, but is increasingly oriented to and driven by larger issues facing contemporary China—specifically, the exercise of autocratic power, the disappearance of Chinese cultural and material history, the absence of human rights, and the impoverishment of people's lives.

Beneath One's Feet

In 2002, Ai Weiwei began an extensive series of photographs entitled *Provisional Landscapes,* 2002–08 (pages 98–101), showing sections of cities all over China that have been razed for future construction. In these leveled areas, nothing remains except the heavy machinery used for demolition and the newly barren landscape. The site therefore appears provisional, a space existing between past and future, not only void of physical objects and activity, but equally, as Ai observes:

a void because no one speaks, no one asks the question of who is behind it, how is it that in a communist country when the people supposedly own the land they have no rights over it: it's a very short moment, but in that moment nobody wants to look. There's a question mark there, a big, big void. The old is so sad, but the new is also sad. It's a unique situation, a void with many questions, yet people don't want to look, or raise these questions.[2]

This series continues what had become the generative point and defining axis of the artist's work. Moving back and forth between construction and destruction, these photographs reveal the instability of the landscape while demonstrating how value is contingent upon those in power.[3] Ai is not invoking nostalgia but rather highlighting the meaningless destruction of homes and property for the profit of the cronies of the State, or the State itself. The bitter historical irony is, as the artist points out, that after 1949, China's land was taken away from the landowners and given to the people under the administration of the State. Now that same land is being auctioned off by real estate developers with the authorization and complicity of the State. This development evokes American artist Robert Smithson's writings of "ruins in reverse," a "zero panorama" in which "buildings don't fall into ruin after they are built but rather rise before they are built."[4]

The ongoing paradoxes and contingency of Chinese cultural heritage are symbolized in *Souvenir from Beijing,* 2002, a piece comprising one or multiple small oblong wooden boxes made from parts of demolished Qing

OPPOSITE
Souvenir from Beijing,
2002
Brick from dismantled house in *hutong,* wood from destroyed Qing Dynasty temples (1644–1911)
3¾ × 14 × 8⅞ in.
(9.5 × 35.5 × 22.5 cm)

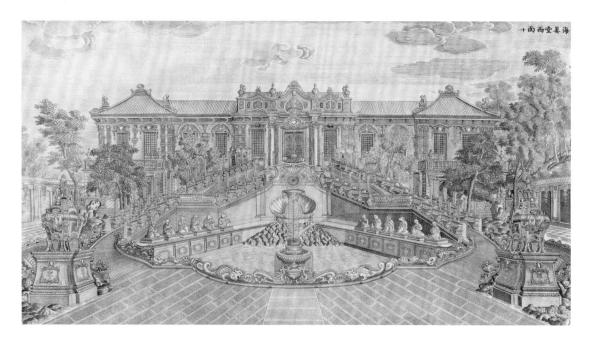

Yi Lantai,
*West Façade of
the Palace of the
Calm Seas (Haiyan
Tang Ximian),* plate
#10 of 20 from *The
European Pavilions at
the Garden of Perfect
Brightness,* 1783–86.
Engraving
19¾ × 34½ in.
(50 × 87.5 cm)

Installation view of
*Circle of Animals/
Zodiac Heads,* 2010,
bronze, each c. 10 ft.
(c. 3 m) at the Hirshhorn
Museum and Sculpture
Garden, Smithsonian
Institution, Washing-
ton, DC, in 2012

Dynasty temples, into which the artist has placed a brick from the razed courtyard houses of a traditional urban alleyway or *hutong.* Located within the city's Second Ring Road, these houses were destroyed to make way for commercial property, massive housing developments, and, subsequently, a further series of ring roads around the central axis of the Forbidden City. At first glance, Ai's work appears to function as a fragment that evokes nostalgia, a memento. The title also suggests, however, that the very houses of the inhabitants have been turned into souvenirs—relics of the past that are now preserved in the remains of the temples. And yet, these readymade ruins become the building blocks for a work of art. Serving as an agency of the State, art transforms Chinese cultural heritage into little more than a souvenir.

One is reminded of Yuanming Yuan, the Garden of Perfect Brightness. Now a tourist destination, the garden, also known as the Old Summer Palace, was the seat of the Qing Dynasty (1644–1911). Built in 1709 by the Kangxi Emperor on what were then the northwestern outskirts of Beijing, the vast estate incorporated both traditional Chinese and Western-style palaces and buildings decorated with China's finest arts, as well as a scientific workshop and ateliers of artists and craftsmen drawn from the ranks of the Jesuit order.

The palace was razed to the ground and looted in 1860 after the British and French military sent two envoys accompanied by troops to conclude trade treaties on behalf of their governments with Emperor Xian Feng and the emperor captured the envoys. Initially he used them as hostages in the negotiations, but later had the envoys tortured and eighteen of the thirty-nine troops killed and their bodies returned to Europe several weeks later. After Yuanming Yuan was destroyed, a portion of

the booty taken from it entered the collections of the French and English courts. Some objects found their way into public displays such as the Paris Tuileries exhibition in April 1861 and the International Exposition in London the following year, while other pieces entered the auction markets of London or were sold in Beijing. At the same time, the building materials of the palace and grounds, most notably the bricks, were stolen by poor villagers to construct their houses.[5]

Nearly 150 years later, the ramifications of this tale of looting and subsequent trading are still unfolding, with the cultural wealth of Qing Dynasty China becoming part of the global commodity market, its aesthetic significance subordinated to its perceived historical value and hence purely symbolic worth (a dynamic that Ai explores and complicates in his recent *Circle of Animals/ Zodiac Heads* public art project that has toured the US, Europe, and Asia). More importantly, however, the great cultural wealth and material history of mainland China continues to be destroyed and looted as the modern state emerges out of the ruins of its own creation. Furthermore, this process of expropriation is now being veiled by the strategic construction of museums preserving the historical and artistic patrimony of Chinese culture by the State. The construction of museums not only obscures the wholesale destruction occurring across the country but also attests to a shift towards the administration of the nation's material culture as State property, to be used by the State regardless of its aesthetic or historical value. This policy has been most evident in the building of the Three Gorges Dam, which has deprived the people living in the area not only of their traditional way of life and ancestral land but also of their cultural heritage. The issue of looting and destruction runs like a coarse

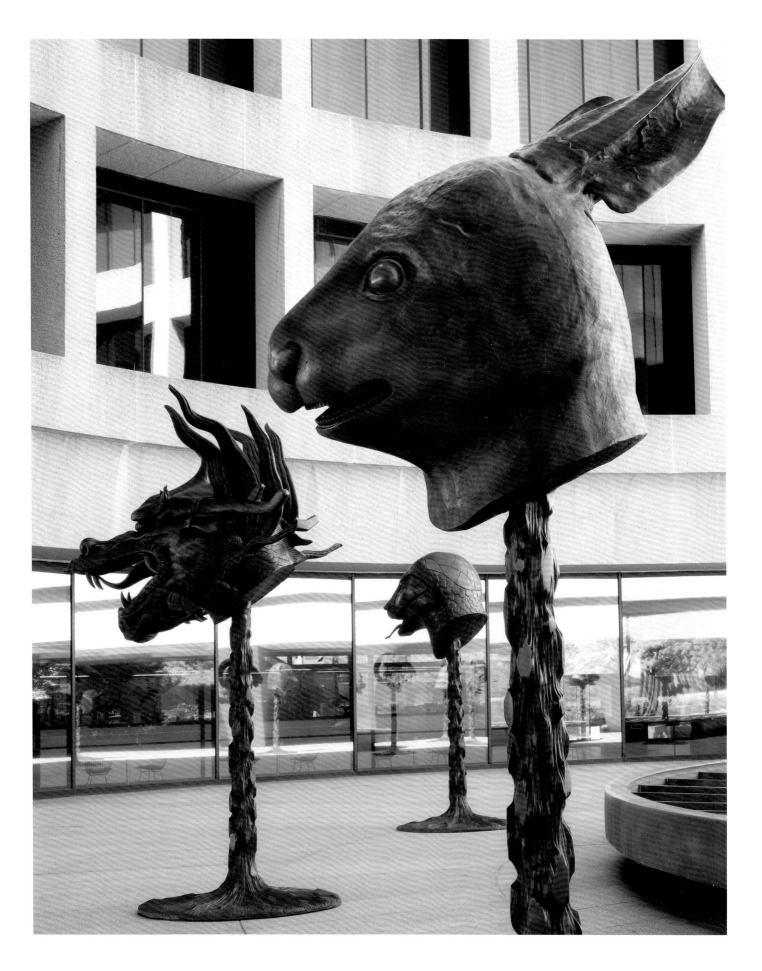

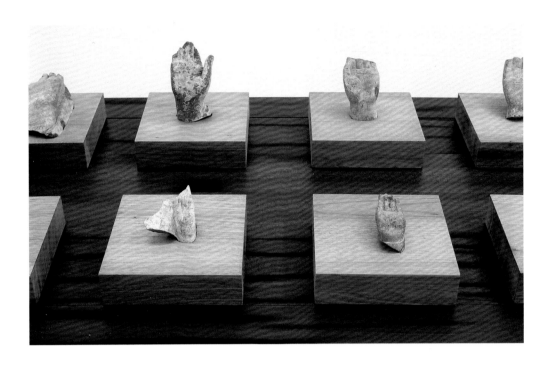

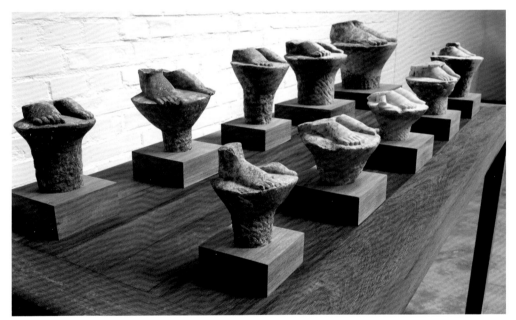

TOP

Hands, 2003
Fragments of hands
from stone sculp-
tures of Buddha from
Northern Wei Dynasty
(386–534)
Dimensions variable

ABOVE

Feet, 2003
Fragments of feet from
stone sculptures of
Buddha from Northern
Qi Dynasty (550–577)
and Northern Wei
Dynasty (386–534)
Dimensions variable

vein through the body of Chinese history, and Ai Weiwei continues to explore its residual effects.

Between 2003 and 2005, Ai approached this subject directly through a number of tableaux, most notably two works from 2003, *Feet* and *Hands*. The former features feet from ten Buddhist sculptures, one group from the Northern Qi Dynasty (550–557) and another from the Northern Wei Dynasty (386–534), and the latter, twelve hands from Buddhist sculptures, also from the Northern Wei Dynasty. In both works, Ai displays the fragments, which he acquired from antiquity markets and other sources, on stone or wooden plinths set atop a wooden table, grouping them as if in a museum display. In the absence of the bodies or heads of the original figures, however, the hands and feet are reduced to anonymity and de-ritualized, as their original function is rendered null. They remain remnants, and hence incomplete, standing in metonymic relation to the missing body.

Ai's act of salvaging these hands and feet and setting them on plinths nonetheless also tacitly pays homage to them as symbols of the dignity of the people's labor, as distinct from the head, a symbol of power and authority.

Between Justice and the Law

In 2003, Ai elaborated still further on his conception of an essential component or fragmented form, such as a brick, that by virtue of its repetition builds not only on its own logic but on its significance. *Forever*, 2003 (pages 91–93), forty-two bicycles assembled together, initially appears to be a playful abstraction, a sculpture made possible by separating the object from its function. Nonetheless, while this title plays directly off of a bicycle company named Forever, the piece can also be read as transforming "an iconic object of Chinese life into a cog in a giant geometric structure, pointedly abstracting it of any content."[6]

The piece took on new associations and significance after Ai Weiwei became deeply interested in the tragic case of Yang Jia. A young Beijing resident, Yang Jia was stopped by police while bicycling in the streets of Shanghai while on a visit there in early November 2007. The police asked Yang Jia for proof that he had rented the bicycle, which Yang Jia could not supply.[7] In response, he asked the police why they had stopped him among the hundreds of other bicyclists. He was eventually taken to the local police station at Zijiang Xilu and held overnight. According to Yang Jia, the police insulted him during their initial interrogation and beat him while he was in custody. Back in Beijing, Yang Jia tried to come to terms with the incident. Eventually he sued for maltreatment, but the local police department refused to cooperate and denied the charges. During this time, Ai produced a new version of *Forever* entitled *Bicycle*, 2008. First shown in the Creative Center at Bund 18, Shanghai, in this variant

he assembled the bicycles in an apparently hierarchical form. While made of the same components as the earlier piece, the towering verticality of *Bicycle*, at some 1,250 centimeters rises precariously from the ground.

On July 1, 2008, Yang Jia returned to Shanghai and stormed the police station where he had been held, killing six officers and injuring three others. Asked why he had committed this violent act, he said he could not remember anything. He pleaded not guilty at his trial, but on September 1, 2008, he was found guilty of premeditated murder and sentenced to death. He appealed the verdict, and at his second trial his attorneys sought to establish that he was mentally unfit. However, Yang Jia himself declared that he was not mentally ill—those who beat him were, he insisted. He was found mentally sound, and on October 20, his appeal was rejected and the death sentence upheld. He was executed by lethal injection on November 26, 2008.

For the Privileged or for the People

One of Ai Weiwei's most significant projects in recent years has been his close collaboration with the architects Herzog & de Meuron to design the Olympic Stadium in Beijing, 2005–08 (pages 102–07). Ground was broken on Christmas Eve 2003 and construction began in March 2004. Halted by escalating construction costs and the elimination of the retractable roof in August 2004, the project resumed with a revised design in early 2005. The stadium was completed on April 17, 2008, in time for the Olympic Games that summer.[8]

Jacques Herzog has noted that the increasing preference for building stadiums rather than museums is due to stadiums' demonstrated capacity to transform cities, a tacit reference to the success of the 1992 Barcelona Olympics in promoting urban renewal and enhancing civic space. This promise is not always fulfilled, however, and the process of renewal sometimes becomes one of gentrification, displacing existing residents. As much as possible, Herzog & de Meuron wished to minimize contributing to political consolidation and state control, one of the potential dangers inherent in modernization and redevelopment. Their solution was to attempt to design a stadium that would be a manifestation of the concept of "Olympic green," a part of a city's park or garden space, belonging to and for the use of the residents. With this as their aim, the architects could not simply reprise a version of the Munich stadium they built for the World Cup in 2006. They sought instead to create a building that would act as an important public space after the Games, akin to, for example, the Eiffel Tower—originally designed and built for the 1889 World Exhibition in Paris, but later claimed by the French as part of their urban geography.

An unwittingly ironic element of Ai's work on such a project is his earlier wry commentary on such monumental

Study of Perspective:
Eiffel Tower and *The*
White House, 1995–
C-prints
Dimensions variable

Study of Perspective:
Tiananmen, 1995–
Black-and-white
photograph
Dimensions variable

public structures. Two years after his return to China in 1993, Ai Weiwei photographed his middle finger in front of the Eiffel Tower. The photograph was part of a series of works entitled *Study of Perspective*, 1995–, which included various national monuments and spaces such as Tiananmen Square, the White House, and the Reichstag, the Parliament building in Berlin. Mimicking a traditional method of gauging the scale of objects, especially in archaeological fieldwork or academic sketching, the artist's irreverent gesture—the gesture of the individual—emphasizes the individual's distance from the monumental objects. As for the stadium, though coming from different positions, both the architects and Ai saw it not as a state monument but as a living form to be designed for the use (if not the ownership) of the people.

The stadium project became celebrated even prior to its completion, and not primarily because of its distinguished architectural team or Ai's involvement, but because the construction was viewed as a symbol of the nation and the city of Beijing as the seat of central-

ized power. This factor, the ability of the Chinese State not simply to commission a high-profile, international architectural firm to create a design worthy of a national stadium, but also to orchestrate its acceptance as a symbolic national monument, was a central factor in the stadium's construction. This notion was formalized in two ways. First, the stadium was placed on an axis dominated by the monumental and memorial spaces of the State, including Tiananmen Square, the Monument to the People's Heroes, and Mao Zedong's mausoleum, as though it was conceived as a monument to the people, unencumbered by the historical associations of the other sites. The fact that it was built by the Communist Party suggests uncanny comparisons with the national triumphalism that characterized the 1936 Berlin Olympics. Second, while the building was initially referred to as the Beijing Olympic Stadium, its name was eventually changed to Beijing National Stadium, or simply National Stadium, to symbolize China's aspirations and to cast the stadium as a monument belonging to and signifying the nation as a whole. This symbolism

was a critical component of the national discourse that began during the bid for the games and continued after Beijing was selected to host them in 2001—an event that recognized China's newfound economic prosperity and affirmed its status as a global power, simultaneously demonstrating both its capability and "worthiness" to host an occasion of such international prestige and importance. The stadium, in other words, would embody the Olympic slogan, "One World, One Dream," and be the jewel in the Chinese State's crown, vindicating its course of governance and its watchful gaze over the nation's development.

And yet the post-Olympic fate of the stadium remains in doubt. Both the architects and Ai Weiwei have asserted their wish that it serve as a catalyst to the process of opening the country up and therefore be "an expression of radical freedom"—an organic space.[9] In fact, the fundamental character of the stadium design, which swiftly led to its characterization as a "bird's nest," is its interwoven structural latticework composed of interconnecting diagonal columns and

beams. This structure provided a means of supporting a retractable roof while also clothing the concrete wall that wraps around the elliptical arena. The effect is a pattern of repeating forms similar in appearance to the interwoven twigs that serve as both the structure and façade of a bird's nest.

In a published conversation with Jacques Herzog, Ai Weiwei notes that he imagines the stadium becoming a "part of nature, and China has this tradition of deeply appreciating something like these natural conditions, like a piece of a rock or walking in a garden." He speaks of the potential for the stadium to be a public space, that is, "a space embraced by people as a gathering place."[10] From this perspective, the importance of the stadium design lies in its potential to create "a place for people to get together in a spontaneous uninhibited fashion with no pressure from the outside."[11] Rather than seeing the stadium as an architectural icon or a symbol of a global nation led by the Communist Party, Ai and the architects looked at it as a structure of freedom—an agent of change initiated by and for the people.

Democratizing Fairytales

In early 2007, during the long period when the stadium was under construction, Ai Weiwei produced a new work for the Tate Gallery in Liverpool, *Fountain of Light, 2007,* that symbolized the failed aspirations of a communist state. Seven meters high and installed in a pool of water, the sculptural work is composed of spiraling forms of light; however, "the spiral is a dynamic upward motion that ultimately goes nowhere . . . the form of the Monument defeats the very intellectual ideal it was meant to symbolize: ironically, it becomes a metaphor for the way in which power ultimately collapses in upon itself, for the romantic sentiments with which the rational mind is eternally in conflict always prove to be its undoing."[12]

Ai's design for this sculptural monument makes direct reference to the famous *Monument to the Third International* created by the Russian constructivist artist Vladimir Tatlin in 1920. Composed of iron, steel, and glass, Tatlin's *Monument* was based on square, pyramid, and spiraling cylindrical forms that, placed above one another, were designed to house different services for the revolutionary workers' everyday lives. Championing the aesthetic principles of Suprematism and Constructivism, Tatlin's *Monument* became famous for making manifest the utopian ideals of Communism guided by aesthetic and spiritual principles as embodied by the State. Ai follows Tatlin's model, but by creating a spiral that goes nowhere, he creates a structure that turns in on itself.

These projects find a certain commonality in their elaboration of the concept of a collective imagination that is neither national nor state-orchestrated. When asked to develop a project for Documenta 12 for the summer of 2007, Ai proposed *Fairytale* (pages 108–15). It appeared to respond to the three leitmotifs: "Is modernity our antiquity?" "What is bare life?" and "What is to be done?"

The most significant aspect of *Fairytale* was the fully subsidized invitation of 1,001 ordinary Chinese citizens to Kassel during Documenta. For the artist, the project was in fact 1,001 projects, insofar as "each individual will have his or her own independent experience." That is, the person sees him or herself as an individual rather than as a collective or undifferentiated part of a mass. Each participant was asked to fill out a questionnaire with ninety-nine questions and was sporadically filmed from the preparatory stages until his or her return to China. As Ai observed, this process "becomes a very foreign experience in anyone's personal life."[13] Yet, it is not only foreign in the sense of being elsewhere, but also in relation to their own country as well as they are removed from it and can view it from an outside perspective. Every stage of this project, from the process of invitation and selection, to arranging for visas and tickets, to the construction of temporary living quarters for the invitees, required thorough planning and oversight. Ai recounts:

> How to make sure that they have the absolutely correct conditions for traveling and being in this Documenta as viewers and at the same time

Fountain of Light,
2007
Steel, glass crystals,
wooden base
275⅝ × 208¼ ×
157½ in. (700 × 529 ×
400 cm)

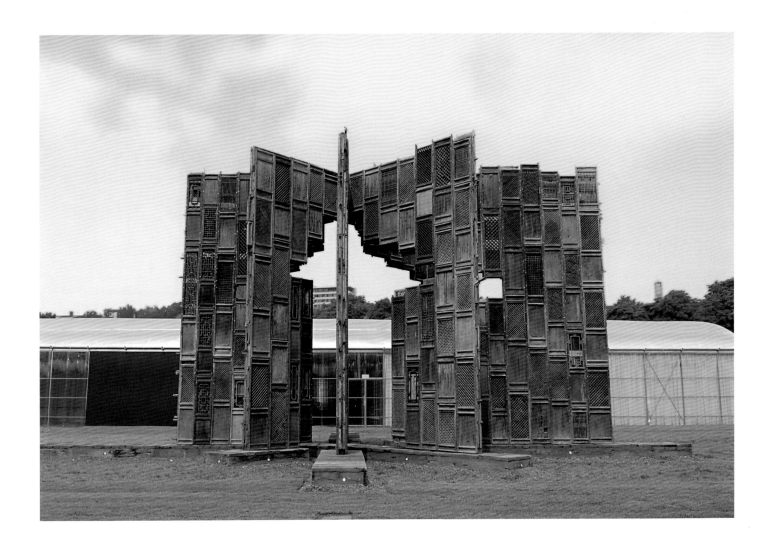

as part of the work? I see the whole process as the work itself. I see what kind of hopes, what kind of worries, what kind of frustrations…and waiting, and anticipating…then the dream, then imagination, then…maybe surprise.[14]

He recognized that "this process made people really realize what it means to be a man or woman as an identity and with a Nation: you have to go through a system, and the system can be simple or complicated."[15] Bringing together ordinary people from all over China, the work literally enacts "being Chinese." We might even extrapolate more broadly to say that all Chinese art is "being Chinese."

The participants lived together over the course of a month in dormitories designed by the artist and his team. The only other requirement was that they agree to be interviewed by the artist before, during, and after the event, upon their return home to China. Travel abroad is still a dream far beyond the reach of most ordinary Chinese citizens, and the experience was unique for the participants both collectively and as individuals, from the arrangements they had to make for their absence to their actual travels—the places they saw and the people they met. Their participation in this project profoundly transformed their perception of the world and of themselves; it also produced a new role upon their return, as they shared their experiences as "Chinese abroad" with others and thereby expanded symbolically what it means to be Chinese. Another part of *Fairytale* was the installation of 1,001 late Ming and Qing Dynasty chairs in clusters around the different exhibition venues. Movable and functional as public seating, the chairs provided an individual and collective place for people to engage in dialogue and exchange. These spaces were also conceived as "stations for reflection" for the 1,001 Chinese visitors, locals from Kassel, and visitors from all over the world.

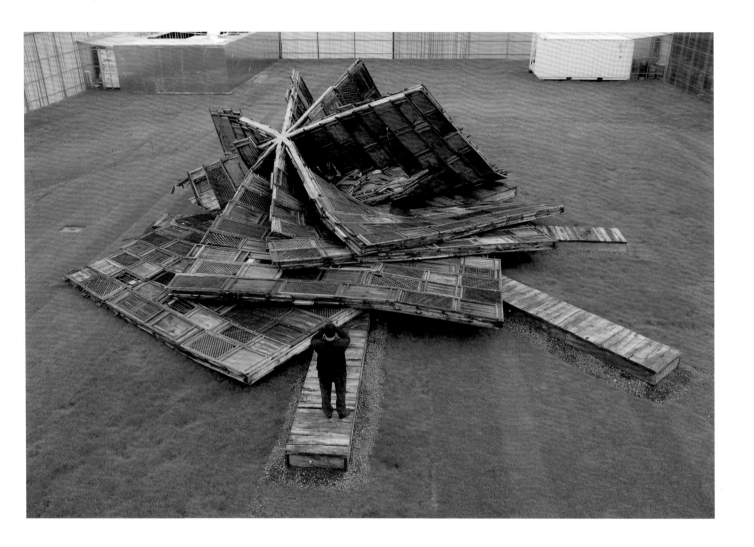

Kassel is a place where people gather, live, and disappear on their own paths once the visit is over. I think that past and future, these two realities which are both internal and external to each person, are all integrated in very different forms and possibilities that make each individual unique, with his or her own life, landscape, possibilities.

The whole West-East imagination or fear will be under the moon, across the street: they will meet. There is such hype around China. Well, it is about 1/5 of the whole world's population. There are a lot of fantasies and concern about this country. I think that now it's time that all these fantasies about life and art can meet.[16]

Another project in Documenta was *Template*, 2007, composed of 1,001 late Ming and Qing Dynasty wooden window frames and doors originally from the Shanxi area of Northern China, an area where entire ancient townships and villages had been demolished. The artist recovered these pieces, joining together five layers per side to form an open vertical structure with an eight-pointed base, creating in its center the volume of a traditional Chinese temple. Ai commented on this work: "To me the temple itself—you know I'm not religious—means a station where you can think about the past and future, it's a void space. The selected area—not the material temple itself—tells you that the real physical temple is not there, but constructed through the leftovers of the past."[17] *Template* collapsed during a storm that swept through Kassel during the exhibition—an ironic development that, though of course unplanned, is in tacit concord with Ai's message of the destruction being visited upon the people and culture of China.

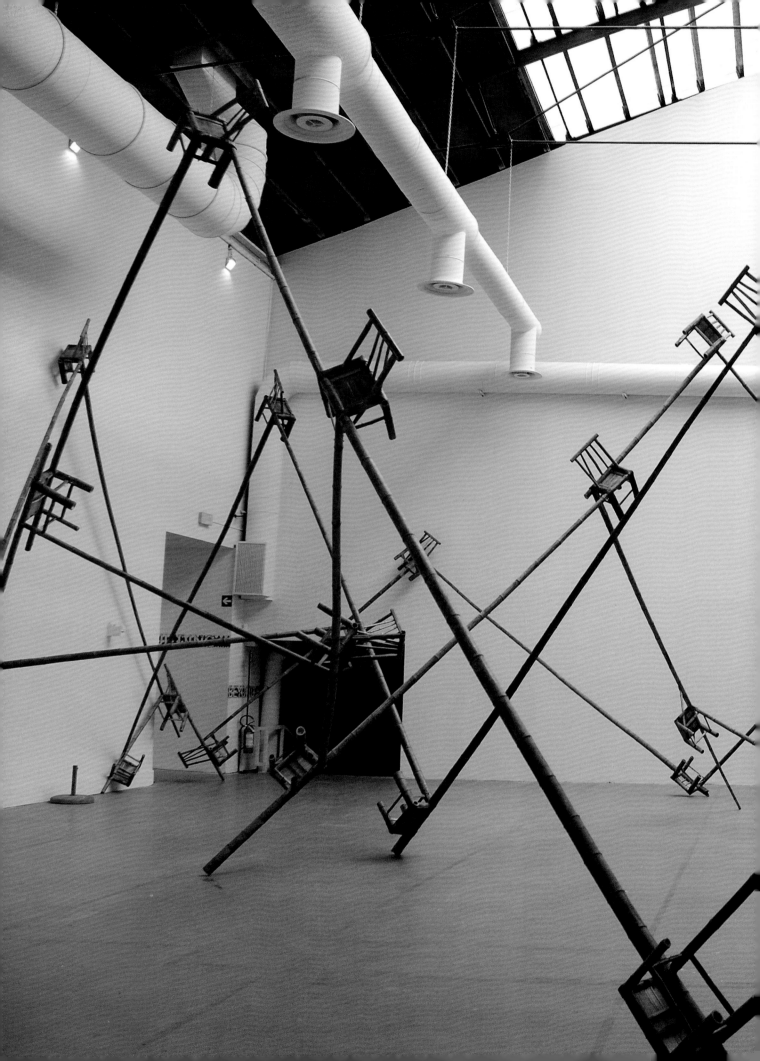

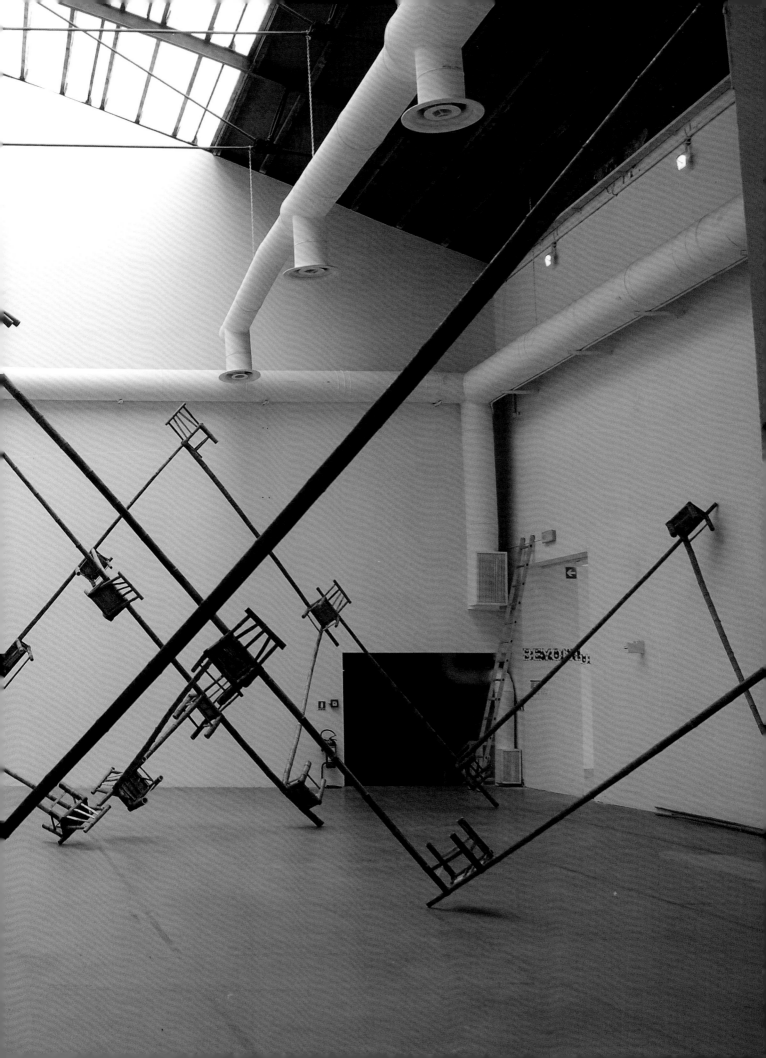

PAGES 34–35
Installation for Venice Biennale, 2008
In collaboration with with Herzog & de Meuron
Bamboo
236¼ × 393¾ × 275⅝ in. (6 × 10 × 7 m)

OPPOSITE
Through, 2007–08
Tables, parts of beams and pillars from dismantled temples of the Qing Dynasty (1644–1911)
157½ × 315 × 527½ in. (4 × 8 × 13.4 m)
Installation view at Sherman Contemporary Art Foundation, Sydney, 2008

Forming Collaboration

Over the past several years, the installation of the sculptural works within the gallery space and Ai's sensitivity to the physical presence of the viewer has led to a critical shift in his work. While the sculptural remains of central importance, its essence is no longer purely visual. Occupancy has become critical to its meaning. Structurally, the form is an architectural frame, a sort of palimpsest of a building, seen inside another space—or inside out, we might say. By occupying another space, it transforms the existing space. What is outside has been interpreted by someone already from the outside and brought inside a gallery space already reconfigured as a modernist cube.

In 2008, Ai developed a new work with Herzog & de Meuron entitled *Installation for Venice Biennale*. In it, we can see how the concept of the architectural influences not simply the installation itself but, as with *Through*, 2007–08, is informed now by the sense of its occupancy, of belonging to those who enter its midst. For the studio model of the Venice piece, Ai constructed an installation in which long bamboo poles stretch across and interweave through the space of the rectangular room, evoking the city of Venice itself with its arching bridges across canals and its numerous winding passages and pathways that crisscross the city. The model appears to echo not only the pattern of Venice but equally that of the disappearing villages and *hutong* neighborhoods of urban China.

In the final realization presented at the Italian Pavilion of the Biennale, the project was pared back to be more abstract and more elemental in its forms and referential signs. There is no bridge, nothing that can be easily associated with Venice or China or seen as a direct metaphor for them. A set of rhythmically interlacing bamboo poles intersect the space, incorporating chairs, also made from bamboo, which are part of the same structural element. The chairs act as points of junctures, syntactical links, or pauses in the multiplicity of crossing lines or pathways that, leading in different directions, offer a multiplicity of options or directions. The bending of bamboo into an abstract form breaks the specificity of its origin and contraposes the architectural form of its installation. It is precisely in this sense of infinite extension that the work supersedes its figurative references, becoming closer to a form that celebrates the play of abstraction.

By using bamboo as a building material and adopting the structure of traditional Chinese urban spaces, Ai references the architecture of China and simultaneously alludes to Venice through the overarching forms in the installation. In this case, with both the architects Herzog & de Meuron and the Chinese craftsmen who fashioned the piece, Ai created a work that embodied collaboration.

Specific technologies serve as the critical axis around which labor is organized, and social relations between peoples and skills are formed in an act of communicative exchange. This shared labor creates forms of collaboration embodied in the work of art.

Naming

On May 12, 2008, the Sichuan earthquake struck, injuring and killing thousands of people. The government issued the number of those killed, but it was little more than a rough estimate, with no names released. A large number of school buildings collapsed during the earthquake, resulting in extremely high casualties among school children. Moreover, it was soon apparent that while the school buildings—later referred to as "tofu-dreg schoolhouses," because of the way they crumbled into pieces—had been destroyed, nearby government offices remained standing.

For months the government did not disclose the death tolls or identities of the students who perished. Many parents protested and asked for an official reckoning from the authorities, but none was forthcoming. By the end of 2008, Ai Weiwei decided to begin investigating how many children had actually died. He formed a group dubbed "Citizens' Investigation," and his volunteers called on local officials, only to be rebuffed. Their next step was to visit the families and schools in the affected region, receiving their permission to upload the information they discovered onto the website bullogger.com. They discovered that the "biggest difficulty was that in local checks and interviews, many families were not willing to release their identities; they lived in fear because many others had been imprisoned or threatened. Facing this kind of danger, they didn't dare to speak the truth, not even simple facts."[18]

Those who did agree to participate viewed it as a reminder of the children they had lost, and as a comfort to other families still waiting for official confirmation of their children's fate. As in so many other cases around the world—Bosnia, Chile, Argentina—the naming of the dead proved to be an essential form of acknowledgement and remembrance for their families and the community as a whole. When asked in an interview if he had undertaken this project for the sake of future generations, Ai responded: "We can't look after the next generation, nor can we look after the previous one. We almost can't look after ourselves."[19]

Both *Fairytale* and Ai's work surrounding the Sichuan earthquake are in part about naming, the naming of ordinary people—in one case, selecting a name, an identity, and in the other, coping with having that name taken away. Each project emerges through collaboration between different and distinct individuals and classes that, in creating communities, form new social and artistic practices.

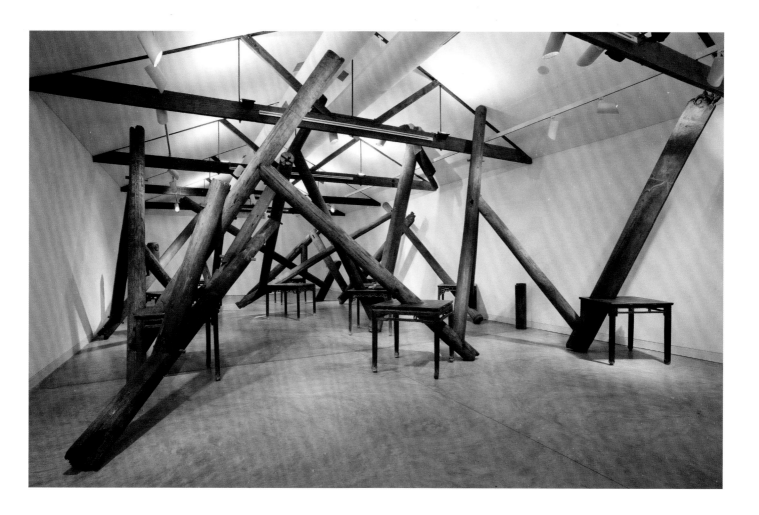

1 Charles Merewether, *Ai Weiwei: Under Construction* (Sydney: University of New South Wales Press; Paddington: Sherman Contemporary Art Foundation; Campbelltown: Campbelltown Arts Centre, 2008).

2 Interview with Adrian Blackwell, "Fragments, Voids, Sections and Rings," *Archinect.com* (Dec. 5, 2006). See also the author's essay "Looting and Empire," *Grand Street*, no. 72 (2003): 82–94.

3 For a discussion of the video series *Chang'an Boulevard*, 2004, *Beijing: The Second Ring*, 2005, and *Beijing: The Third Ring*, 2005, see op. cit. *Ai Weiwei: Under Construction*.

4 Cited by David Spalding in his review of Ai Weiwei's exhibition at Galerie Urs Meile in *Artforum* 45, no. 1 (September 2006): 395.

5 For the history of Yuanming Yuan, see Geremie R. Barmé, *China Heritage Quarterly*, no.17 (March 2009). In regard specifically to looting of the palace, refer to James L. Hevia, "Loot's Fate: The Economy of Plunder and the Moral Life of Objects 'From the Summer Palace of the Emperor of China,'" in *History and Anthropology* 6, no. 4 (1994): 319–45. See also the author's essay, op. cit. "Looting and Empire."

6 Jonathan Napack, "Ai Weiwei," in *Ai Weiwei Works: Beijing: 1993–2003*. Edited by Charles Merewether (Beijing: Timezone 8, 2003).

7 For a detailed account, see Eva Pils, "Yang Jia and China's Unpopular Criminal Justice System," in *China Rights Forum*, no.1 (2009): 59–66.

8 For a more comprehensive discussion regarding the construction of the Olympic Stadium, see the author's essay "In the Making," in *Ai Weiwei, Herzog & de Meuron: Beijing, Venice, London*. Edited by Charles Merewether and Matt Price, 2 vols. (London: Albion Gallery; Basel: Walter Konig, 2008).

9 Interview with Roman Hollenstein, "A Sport Temple for a Totalitarian State: Building in China—Jacques Herzog on Architecture and Morality," in *Neue Zurcher Zeitung* 7/8, no. 131 (June 2008): B1.

10 Ai Weiwei and Jacques Herzog, "Concept and Fake," in *Parkett*, no.81 (2007): 122–45; reprinted in *Ai Weiwei, Herzog & de Meuron*, vol. 1, 127.

11 Simon Kuper, "Bird's Nest offers Beijing a Chance to Prove its Mettle," *Financial Times*, July 26, 2008, 12.

12 Quoted by Karen Smith in *The Real Thing: Contemporary Art in China* (Liverpool: Tate Liverpool, 2007), 38–40.

13 Cited from interview with artist held in 2007 by Nataline Colonnello (Beijing: Galerie Urs Meile), 2007. See Nataline Colonnello, "1=1000." *Artnet* (August 10, 2007), available from http://www.artnet.de/magazine/11000/

14 Ibid.

15 Ibid.

16 Ibid.

17 Ibid.

18 "Ai Weiwei: Q&A on Earthquake Toll Accounting Efforts," *China Digital Times* (April 12, 2009) http://chinadigitaltimes.net/2009/03/ai-weiwei-qa-on-earthquake-toll-accounting-efforts. Posted by Paulina Hartono on March 28, 2009.

19 Ibid.

Reconsidering Reality:
An Interview with Ai Weiwei

Kerry Brougher

Kerry Brougher

I suppose we should start by stating that this is not a conventional interview but an electronic "dialogue" done by email exchange. At this moment, you are still under house arrest in China, and I'm formulating questions in Washington, DC. The Hirshhorn decided to work with you and the Mori Art Museum to bring your retrospective to DC several years ago, before your detainment by Chinese authorities for eighty-one days and the imposition of a year-long house arrest. Obviously, the events of the past year have meant that making this show a reality has been a somewhat unusual process! Can you tell me if your feelings about having a survey of your work in the US have changed at all during this time? What does it mean now to you to have a show in Washington?

Ai Weiwei

The Hirshhorn exhibition in DC, is my first survey show in the United States. I lived in the US for twelve years from the 1980s to early 1990s, so the opportunity for a show here is very meaningful to me. The exhibition is based on a 2009 show at Tokyo's Mori Art Museum, but has been developed especially for the US and includes new works and fresh perspectives on the old. About a third of the works in this version of the show differ from those on view at the Mori. I've experienced dramatic changes in my living and working conditions over the past few years, and this exhibition has been an opportunity to re-examine past work and communicate with audiences from afar. I see it as a stream of activities rather than a fixed entity. It is part of a continual process in self-expression.

KB *If one thinks back over contemporary art history, a lot of art is linked indirectly to social commentary. I'm thinking of Andy Warhol's* Disaster *paintings or Bruce Conner's films like* A Movie. *But then there are more active works, Gustav Metzger's auto-destructive art or Yoshitomo Nara's vandalized ukiyo-e prints, to name a couple. But even in those cases, the work is distanced from specific referents. In your work, some pieces, like* Snake Ceiling, *2009 (pages 120–123), appear to be a direct commentary, while others, for example* Dropping a Han Dynasty Urn, *1995/2009 (pages 88–89), are more intangible. So, I'm curious as to where you see your works in the broad, perhaps badly named-arena of "social protest."*

AW An artist can only raise new questions and offer insight into social change after reflecting on the feelings of the time. I don't see art as a highly aesthetic practice. Warhol said, "An artist is somebody who produces things that people don't need to have but that he, for some reason, thinks it would be a good idea to give them." Some of my works are dissociated from immediate social consequences, but others are more direct. I depend heavily on social involvement. Rather than thinking of my projects as art, they attempt to introduce a new condition, a new means of expression, or a new method of communicating. If these possibilities didn't exist, I wouldn't feel the need to be an artist.

KB *Have your arrest and experiences since then in any way changed your view of what art can accomplish or your role as an artist? Is the art you are making now different from your work before your detainment? Has the focus changed?*

AW I have lived with political struggle since birth. As a poet, my father tried to act as an individual, but he was treated as an enemy of the State. My detention was an extreme condition for any human to endure. Many, including my family and the people who know me and care about the incident, were frustrated by the lack of an explanation or reason. Some of my life experiences have been tragic and painful, but I value them all. Going through these events allowed me to rethink my art and the activities necessary for an artist. I re-evaluated different forms of expression and how considerations of aesthetics should relate to morality and philosophy. These reflections give new strength to my work. I am able naturally to conceive of works that confront the accepted ethical or aesthetic views. I've always believed it is essential for contemporary artists to question established assumptions and challenge beliefs. This has never changed.

KB *Much of the press attention that has been focused upon you since your arrest has been directed more to your role as a dissident or outspoken critic of the Chinese government rather than as an artist. How do you see yourself? Do you still feel as compelled to speak through your art when you also have a direct voice through interviews and the Internet? Do you consider these roles intertwined, or are these aspects of communication different for you?*

AW A friend once reminded me, saying, "Weiwei, beware of newspapers calling you a dissident. It is dangerous." In normal circumstances, I know it's undesirable for an artist to be labeled a political activist or dissident. But I've overcome that barrier. The suits that people dress you in are not as important as the content you put forth, so long as it gives meaning to new expression. The struggle is worthwhile if it provides new ways to communicate with people and society. As an artist, I value other artists' efforts to challenge the definition of beauty, goodness, and the will of the times. These roles cannot be separated. Maybe I'm just an undercover artist in the disguise of a dissident; I couldn't care less about the implications.

KB *I would like to shift attention and focus back to your art as well as your approaches and influences. This survey contains examples from most of the various aspects of your work, including your sculpture, videos, photographs, architecture, and installations. Could you comment on your diversity of approaches to art-making? What draws you to work in so many different mediums? How do you determine which medium is most appropriate for the concept you wish to convey?*

AW At different times I've worked in different mediums. For me, the variation is not an artistic judgment, but a necessary choice. It's just as normal to eat with chopsticks, as it is to eat with forks or hands. Different circumstances call for different tools. I try to express ideas with the most appropriate available materials and forms. Very often the medium comes first, and then my reasons for it. Sometimes, I work with a medium I don't like out of curiosity. It is an experiment to challenge my pre-existing concepts and tastes. I've taken hundreds and thousands of photographs, and it's not because I liked the medium. I wanted something to parallel my daily activities, and photography is the most logical way of doing that. I filmed documentaries because that medium reflects real conditions the most completely. I don't think artists should only work with what is handiest and most familiar, because the unfamiliar provides a challenge, and it creates another language. It defines the condition for new possibilities.

KB *Much of your work, such as* Moon Chest, *2008 (pages 78–81), or furniture pieces like* Grapes, *2010 (page 77), seems to gain power through loss, by undermining the original function and purpose of an object. Clearly, the marble security cameras you recently created reflect this approach as well—objects that once looked at us now are now looked at, rendered impotent. Can you describe this fascination you have with changing the utilitarian and metaphoric purpose of an object?*

AW My work often relates to history and memory. I like to explore the interrelation between them and the skills that mankind evolved over millennia of struggle. It is about my mind negotiating with the past. Our understanding of a material is related to its purpose. According to Wittgenstein, if meaning is use, material acquires its significance from the role it plays in our survival. This is what enables art to play a constructive role in our minds and in our praxes. I'm interested in understanding reason and questioning it at the same time.

KB *The concept of "fake" permeates your art, and you have said, "My work is always dealing with real or fake, authenticity, and what the value is, and how the value relates to current political and social understandings and misunderstandings."*[1] *In addition, your studio operated under the name FAKE Design. Why is this concept so important to you?*

AW Our thoughts about art, culture, morality, philosophy, and rationality are closely related to a judgment about value. Society's collective judgment establishes our views of reality and what is deemed acceptable. These beliefs must exist in order for people to have a sense of security. To encroach on those fixed notions of the world is to question our fundamental state of mind. Art should always play on that understanding. It should create room for us to reconsider our reality.

Sunflower Seeds,
2010
Porcelain
Dimensions variable

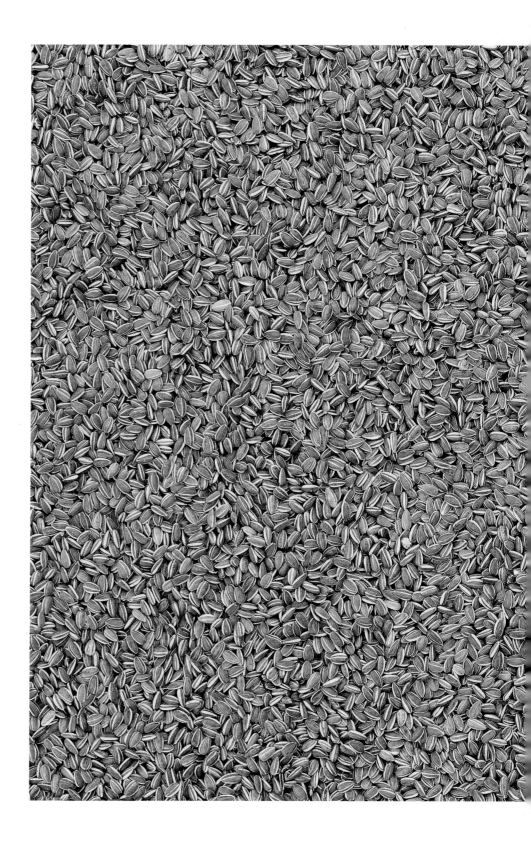

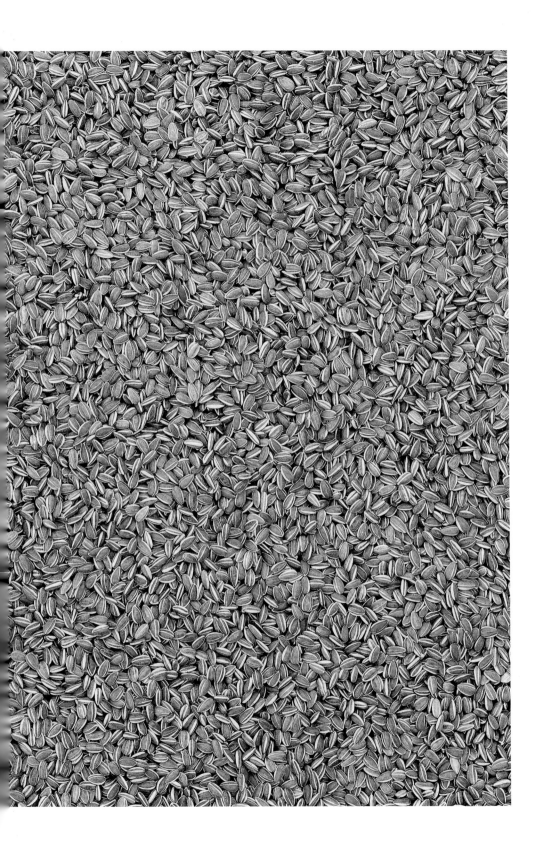

KB *Tied in with the notion of authenticity and "the original" is your practice of producing mass quantities of small objects, the sunflower seeds, for example, or your new piece of three-thousand tiny red and black crabs. Somehow this mass production seems to relate back to China itself, the videos you did of street life and to the millions and millions of people who make up the country. Can you elaborate on this idea of mass production?*

AW Mass production is nothing new. Weren't cathedrals built through mass production? The pyramids? Change has always required mass effort. Paintings can be painted with the left hand, the right hand, someone else's hand, or many people's hands. The scale of production is irrelevant to its content. I have individualistic works as well, such as *Profile of Duchamp* or the photographs taken in New York. Living in China gives me the opportunity to create works that require the effort of many people. Given a lifetime, it would be impossible for an individual to complete *Sunflower Seeds*. The piece can only be accomplished with the involvement of many people. Mass production existed before and after the Industrial Revolution. It has always existed in human history. In a commercial society, it is often a factor for a product's strength and impact on the masses. Andy Warhol was aware of this. It is evident in his screen-prints. The reality of our world is that many people need work, and the work accomplished by many people has distinct characteristics from that achieved by an individual. These distinctions reflect the special relationship between the author and the society of his time.

KB *The Hirshhorn recently acquired one of your chandelier pieces,* Cube Light, *2008 (pages 56–57). Sergei Eisenstein uses the chandelier as a symbol of the coming fall of bourgeois society in his 1928 film* October, *a scene it is said inspired your work. At the same time, the piece seems to respond to the Minimalist art tradition exemplified by such sculptors as Donald Judd. Could you talk a bit about how you view works like* Cube Light *and how they respond to or reject artistic and cultural traditions, both western and eastern?*

AW *Cube Light* embodies many meanings. From a social perspective, the chandelier is a symbol of luxury and power. In Eisenstein's film, there was a sequence on the attack of the Winter Palace. The navy opened fire at the palace and the chandelier shook. The royal residence was as fragile as the lamp. In my childhood, we didn't even have electricity, not to mention chandeliers. There was only one candle in the house. But it created a similar effect, when light and shadow sway in the wind. So it's a work about light. The basic form of *Cube Light* was

influenced by Donald Judd and artists of his generation, but I added a layer of worldliness and texture. It is a bricolage of contemporary art and social history. I find it more interesting that way.

KB *You not only change the function of objects, but in some instances, such as the dropping of the Han Dynasty urn or the dipping of Neolithic vessels into paint, you destroy to create. Do you feel that art has to sometimes become as destructive as the negative forces in society and nature?*

AW Regardless of how art represents destruction or negativity, it is a progressive explanation of mankind's understanding of self and of the world. Art does not have a negative or destructive quality, no matter which period it belongs to. Whether it is Dadaist or post-modern, representational or abstract, it provides new possibilities for human self-awareness. This kind of introspection is the pinnacle of human thought. Like philosophy, it is an important tactic for understanding the world.

KB *In your recent pieces, you seem to have continued, perhaps even redoubled, your efforts to tell the true story of what happened in the 2008 Sichuan earthquake—this despite the fact that your probing of the subject seems to have been a catalyst for your troubles with the authorities. Can you explain your focus on this incident and why you continue so actively to pursue it in your art?*

AW The reasons for an artist to create are dependent on his understanding of the world at the time. This understanding can be abstract or aesthetic. It can be a value judgment, or it can represent the living conditions of many. From childhood, I have felt that my experiences have guided me to emphasize basic values. Basic values are about freedom of speech, free expression, the value of life, and individual rights. I am on a perpetual quest to realize them, and my work has never departed from this search. I envy explorations that can transcend reality and focus purely on aesthetics, but these cannot change the reality in which I live. To a large extent, my work is dependent on reality. I don't rely on it for self-expression, but I must connect to it to feel the desire to create. I realize a piece of art cannot change the political or social conditions of the world directly. But I myself change when I participate in these conditions. I gain an understanding of the relationship between my art and society. It helps me feel grounded in the creative process. I am not seeking to create complete or perfect works. I am doing what I must do.

KB *Much of the Arab Spring of 2011 came about as a result of blogging and access to the Internet. Once upon*

a time, not so long ago, you weren't even very interested in computers; then you became a leader in this very progressive arena. Indeed, your blog was shut down by the Chinese authorities in 2009. Blogging seems to be, at least for you and a handful of others, a new art form. And it is clearly one that disturbs the authorities—perhaps far more than any medium. In your interview with Hans Ulrich Obrist back in 2006 you said that "Life in blogs is real because it's your own life…."[2] Is the use of the Internet art? And if so, is it a place to operate, as Rauschenberg desired, in the gap between art and life?

AW At first we called the Internet a virtual world, but it has become more and more real. For instance, my child is three years old, but he has had an iPad for two years. He is a digital native, and his favorite hobby is computer games. It's hard for reality to compete with the stimulation, active exchange, and intensity that the digital world can offer. You may say that this is not the real world. But for many people, the Internet is not only real; it is closely tied to the future. We cannot fully comprehend every instance of change that the Web has brought to society. It is because our understanding of society and entities is tied to our experiences with the past. With the Internet, our past experiences do not apply. We've not only created a new tool, but a powerful force that is influencing the world and changing mankind simultaneously. Its impact is obvious. I am very interested in its possibilities. I enjoy its direct conversations, discussions, and debates much more than other forms of communication. I spend over eight hours daily on the Internet, and the thoughts and joy it has generated are something that I've never experienced before. At first my wish was to create works related to the web, but then I realized that this wish comes from outdated thinking. It would be forced and unnatural to make it the basis of my work. After *Fairytale* at Documenta in 2007 (pages 108–115), the relationship has become more natural and even beyond my imagination. My experiences, my living environment, and my use of the Internet all shape who I am as an artist. The Internet is not only a tool. To me, it is concurrent with life. It introduces me to a condition that I don't understand; I could have never predicted that it would lead me to my current state. Nonetheless, I am still alive and struggling. I have no idea what the future will be, but I believe that the web has established a direct connection with many people's happiness and grief. It will only get stronger and stronger.

KB In one of your early blogs, you stated: "Our dreams are composed of realistic limitations on life and the eager impulse to surmount these limitations." Shortly before that, you also observed "To speak of beautiful dreams

and grand ideals is safe—you could go on forever. But to realize them through action is dangerous…. Action can only be executed with actions."[3] What side does art fall on: dreaming or action? Or is art when dreams turn into action?

AW Art is an action that transforms our thoughts. It is a process that turns nothing into something. As Confucius said in the Analects, "Thought without action is laziness; action without thought is labor lost." On one hand, if we merely think but take no action, there would be no progress. On the other, acting on thoughtless impulse is doomed to failure. Our ancestors understood this quite well. The relationship between thought and action is the most important source of human wisdom and joy. With both, the process of turning art into reality is the path to happiness. It's like a game. Only through this process can we understand who we are. So the game will continue.

1 *Ai Weiwei: Circle of Animals.* Edited by Susan Delson (Munich and New York: Prestel, 2011), 59.

2 *Ai Weiwei Speaks: with Hans Ulrich Obrist* (London: Penguin, 2011), 5.

3 Ai Weiwei, *Ai Weiwei's Blog: Writings, Inteviews, and Digital Rants, 2006–2009.* Edited and translated by Lee Ambrozy (Cambridge, Massachusetts: The MIT Press, 2011), 25 and 13.

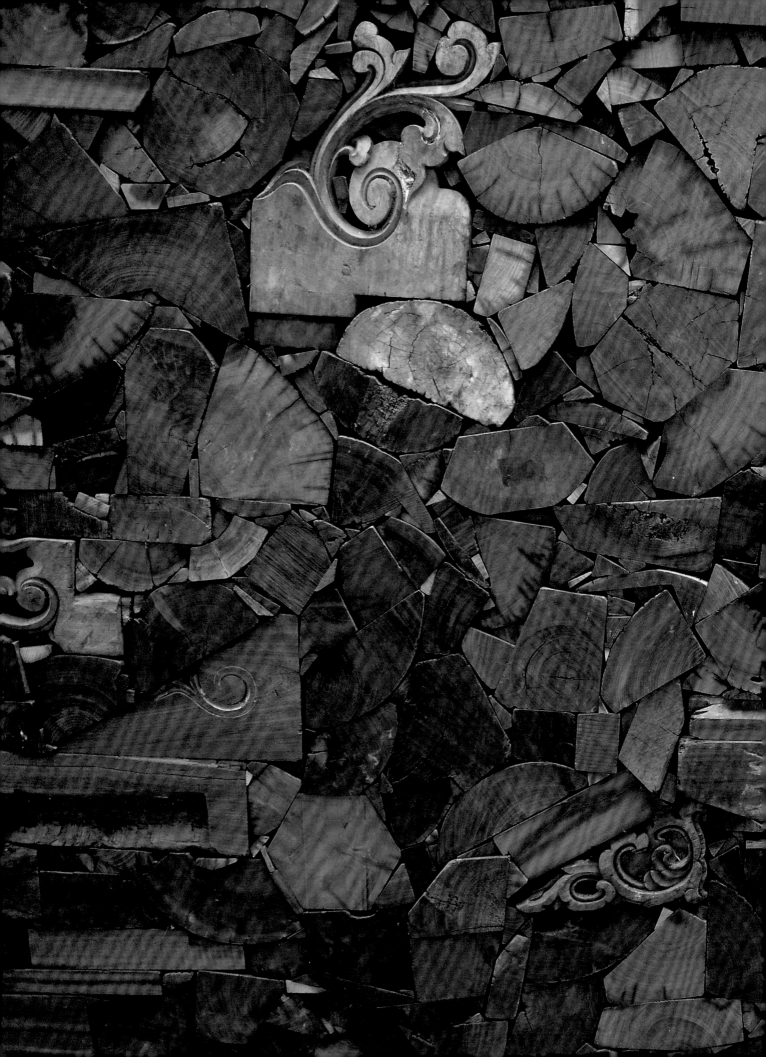

Plates

PAGES 46–51
New York Photographs, 1983–93
A selection of 98 black-and-
white photographs
33 1/16 × 33 1/16 in.
(84 × 84 cm), each
Collection of the Artist (exhibition copy)

**CLOCKWISE FROM
TOP RIGHT**
Hu Yongyan, Xu Weiling, Street Per-
formance in Greenwich Village, 1986;
Zhou Lin and Cat, San Francisco, 1986;
Ai Dan Delivering Newspapers in New
York Subway, 1987; Self-Portrait, East
3rd Street Apartment, 1986; Ai Weiwei,
Williamsburg, Brooklyn, 1983

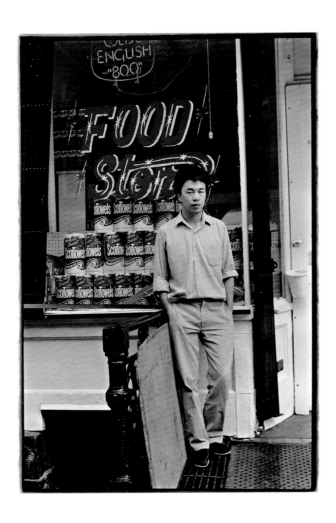

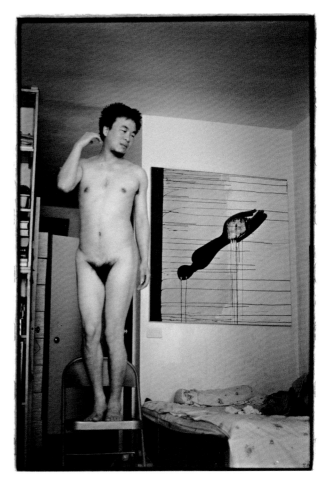

Ai spent a decade in New York City photographing
moments of interest and daily life. Some of these
photographs document now-famous individuals
including the composer Tan Dun, the film director Chen
Kaige, and the poet Allen Ginsberg. He also captured
events like the 1988 Tompkins Square Park riots,
as well as political activism and social problems such
as homelessness and the AIDS crisis. Furthermore,
the New York photographs reveal Ai's interest in the
work of Jasper Johns and Andy Warhol, as well as
earlier twentieth-century art movements, particularly
Dadaism and Surrealism.

**CLOCKWISE
FROM TOP**

Wang Keping and Ai Weiwei,
1987; Backstage at the Met, 8th
Street Subway Station, 1987;
Dress Rehearsal for Turnadot at the
Metropolitan Opera, 1987; Gang Liu,
Li Gang, and Gu Cheng, JFK Airport,
1988; In front of Duchamp's work,
Museum of Modern Art, 1987

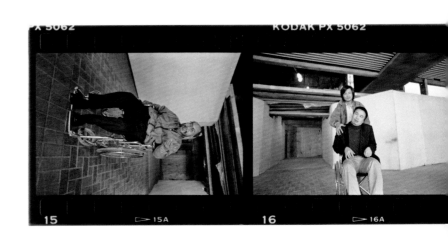

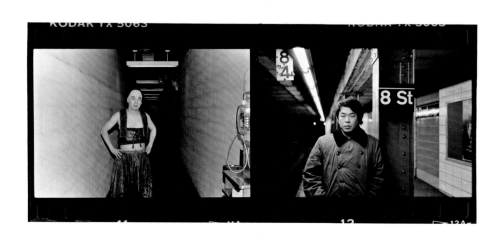

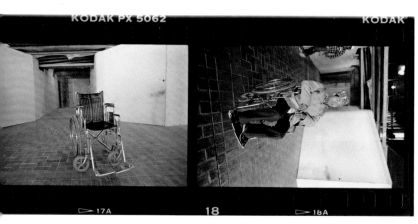

**CLOCKWISE
FROM TOP**
Portrait in the Mirror, 1989;
Aliafu, 1990; Feng Xiaogang
on top of a Rented Taxi, Times
Square, 1993; Chinese New
Year on Mott Street, 1989;
Gu Changwei, Chinese New
Year on Mott Street, 1989

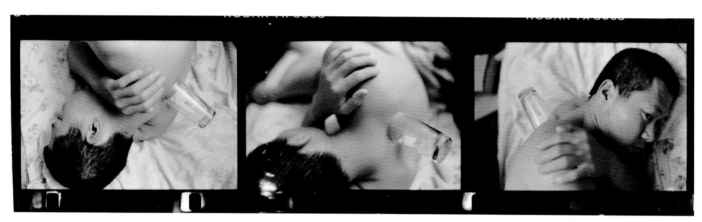

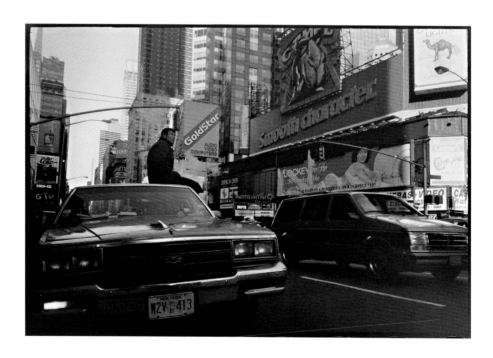

Beijing East Village Photographs, 1993–
A selection of 34 black-and-
white photographs
33 1/16 × 33 1/16 in.
(84 × 84 cm), each
Collection of the Artist (exhibition copy)

**OPPOSITE
AND BELOW**

Last photo in the East Village,
1994; Last dinner in the East
Village, 1994

Bowls of Pearls, 2006
(overhead view of
a single bowl)
A pair of porcelain bowls
and freshwater pearls
14 15/16 × 38 9/16 in.
(38 × 98 cm), each
Stockamp Tsai Collection

Begun in 2002, Ai's celebrated chandelier series includes large-scale installations composed of thousands of glass crystals. *Cube Light,* a seminal piece in this body of work, extends Ai's interest in re-examining Minimalist artistic strategies and, more specifically, in questioning the perceived solidity and exactitude of the iconic cube. The artist's use of glass crystals exemplifies his interest in the manipulation of materials that interrogate conventions of culture, history, politics, and tradition. According to Ai, an important inspiration for the series was a scene in Sergei Eisenstein's 1928 film *October,* in which the shaking crystal chandelier suggests the instability of a society undergoing profound change.

OPPOSITE
Cube Light, 2008
Glass crystals, lights, and metal
163 × 157 ½ × 157 ½ in.
(414 × 400 × 400 cm)
Hirshhorn Museum
and Sculpture Garden,
Smithsonian Institution,
Washington, DC

BELOW
Glass crystals for
Cube Light

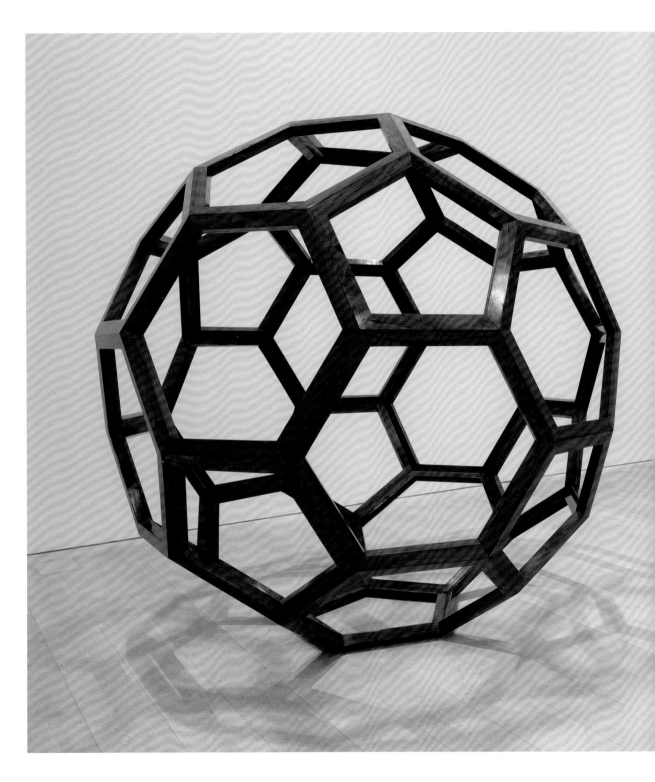

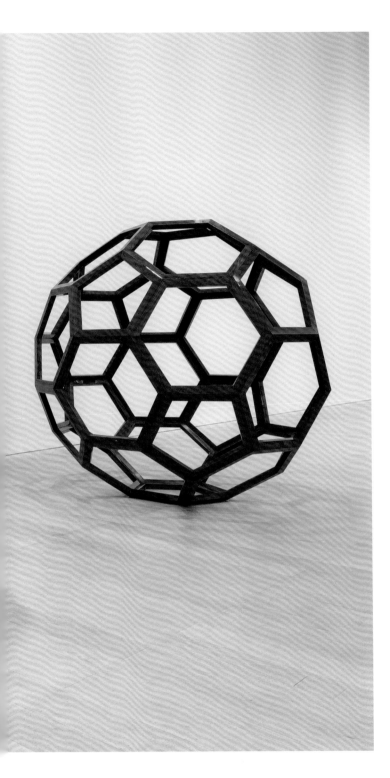

These wooden sculptures, assembled without nails using traditional joinery techniques, are truncated icosahedrons. Their shape is similar to the surface pattern on a soccer ball. Leonardo da Vinci illustrated this form, consisting of twelve pentagons and twenty hexagons, for mathematician Luca Pacioli's 1509 treatise *De Divina Proportione* [The Divine Proportion]. Ai has created several works using this geometric form, focusing either on the framework or on the solid faces of the component shapes.

LEFT TO RIGHT
Untitled, 2006
Huali wood
Diameter: 66 9/16 in.
(169 cm)
Collection of J. Chen

Untitled, 2011
Huali wood
Diameter: 51 3/16 in.
(130 cm)
Collection of the Artist

BELOW
Prototype for
Untitled, 2006

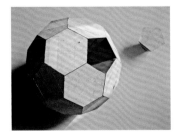
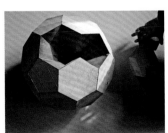
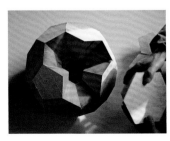
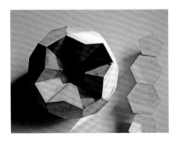

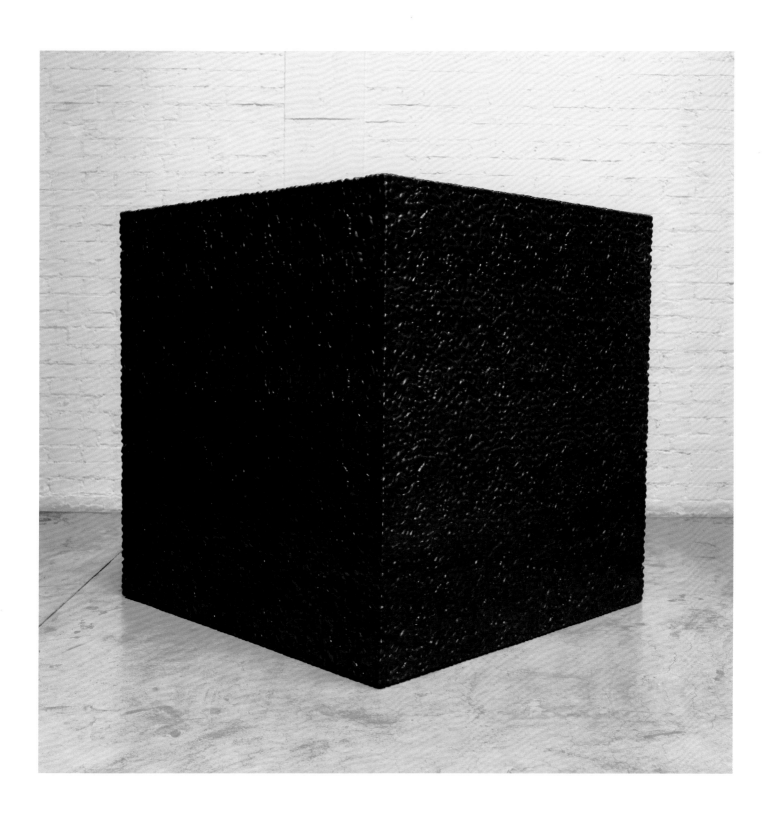

Cube in Ebony, 2009
Rosewood
39 3/8 × 39 3/8 × 39 3/8 in.
(100 × 100 × 100 cm)
Collection of the Artist

This piece, one cubic meter in size, is made of carved rosewood boards. In China, rosewood is a favorite material for traditional artisans, who value its hardness and density when creating intricate carvings. During the Tang Dynasty (618–907 CE), rosewood was considered one of the "three precious woods" and was an important export to Japan. In *Cube in Ebony*, Ai conceived of a contemporary minimalist work using traditional Chinese artisan techniques.

Small wooden box from artist's father
Wood
2 3/8 × diameter 3 9/16 in.
(6 × diameter 9 cm)

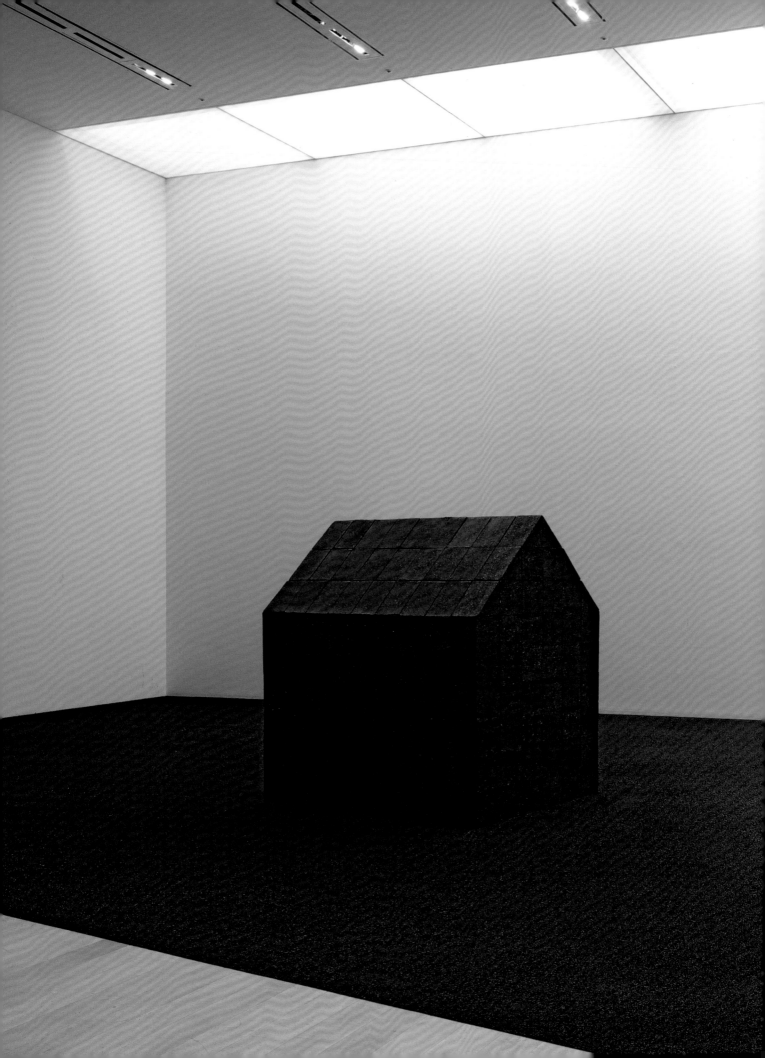

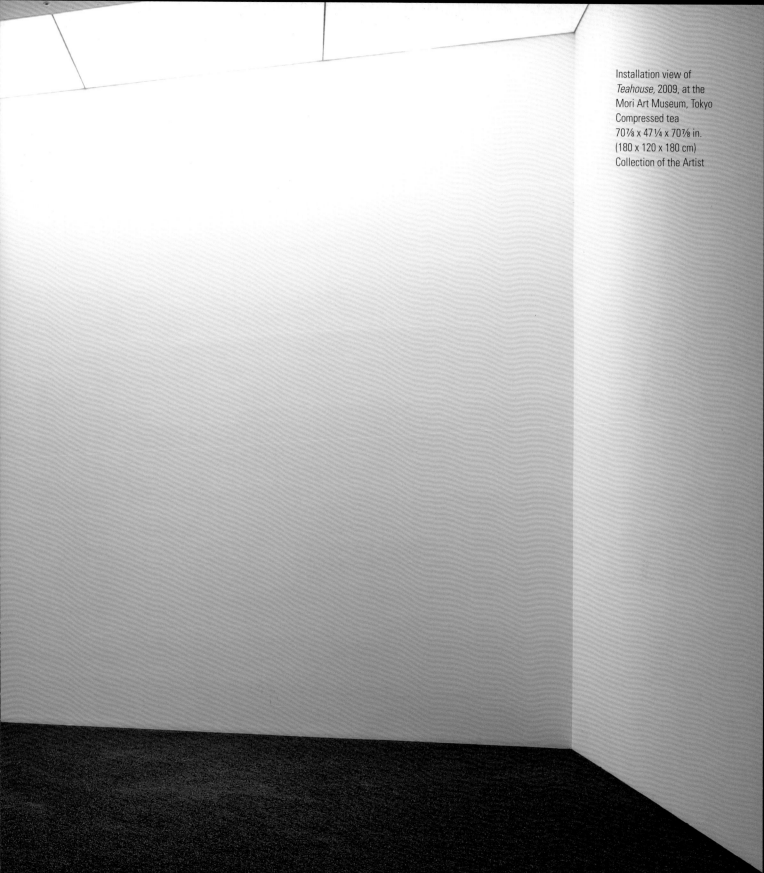

Installation view of
Teahouse, 2009, at the
Mori Art Museum, Tokyo
Compressed tea
70⅞ x 47¼ x 70⅞ in.
(180 x 120 x 180 cm)
Collection of the Artist

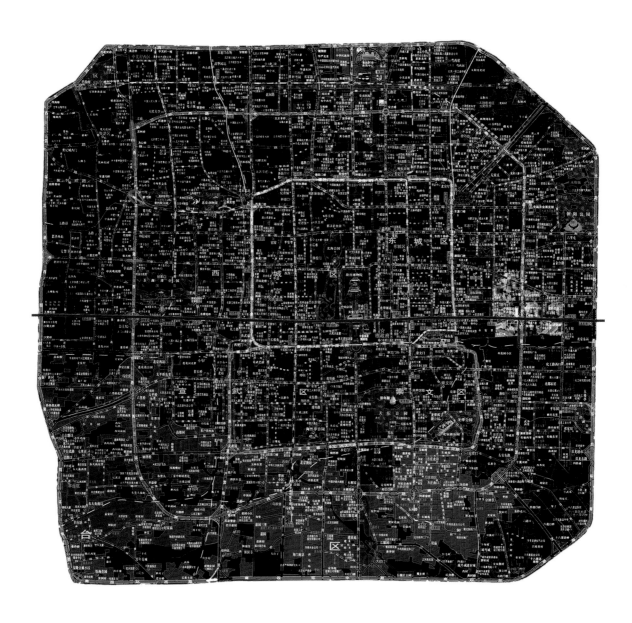

Chang'an Boulevard, 2004
Video
Running time: 10 hours, 13 minutes
Collection of the Artist

This is a video work capturing the uniformity of Beijing's urban landscape. Beijing is laid out in a grid with numerous ring roads. Chang'an Boulevard runs east and west for forty-five kilometers, intersecting the city's core and demarcating a diameter of Sixth Ring Road. In the winter of 2004, Ai Weiwei spent over a month driving along the boulevard and shooting a minute of video every fifty meters. The video, which is over ten hours long, begins in a suburban area, gradually shifts into the city center with its tall buildings, and then moves out to the suburbs on the opposite side of the city. As a video consisting of one-minute fragments assembled in a uniform rhythm, it can be regarded as an accumulation of moments capturing a specific time and place.

Beijing: The Second Ring, 2005
Video
Running time: 1 hour, 6 minutes
Collection of the Artist

北京·二环立交桥　2005
The Second Ring·Beijing 2005

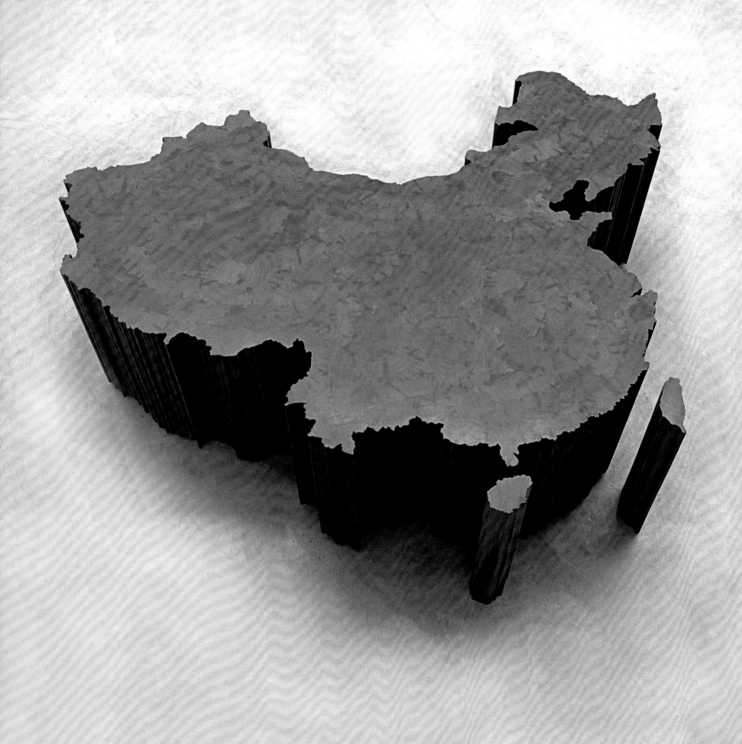

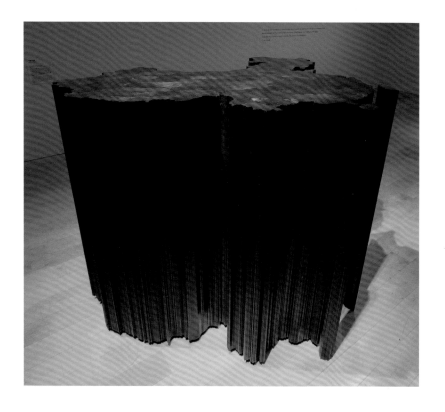

Using traditional Chinese joinery techniques, this sculpture is a map of China made of salvaged wood from dismantled Qing Dynasty (1644–1911) temples. The work can be interpreted in a variety of ways. As a map of China, it can be understood as symbolizing the political unity of a country made up of many different cultural and historical factors. The monumental scale of the work suggests the long history of the Chinese nation.

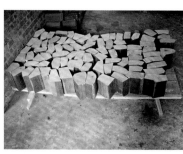

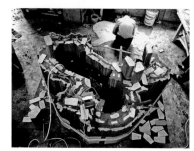

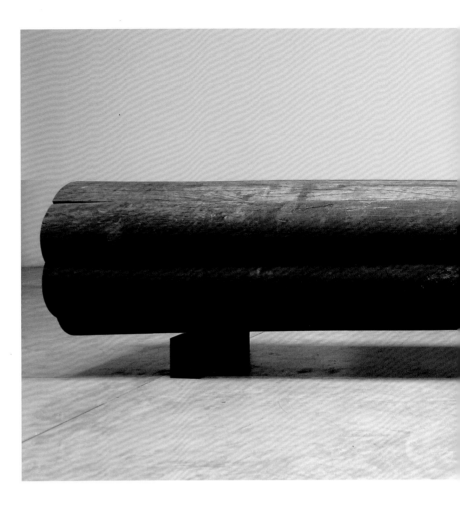

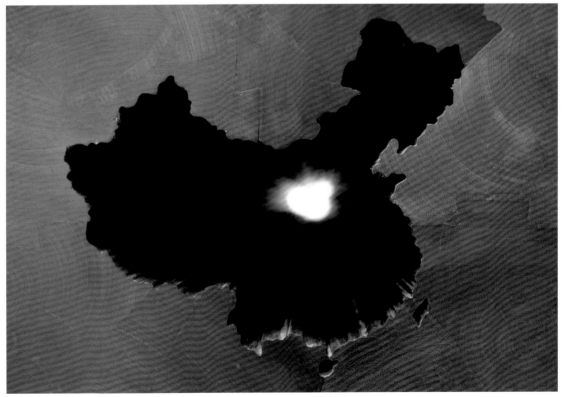

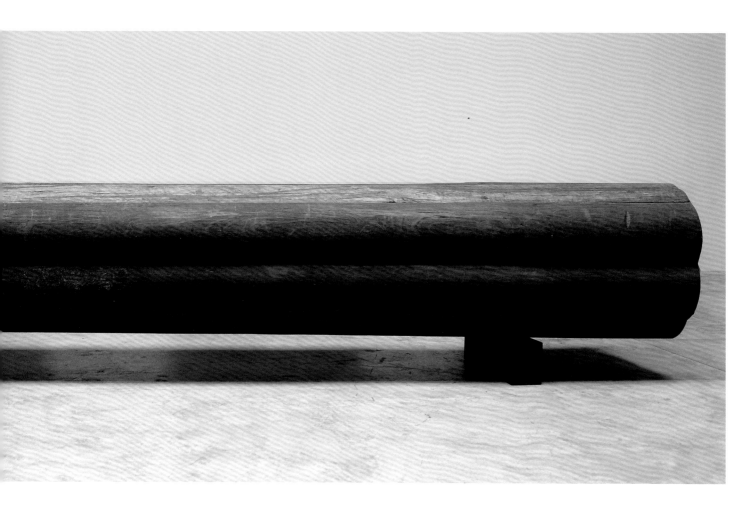

This sculpture is made of wood from eight pillars salvaged from Qing Dynasty (1644–1911) temples and was assembled using traditional Chinese joinery techniques. A map of China can be seen when looking at a cross-section of the work. Like *Map of China* (pages 68–69), *China Log* implies that the present Chinese nation has been put together from a variety of cultural and historical elements.

PAGES 72–75
Kippe, 2006
Tieli wood (iron wood) from dismantled
temples of the Qing Dynasty (1644–1911)
and iron parallel bars
71 ⅝ × 112 ⅝ × 40 ¹⁵⁄₁₆ in.
(182 × 286 × 104 cm)
Collection of Honus Tandijono

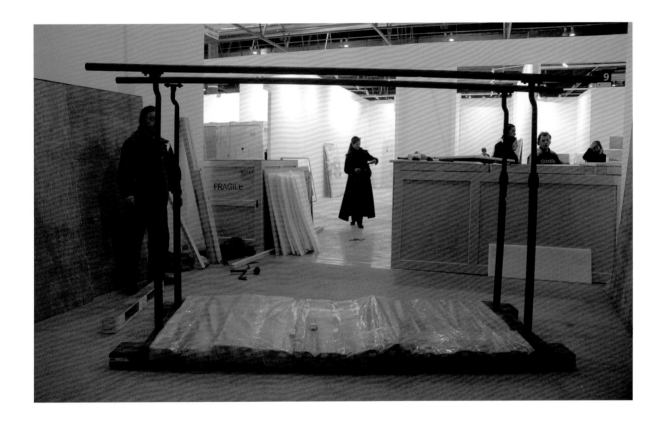

In this work, gymnastic parallel bars function as
a frame for a three-dimensional puzzle consisting
of tightly fitted pieces of wood salvaged from
dismantled Qing Dynasty (1644–1911) temples.
This sculpture expresses two of the artist's childhood
memories. According to Ai, "during the Cultural
Revolution, there was always a set of parallel bars
and a basket ball hoop in every schoolyard." Addi-
tionally, when the family lived in the Xinjiang region,
people in the neighborhood would stop to convey
their admiration for the beautifully stacked firewood
outside his family's home.

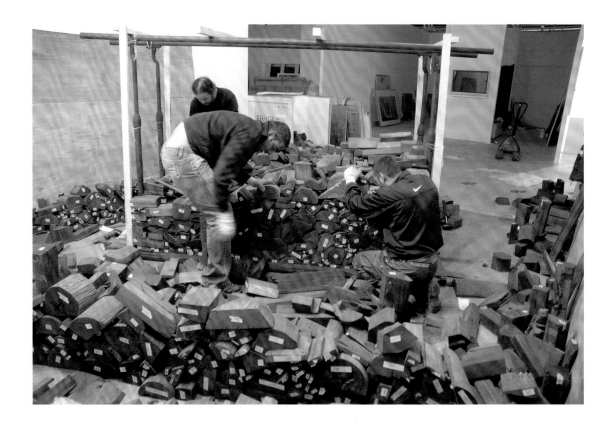

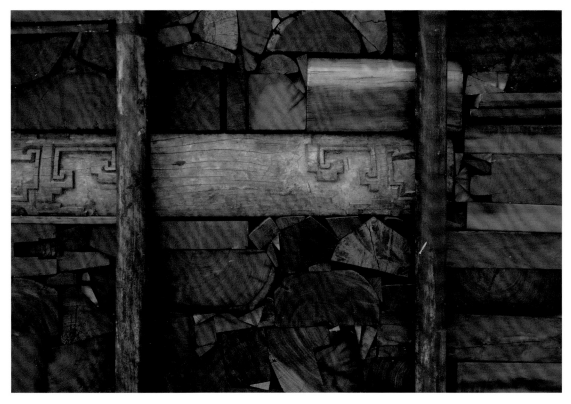

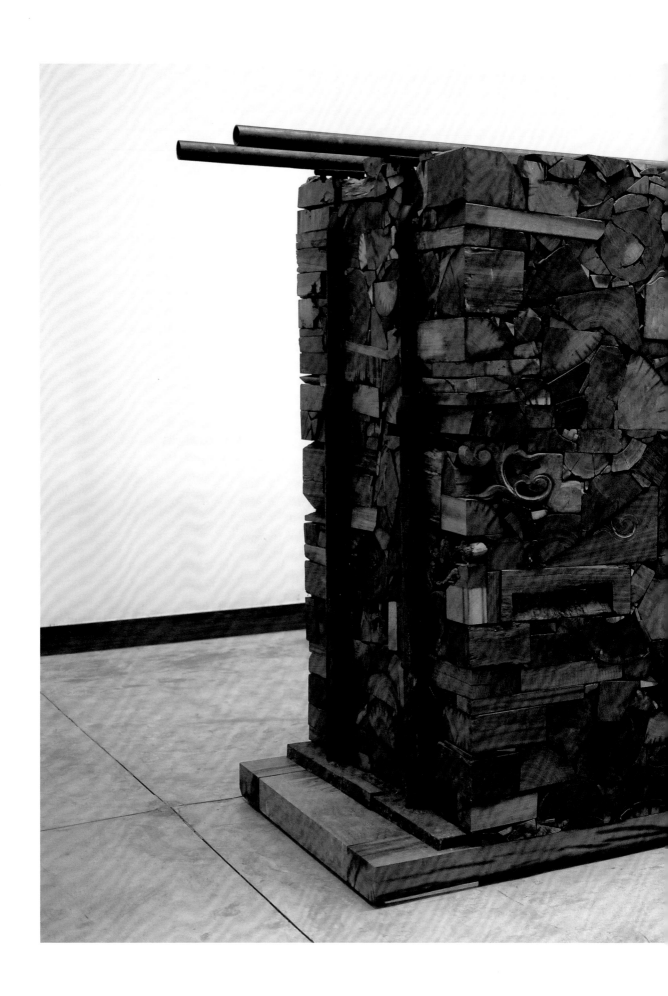

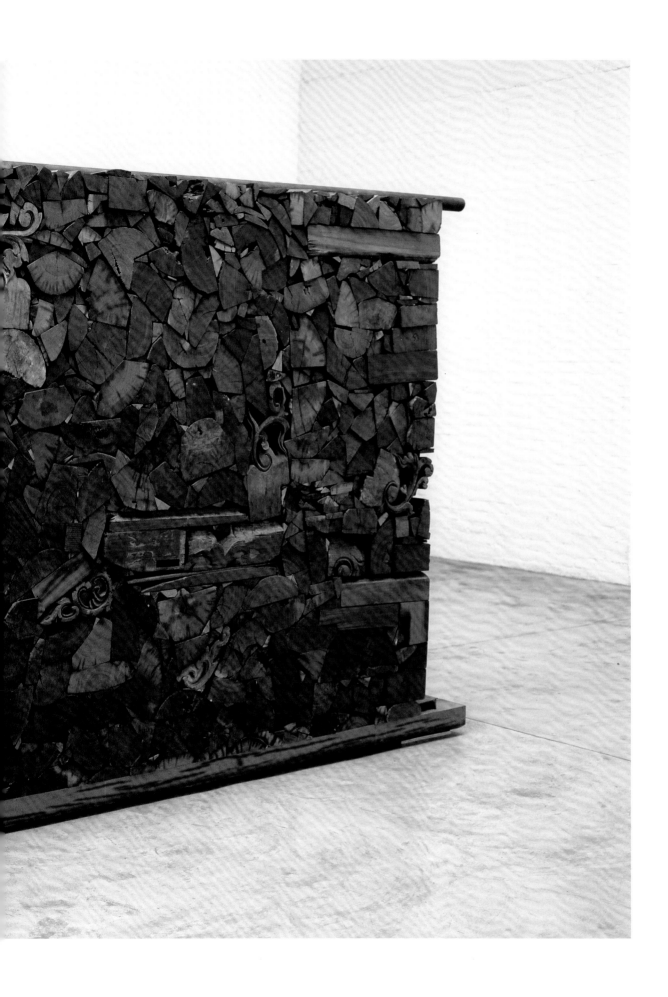

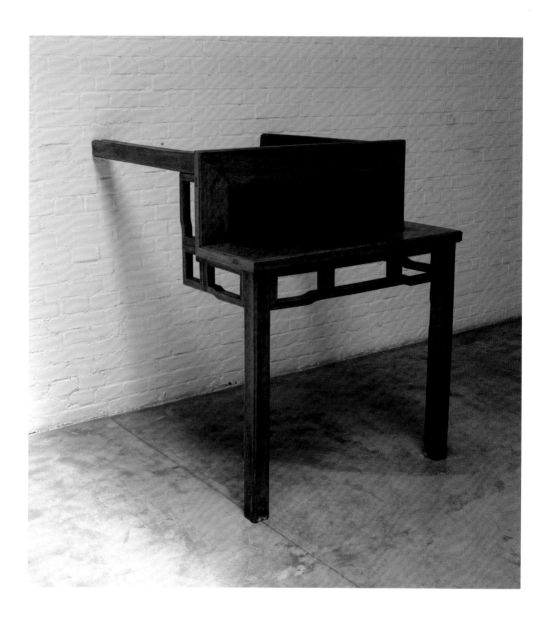

Ai first began working on this series of objects in 1997. He uses Qing Dynasty (1644–1911) furniture, which was made without nails and held together solely by traditional joinery techniques. There are numerous variations in this series, however, all are based on the idea of disassembling the furniture and reassembling it in ways that transform its meaning and obscure its function. Through this manipulation, Ai is able to focus the viewer's attention on the artisanship and elegant simplicity of the original furniture's design.

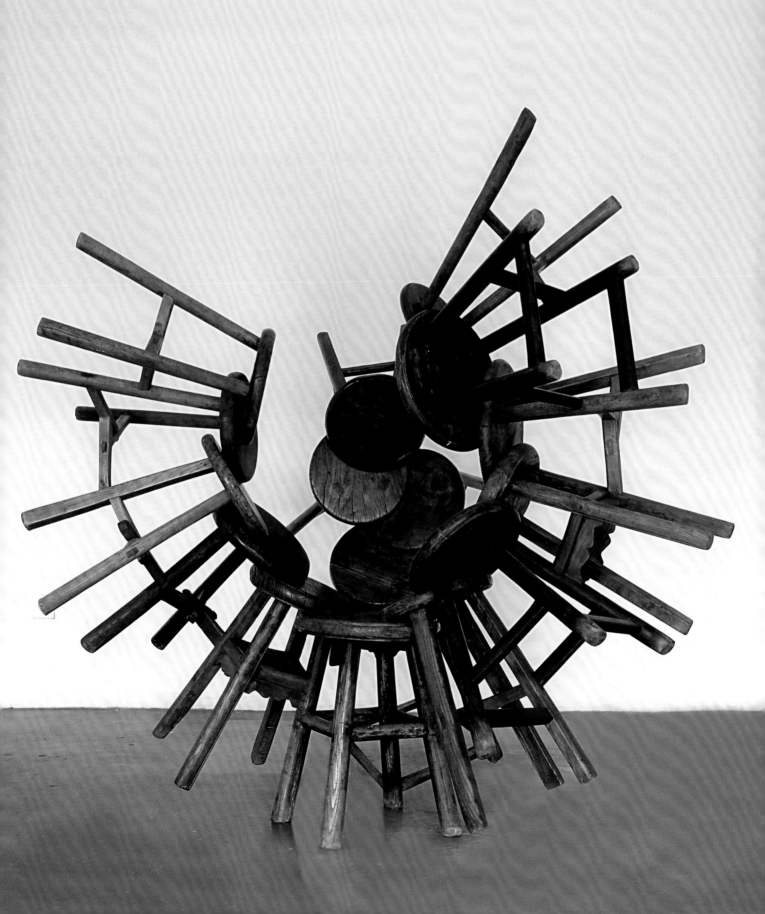

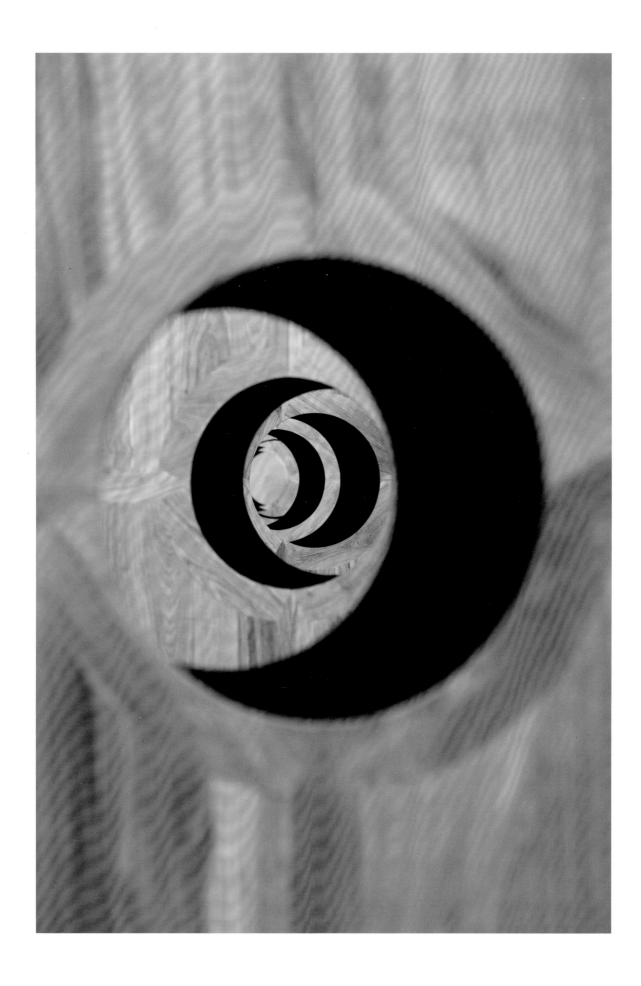

PAGES 78-81
Moon Chest, 2008
7 chests in huali wood
126 × 63 × 31 ½ in.
(320 × 160 × 80 cm), each
Collection of the Artist

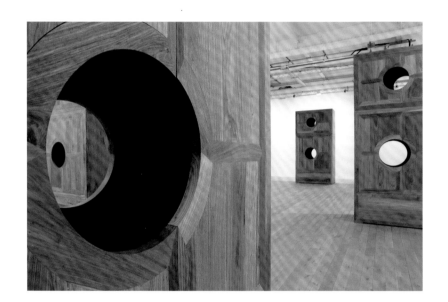

These chests are made from Chinese quince (huali), a precious and highly desirable wood. In each, the artist has incised four circular openings—in the upper and lower panels on the front and back—that transform these objects from functional pieces into pure artworks. The eighty-one chests in the series (seven of which are on view in this exhibition) are each unique as the precise placement of the holes varies. Nevertheless, the upper and lower openings always align so that they create the effect of showing every phase of the moon to visitors who walk through the installation. As with Ai's furniture series (pages 76–77), by taking away the functionality of these objects, their design—and in this case architectural presence in the gallery—becomes central.

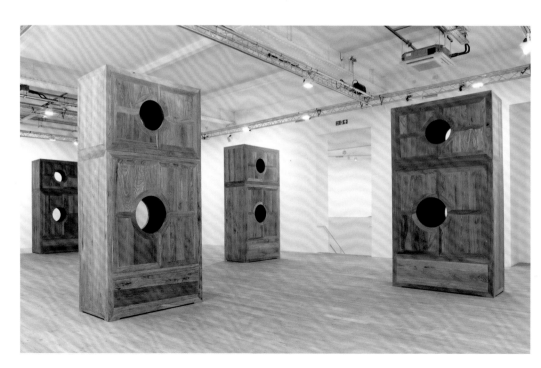

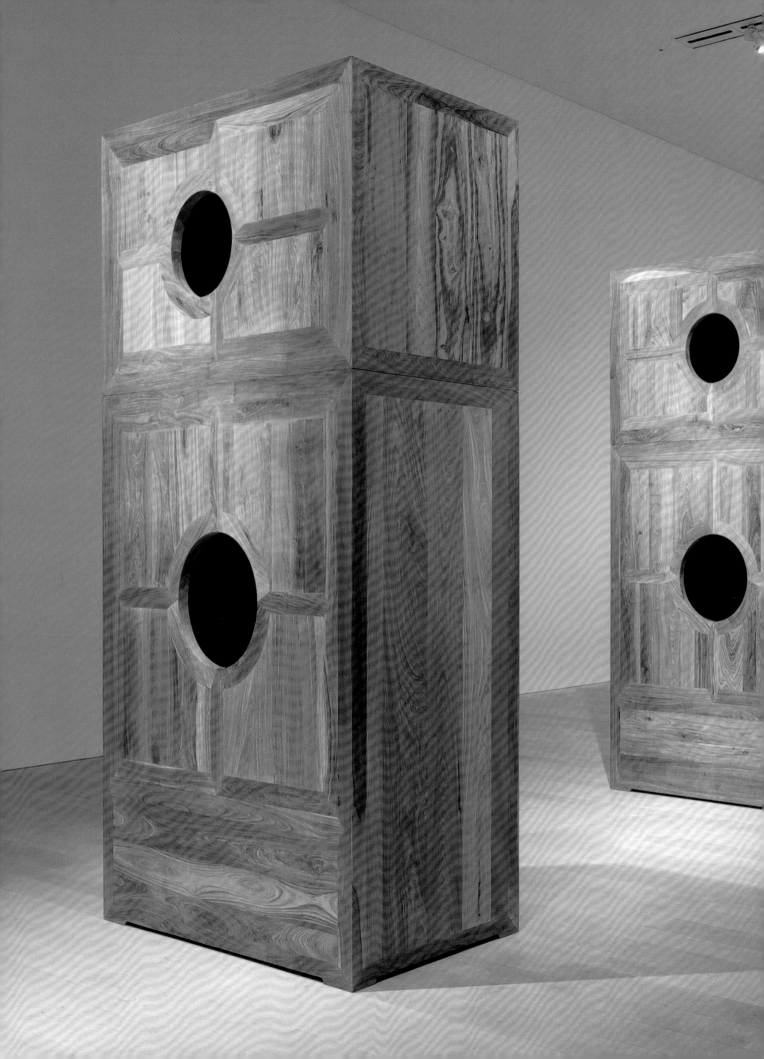

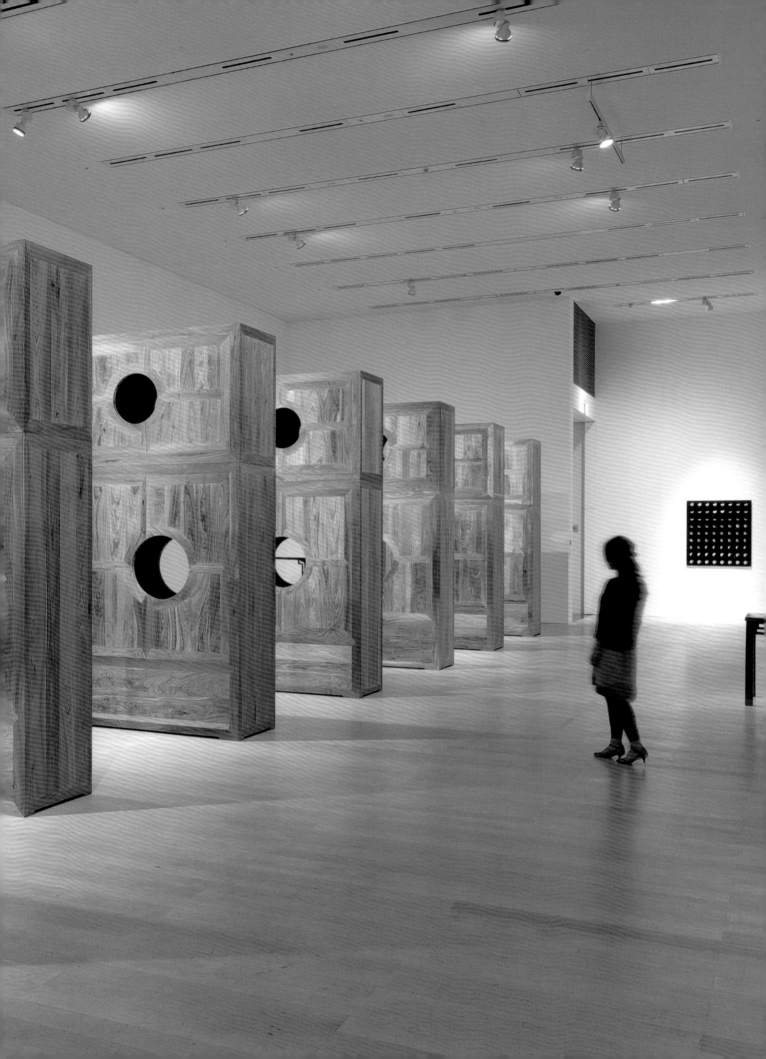

Château Lafite, 1988
Shoes and bottle
12 3/16 × 4 5/16 × 3 9/16 in.
(31 × 11 × 9 cm)
Collection of the Artist

Coca-Cola Vase, 2007
Vase from the Neolithic age
(5000–3000 BCE) and paint
11 × 9 13/16 in. (28 × 25 cm)
Private Collection, USA

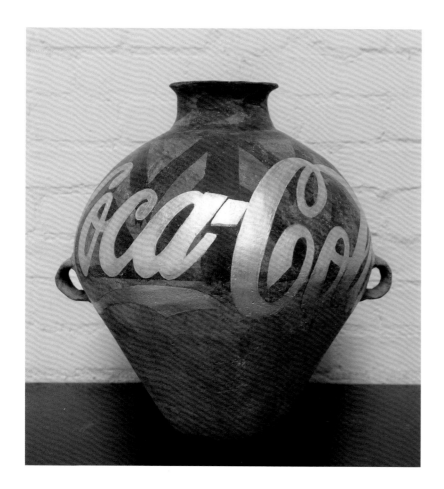

In this series, Ai Weiwei has inscribed the Coca-Cola logo on pottery jars he found in antique markets, tailoring the lettering to each jar's shape. The work blends contemporary design and branding from the global marketplace with the aesthetics and taste of people many centuries earlier. This is the artist's earliest series using antiques.

Colored Vases, 2007–10
16 Han Dynasty (206 BCE–220 CE) vases
and industrial paint
Dimensions variable
Collection of the Artist

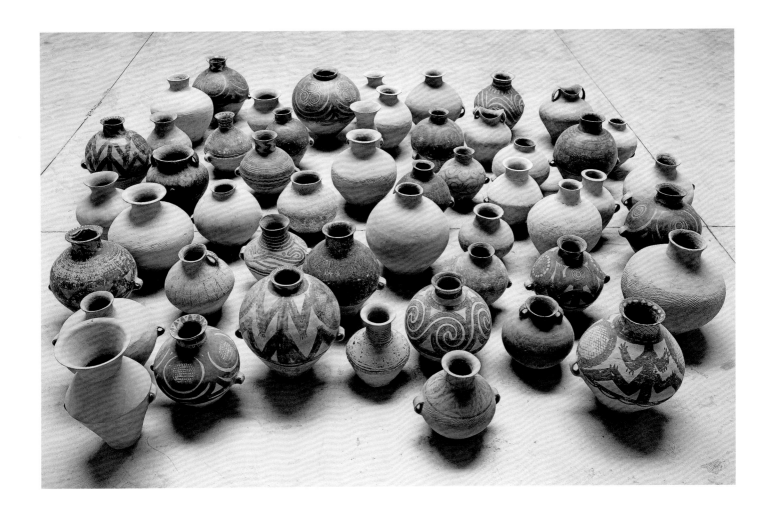

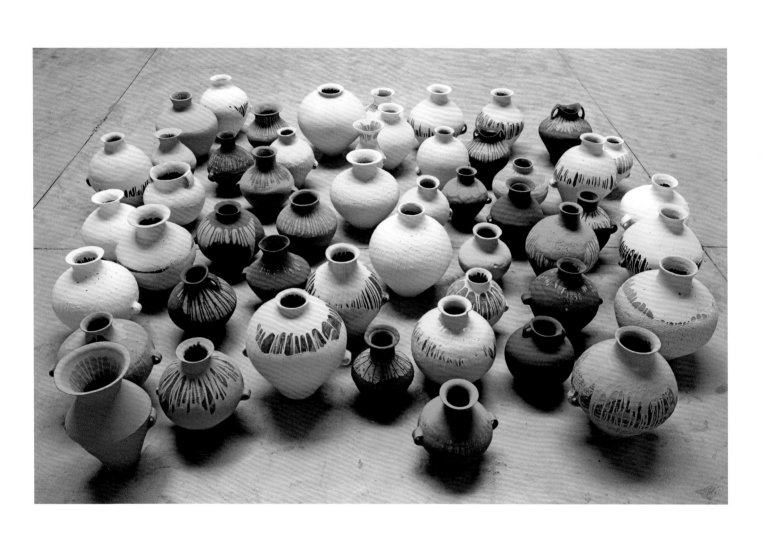

This series consists of Han Dynasty vases dipped in industrial paints as if they were glazes. The faded, richly patterned surfaces of the jars are concealed by the bright modern colors, but the jars retain their original forms. With their materials and shapes intact and only their surfaces changed, the vases force viewers to consider questions of authenticity and the value and meaning of an original artwork.

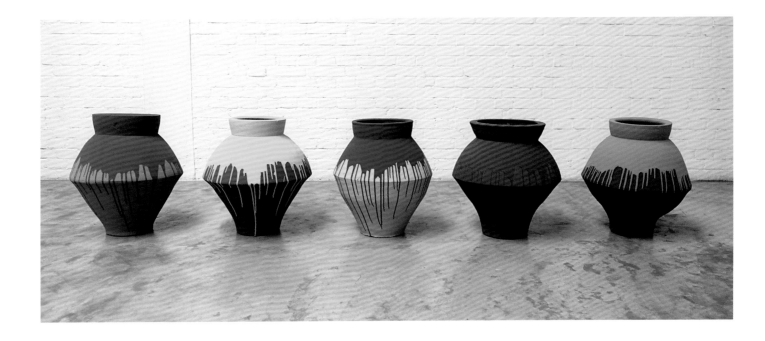

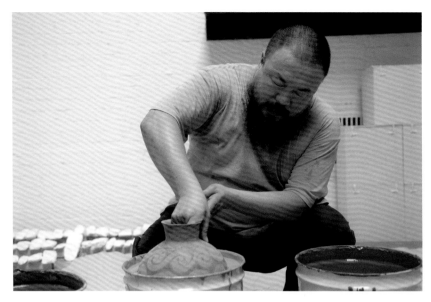

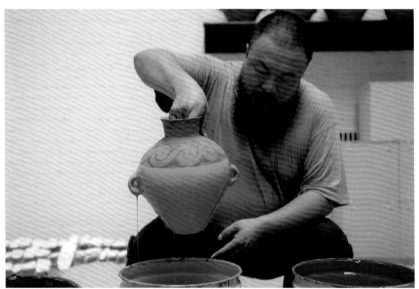

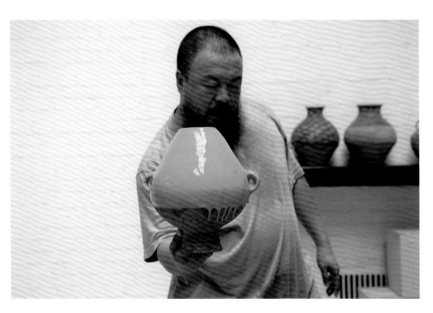

Dropping a Han Dynasty Urn, 1995/2009
Triptych: Lambda prints
75 ⅜ × 70 ⅞ in. (191.5 × 180 cm), each
Collection of the Artist (exhibition copy)

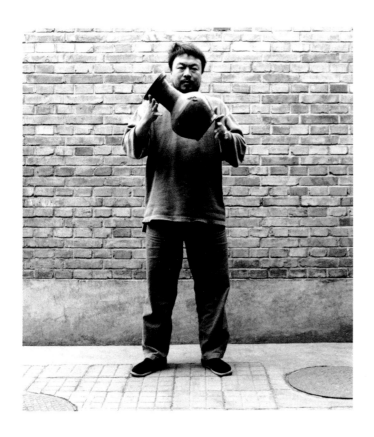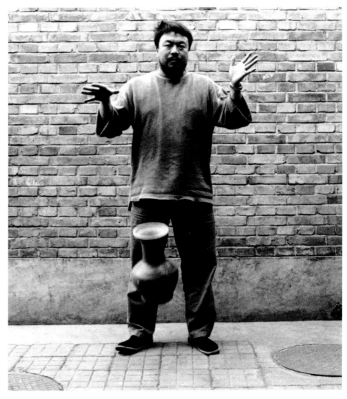

The act of dropping a Han Dynasty urn to the floor and thus destroying 2,000 years of cultural tradition and legacy expresses the notion that new ideas and values are produced through iconoclasm. The three photographs that record the artist's performance form a work of conceptual art that captures the moment when tradition is transformed and challenged by new values.

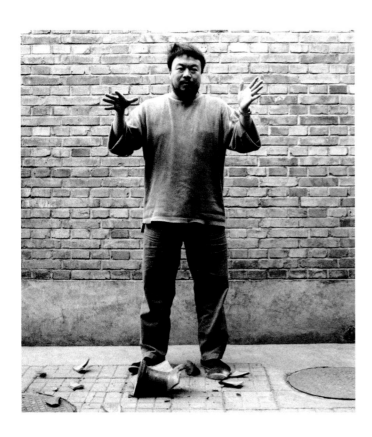

PAGES 91–93
Forever, 2003
42 bicycles
108 ¼ × 177 ³⁄₁₆ in.
(275 × 450 cm), overall
Courtesy of the Tiroche De Leon
Collection & Art Vantage Ltd.

Ai Weiwei dismantled forty-two Forever brand
bicycles and reassembled them into an interconnected
circular form. The Forever Company began producing
bicycles in Shanghai in 1940, and since that time the
company has grown to be the leading manufacturer
of bikes in China. With rapid modernization, the once
familiar swarms of bicycles are disappearing from city
streets, and the name Forever has come to have an
ironic ring to it. Nevertheless, many Chinese still cher-
ish memories of their bicycles that will last "forever."
In this work, the simple bicycle expands artist Marcel
Duchamp's concept of the Readymade to a monumen-
tal scale.

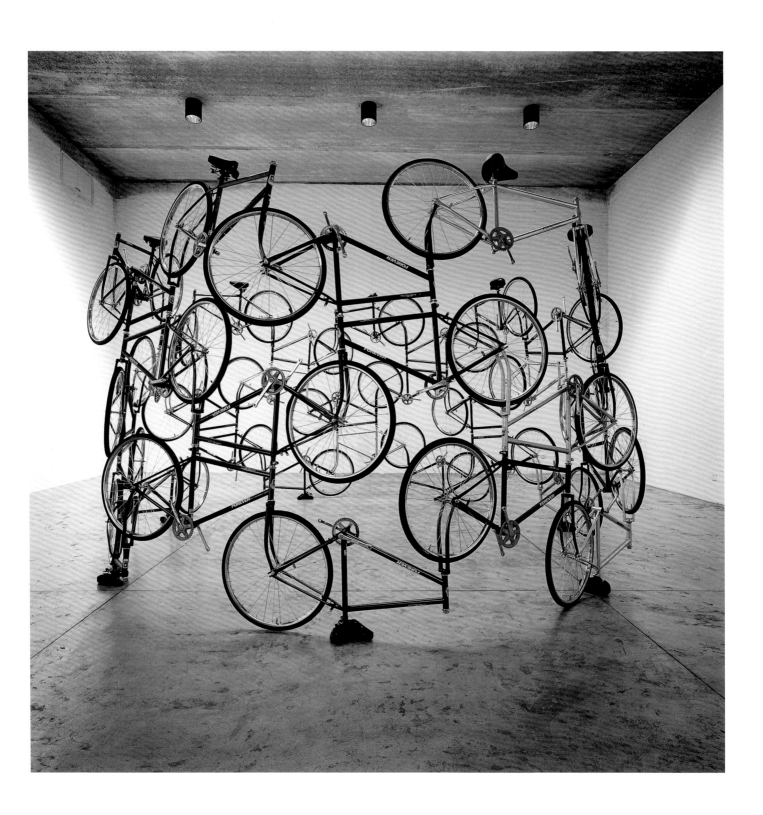

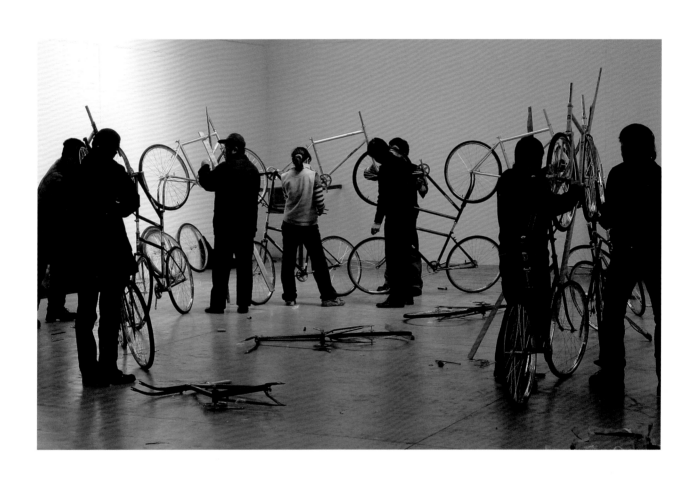

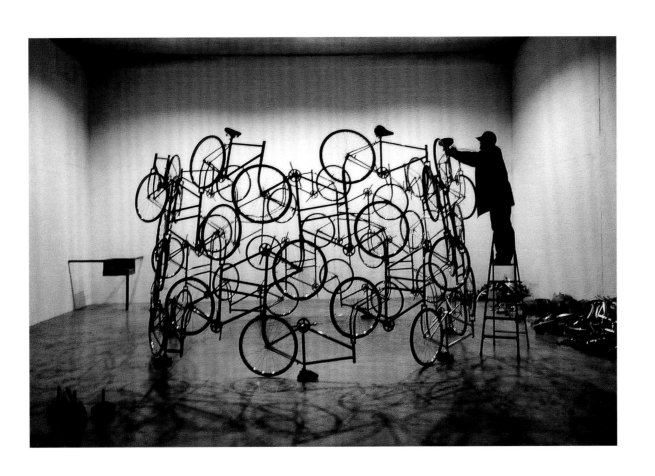

PAGES 95–97
Fragments, 2005
Table, chairs, parts of beams, and
pillars from dismantled temples of the
Qing Dynasty (1644 – 1911)
196 7/8 × 334 5/8 × 275 9/16 in.
(500 × 850 × 700 cm), overall
Sigg Collection

Included in the exhibition
Perspectives: Ai Weiwei,
May 12, 2012 – April 7, 2013,
Arthur M. Sackler Gallery,
Smithsonian Institution,
Washington, DC

This work is constructed from fragments left over
from other artworks Ai Weiwei has created using
antique Chinese furniture and temple pillars and
beams, such as his furniture series (pages 76–77).
These remnants from temples in part represent the
rebuilding that is going on throughout China during
its present wave of modernization. Like *Map of China*
(pages 68–69), when seen from above, this structure,
assembled according to traditional wood joinery meth-
ods, without nails, forms a map of China, suggesting
that the nation and history are the accumulation of
various cultural and social fragments.

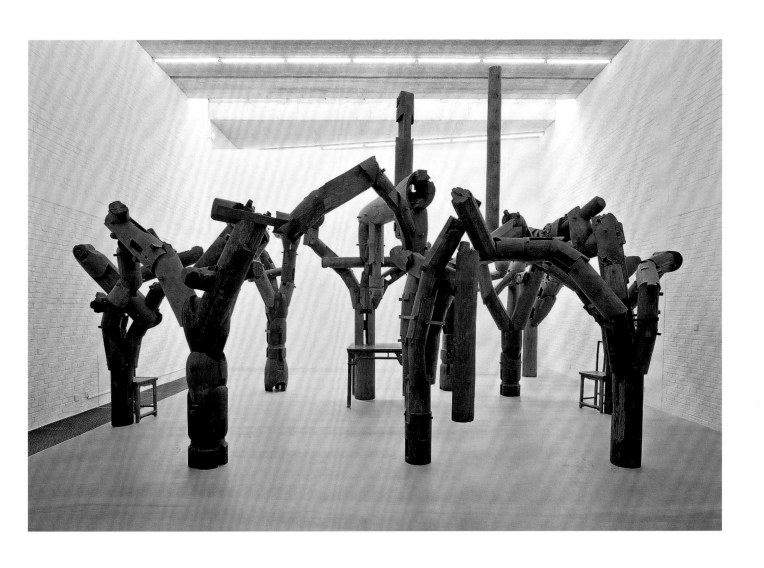

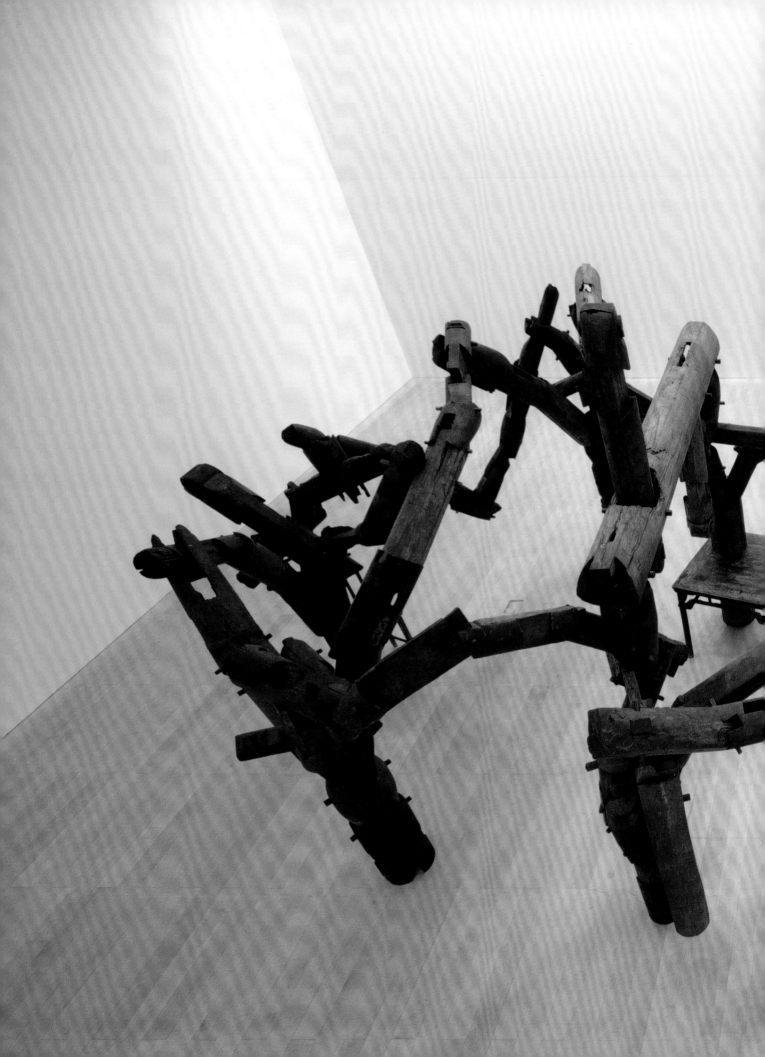

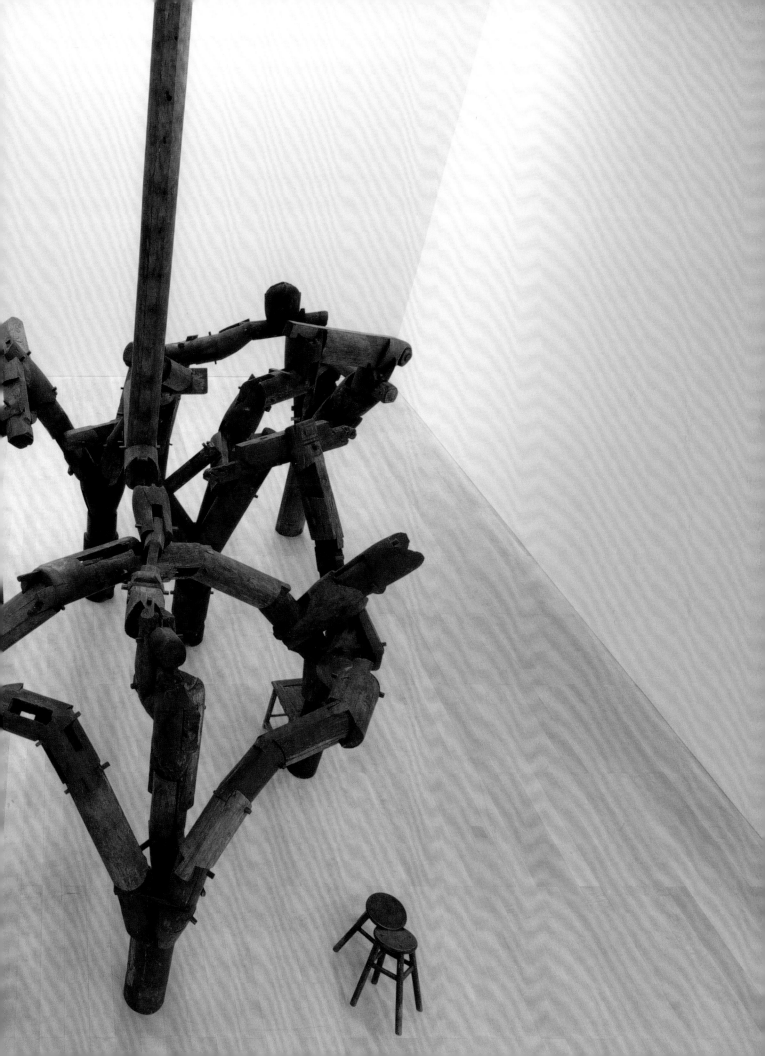

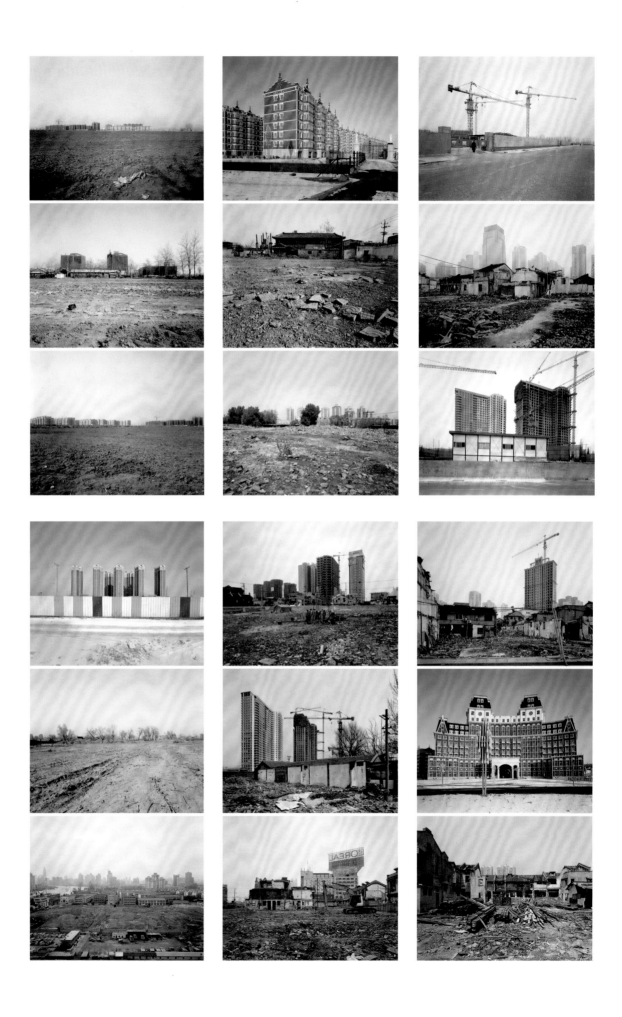

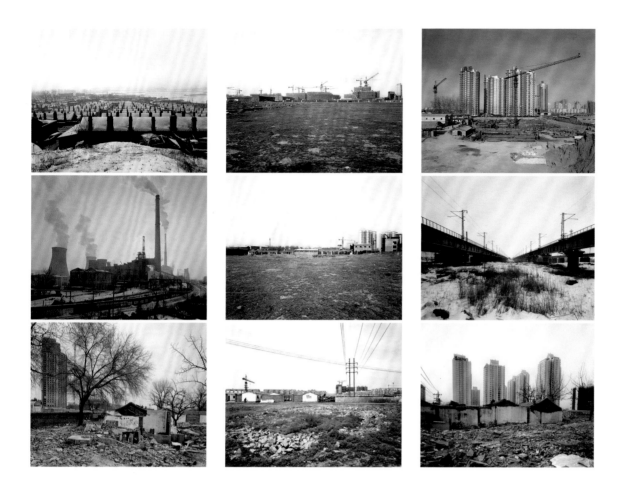

PAGES 98–101
Provisional Landscapes, 2002–08
Inkjet prints
Dimensions variable according
to installation
Collection of the Artist (exhibition only)

Since the Chinese Cultural Revolution in 1949, all
land in China has belonged to the State, and the gov-
ernment has been able to develop huge tracts without
engaging in any negotiations with landowners.
Provisional Landscapes presents viewers with a series
of photographs depicting the intermediate stages
of this rapidly changing backdrop. Ai locates vast open
spaces created by the demolition of buildings. These
barren landscapes are ephemeral, however, and
the artist aims to capture the moments before new
construction and the arrival of the new age.

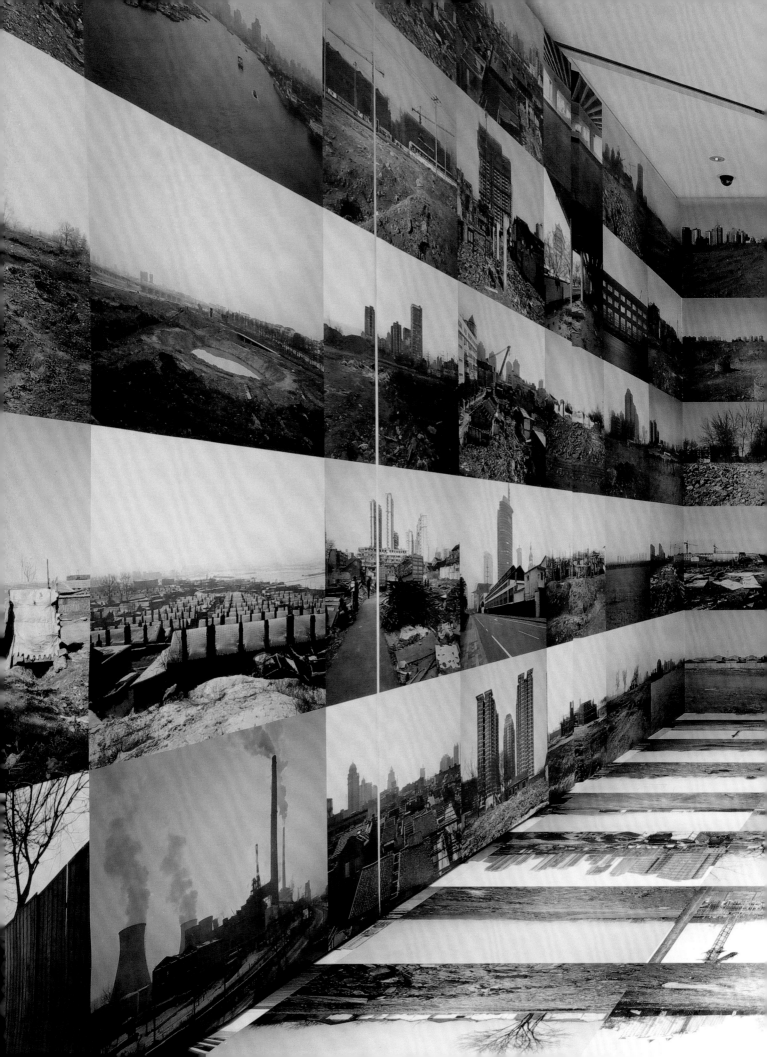

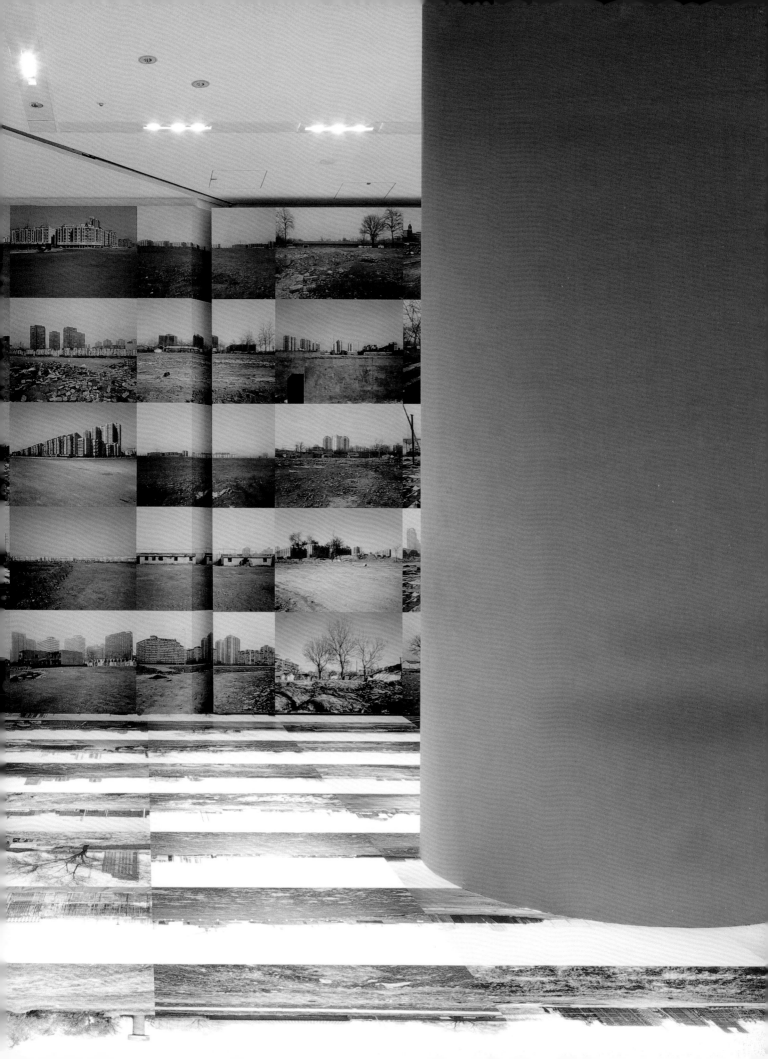

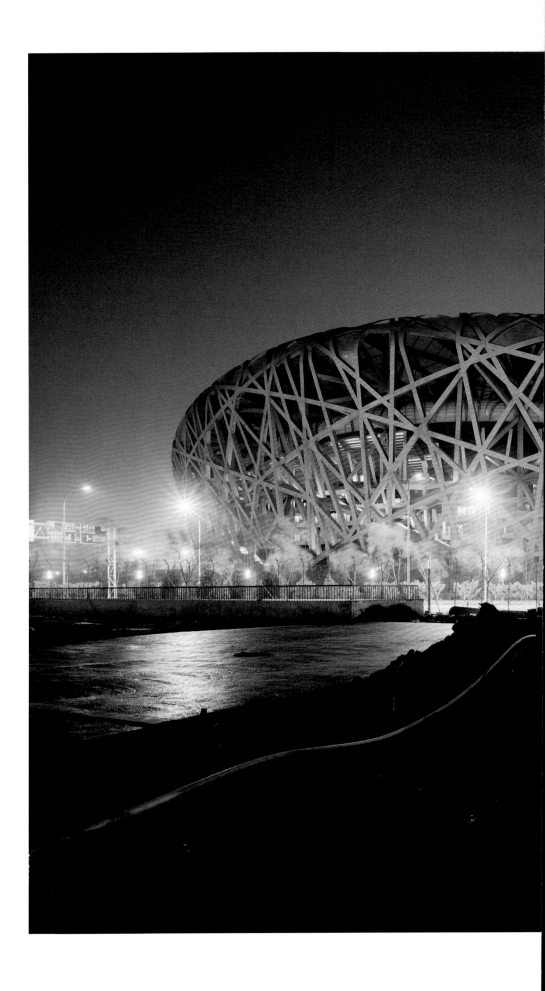

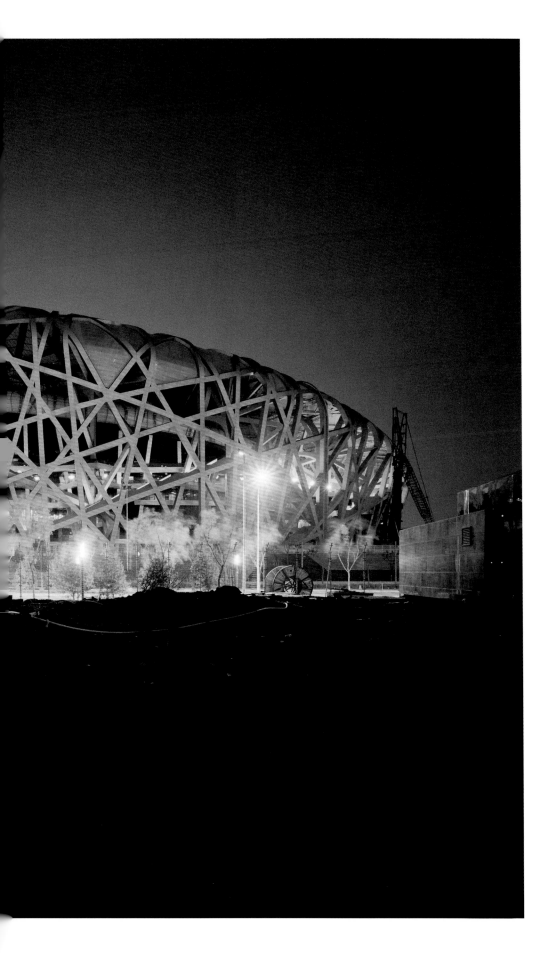

PAGES 102–07
Beijing's 2008 Olympic Stadium,
2005–08
Inkjet prints
Dimensions variable according
to installation
Collection of the Artist (exhibition only)

Ai Weiwei collaborated with the Swiss architectural firm Herzog & de Meuron to design the 2008 Olympic Stadium (The National Stadium, Beijing), as well as the surrounding landscape. The process of building the stadium is recorded in these photographs taken between 2005 and 2008.

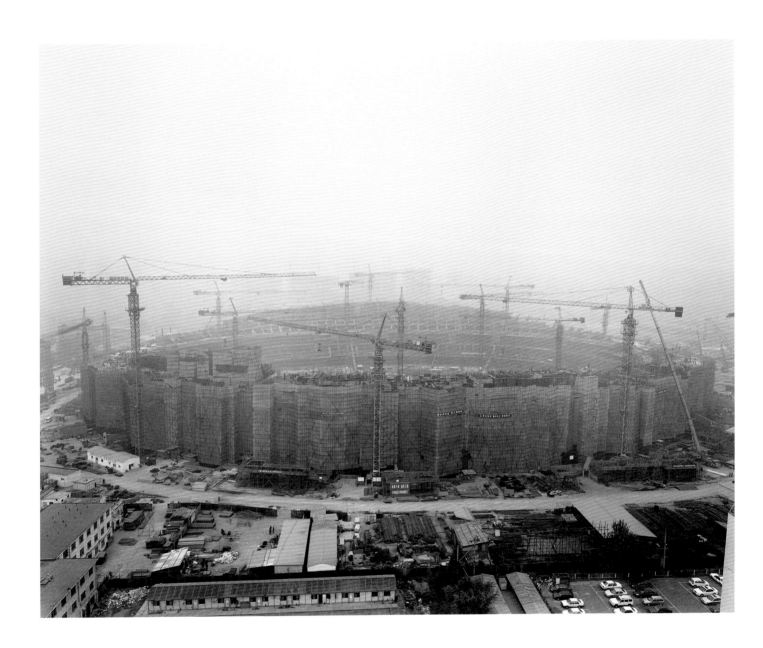

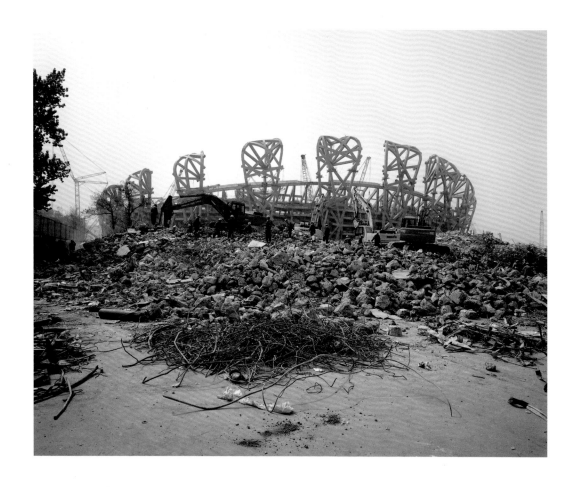

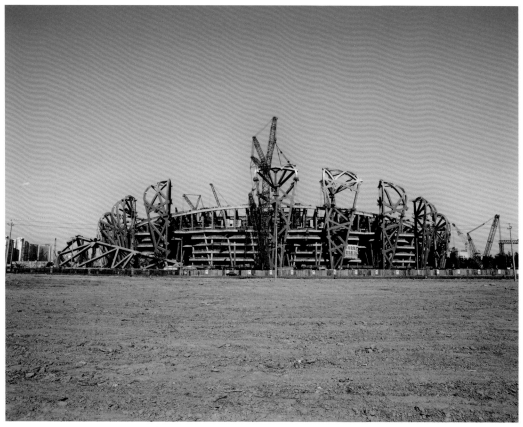

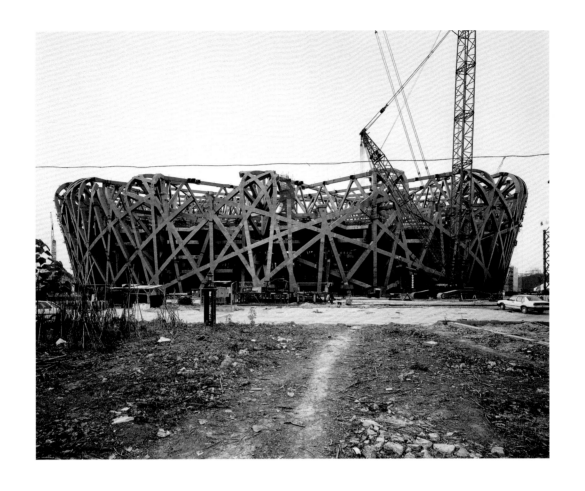

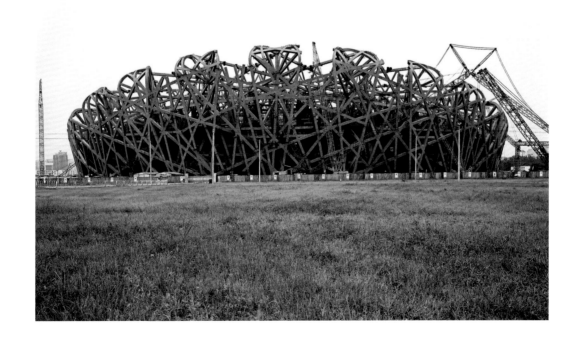

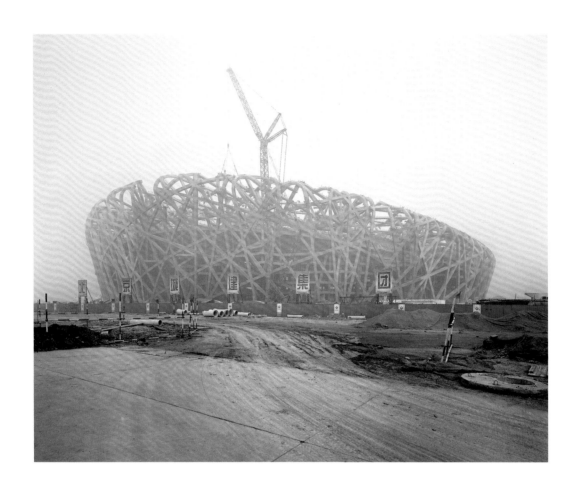

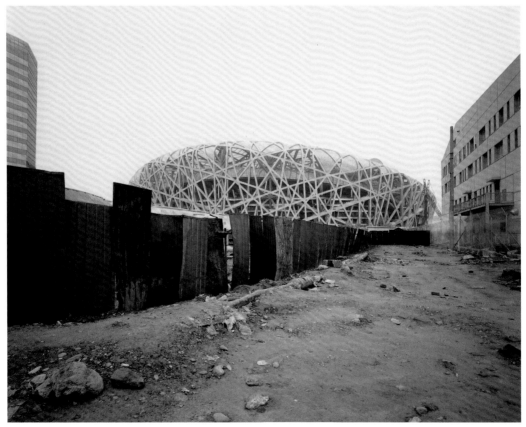

PAGES 108–15
Fairytale, 2008
Video
Running time: 2 hours, 32 minutes
Collection of the Artist

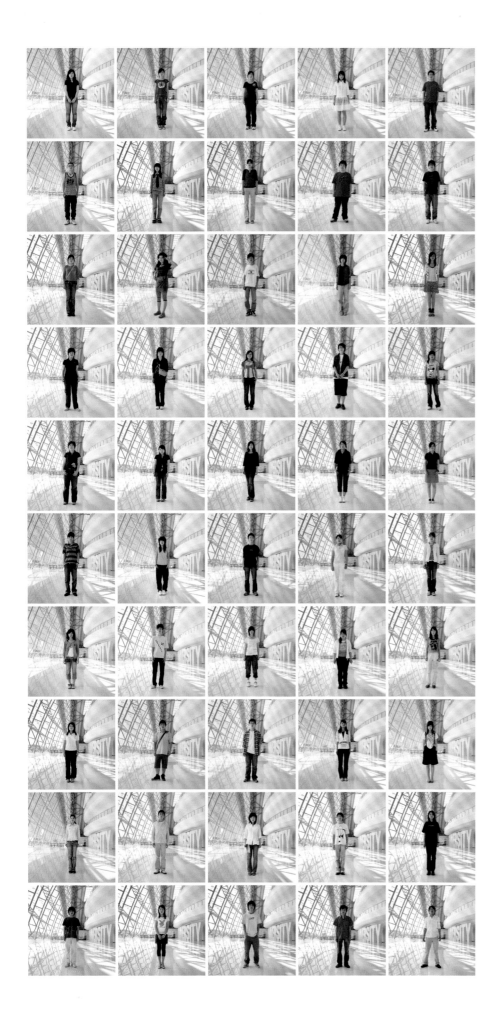

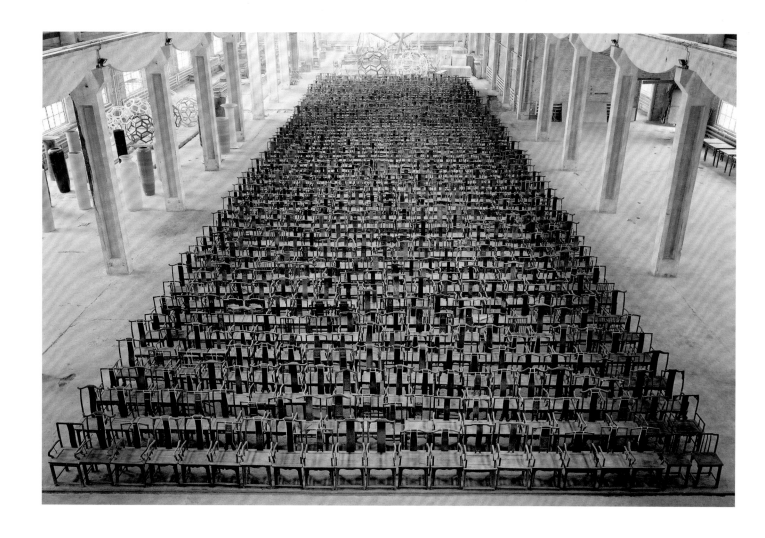

Ai Weiwei's *Fairytale–1001 Chinese Visitors* entailed sending 1,001 Chinese to Kassel, Germany during the Documenta 12 exhibition in 2007. In addition to being the site of the Documenta exhibitions, Kassel is known for being the place where the Grimm brothers collected and edited their famous collection of fairytales.

The masses often obscure the individual in the densely populated nation of China, and with this work and his choice to involve 1,001 people, the artist was calling attention to the one, the individual, amongst the 1,000, emphasizing the importance of a single person among the group. The work included an installation of 1,001 Qing Dynasty chairs and a documentary video, *Fairytale*, which shows the process and the obstacles overcome by the Chinese citizens who participated and made their first trip overseas. Beginning with an explanation of the project, the video includes scenes of participants applying for passports, leaving China, their twenty-eight day stay in Kassel, and their return home. In a way, viewers are presented with a collection of 1,001 fairytales as they experience the stories and challenges of the participants.

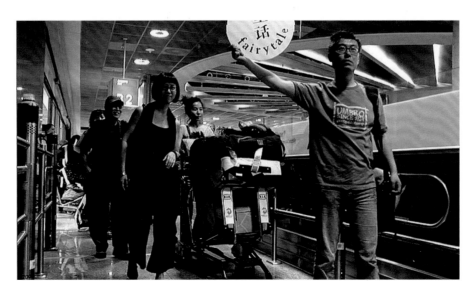

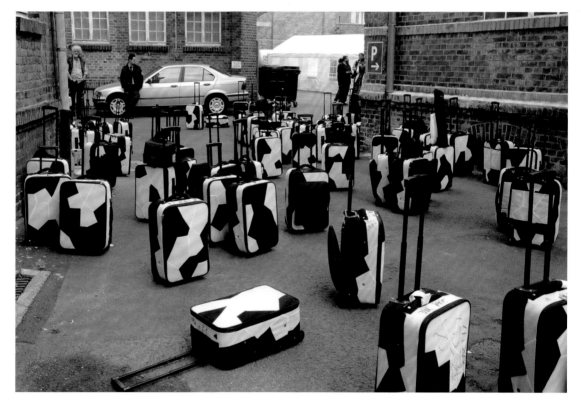

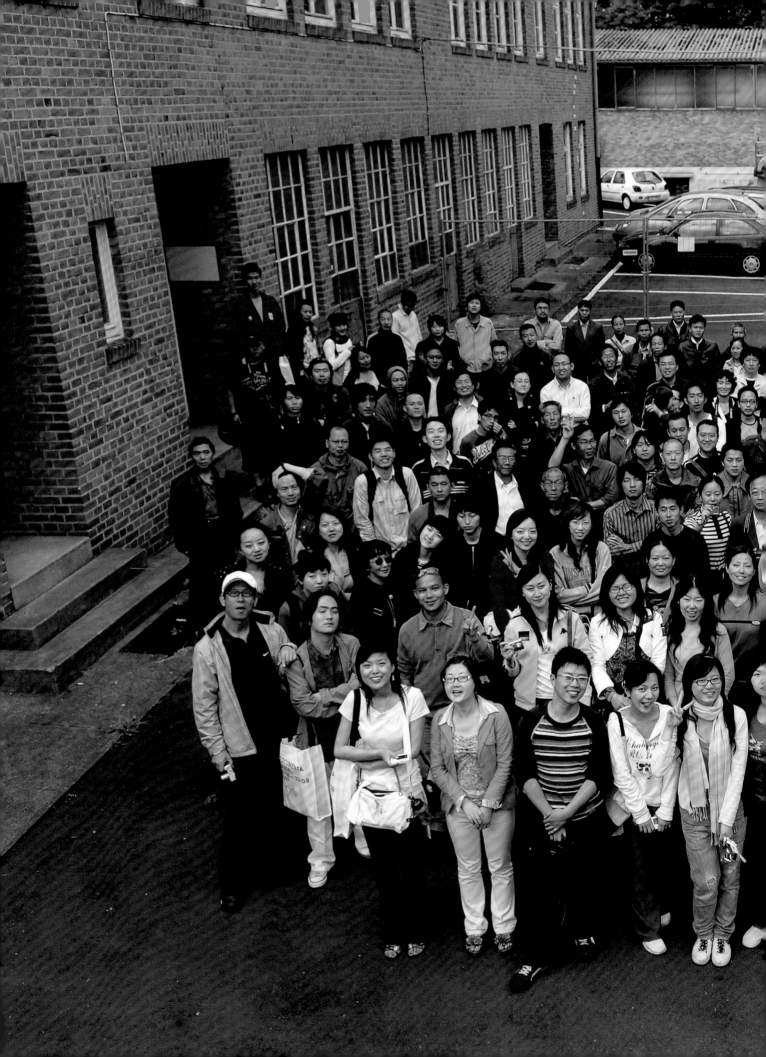

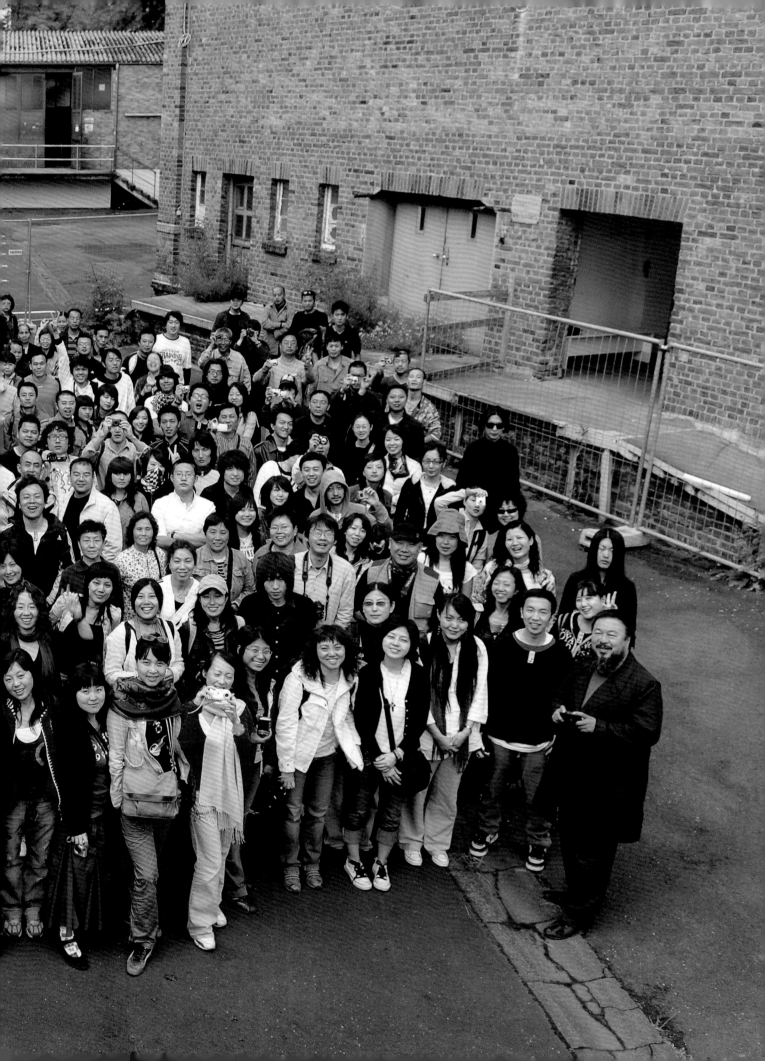

PAGES 116–19
Sichuan Earthquake Photos, 2008–
16 black-and-white photographs
20 × 13 5/16 in. (50.8 × 33.8 cm), each
Collection of the Artist (exhibition copy)

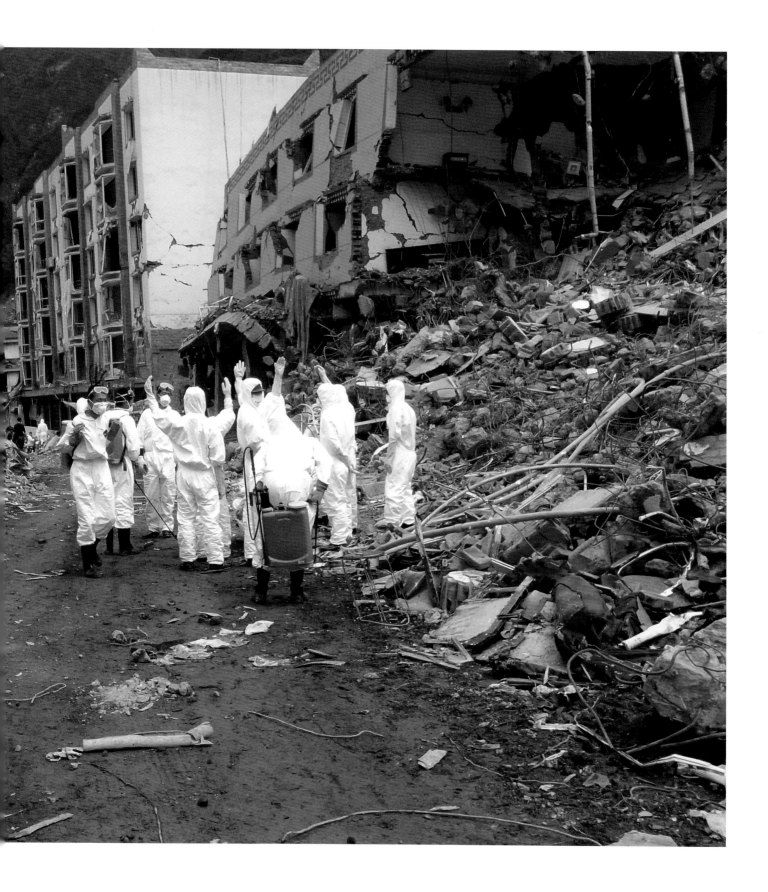

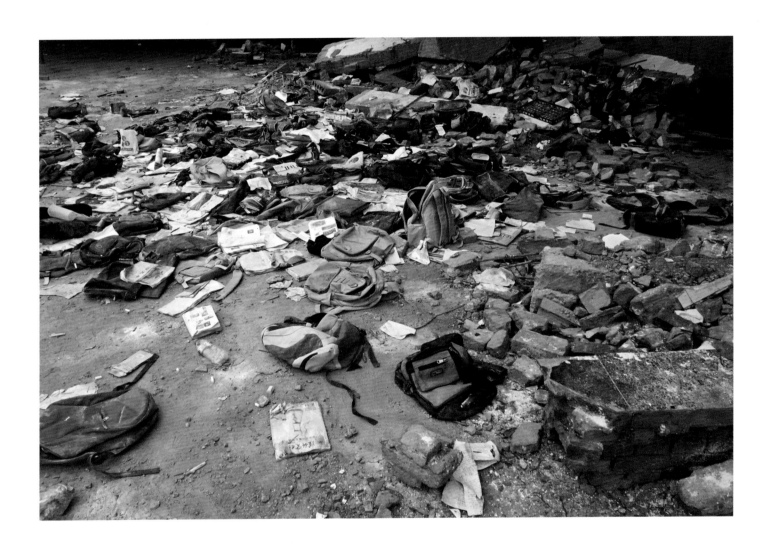

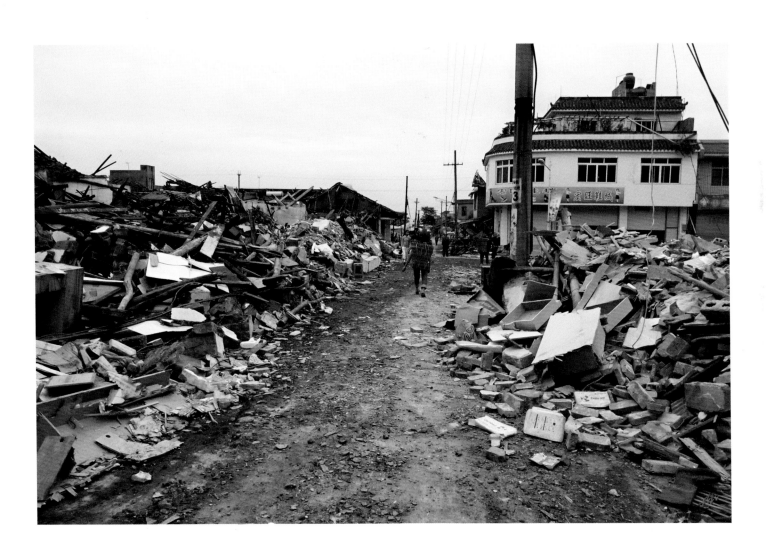

Approximately 90,000 people were killed or went missing in the May 12, 2008 Sichuan earthquake. Many school buildings collapsed, killing many children and leaving their backpacks scattered across the quake areas. This work, which is hung from the ceiling and resembles a giant snake, is formed from commonly used student backpacks in various sizes (representing children from elementary school through junior high) laid out as a requiem for the souls of those who died in the disaster.

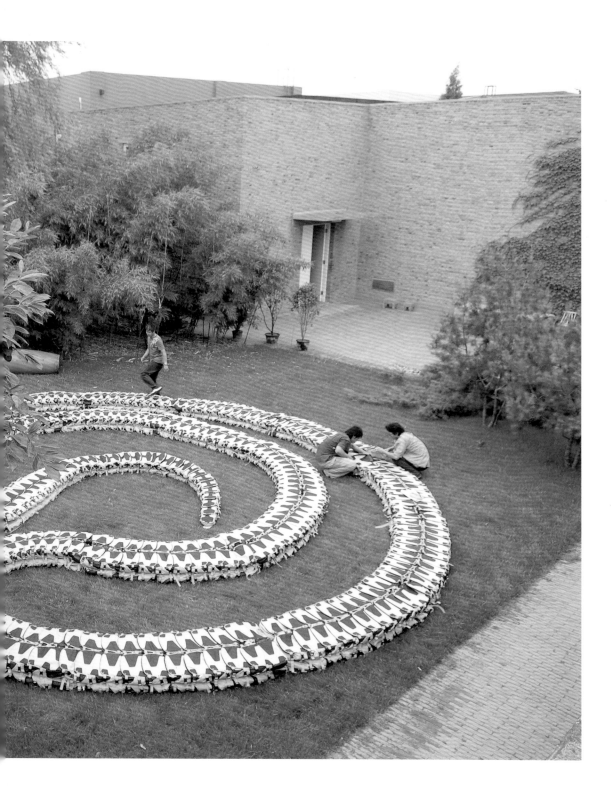

PAGES 120–23
Snake Ceiling, 2009
Backpacks
15 ¾ × 354 ⁵⁄₁₆ in.
(40 × 900 cm)
Private Collection, USA

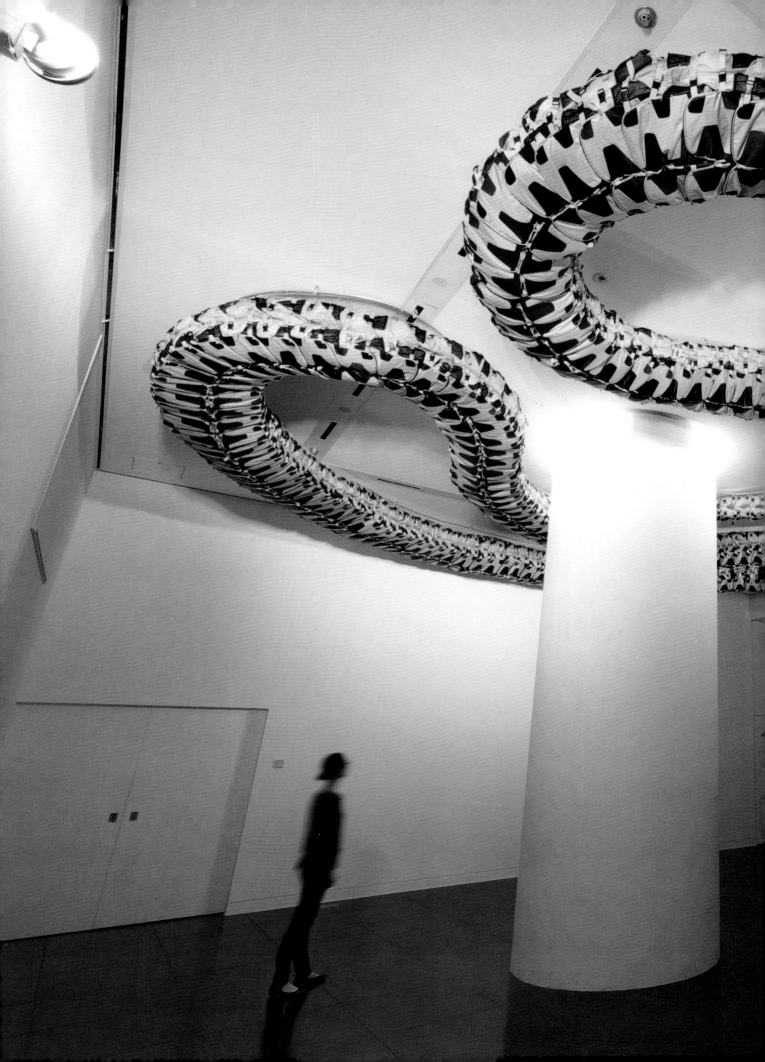

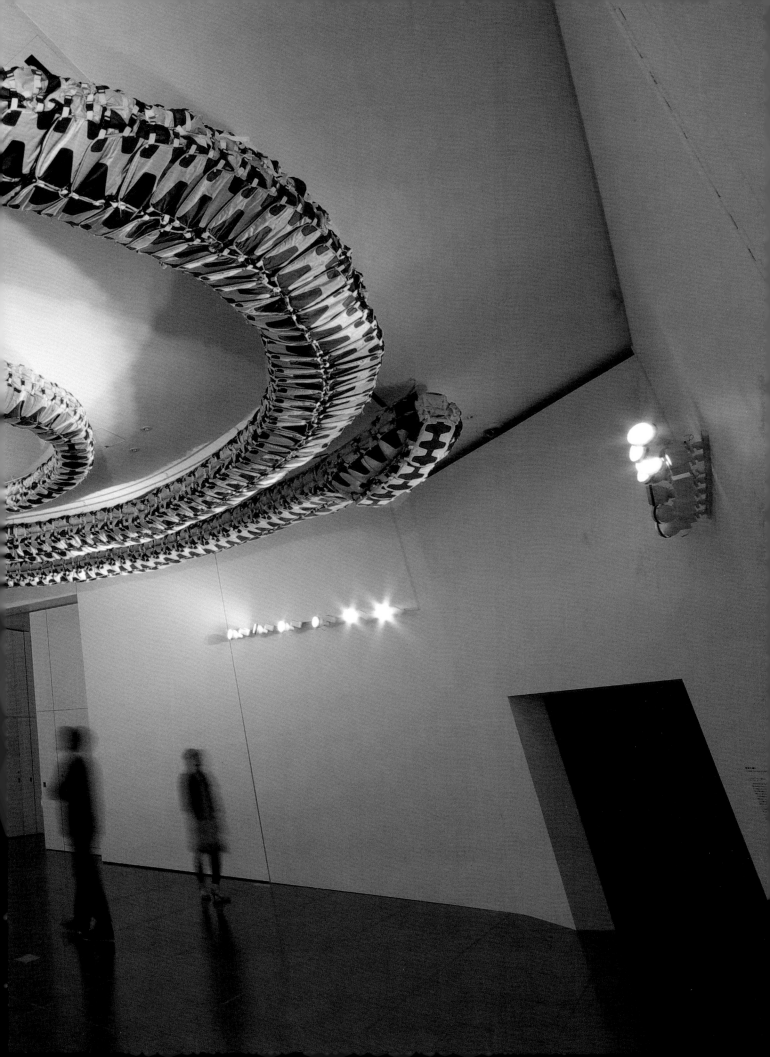

Names of the Student Earthquake Victims
Found by the Citizens' Investigation, 2008–11
Black-and-white print
Collection of the Artist

Ai created the Citizens' Investigation project with the goal of compiling a list of all the children who died in collapsed schoolhouses. The list, which records the name, year, class, and sex of each victim, has grown to include over 5,000 names. It is posted on the wall of Ai's studio, and the investigation continues. For this exhibition, the names are printed in ink on white paper and displayed on the gallery walls. In Washington, DC, the names of nearly 60,000 war-dead are inscribed on the black granite of the Vietnam Veterans Memorial, emphasizing the fact that the function played by a name in symbolizing a life is universal.

Twitter: @aiww

艾未未作品
REMEMBRANCE
Work by Aiweiwei

Remembrance, 2010
Voice recording listing the names of students
who died in the Sichuan earthquake
Running time: 3 hours, 41 minutes
Collection of the Artist

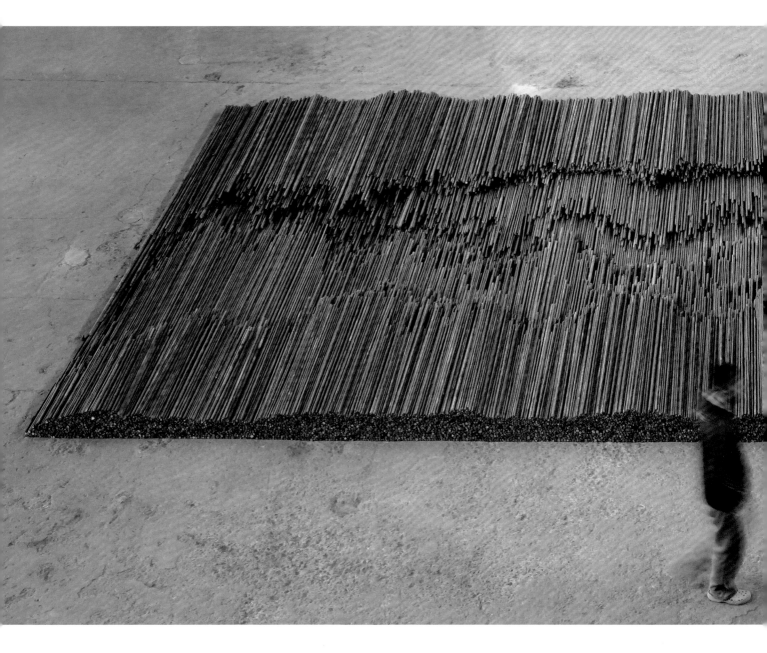

ABOVE
Wenchuan Steel Rebar, 2008–12
Steel rebar (40 tons)
236 ¼ × 472 ⁷⁄₁₆ in.
(6 × 12 m)
Collection of the Artist

RIGHT
Detail of *Wenchuan Steel Rebar*

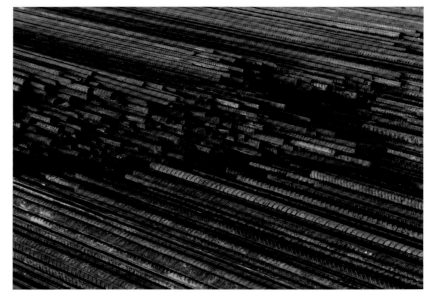

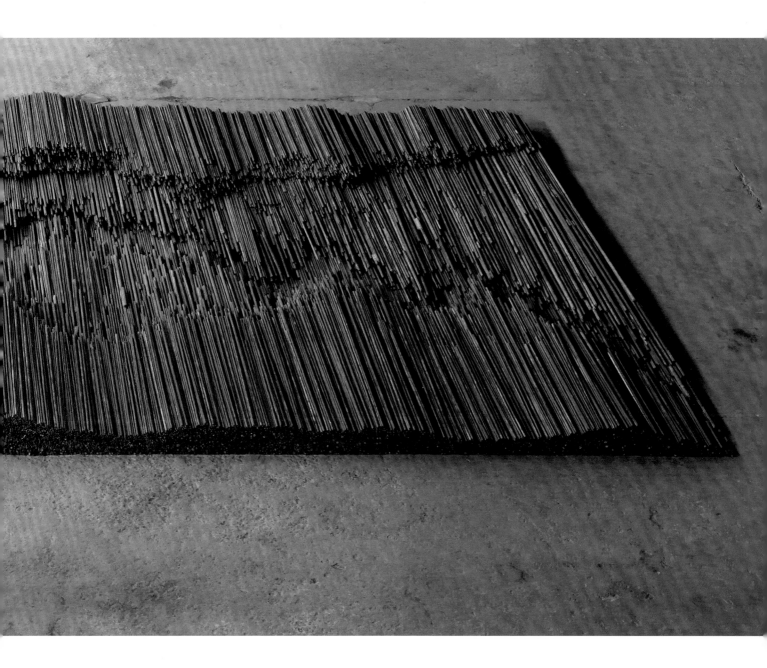

In *Wenchuan Steel Rebar*, a new work for this exhibition, Ai Weiwei uses rebar recovered from the rubble of collapsed schoolhouses in Sichuan following the 2008 earthquake. The work serves as a reminder of the repercussions of the earthquake and expresses the artist's concern over society's ability to start afresh "almost as if nothing had happened." The orderly arrangement of rebar evokes a Minimalist artistic aesthetic, but the large divide in the piece is reminiscent of both a ground fissure and of a gulf between values. It is a massive, physical work, designed to remind audiences of the individuals in danger of being forgotten.

So Sorry, 2011
Video
Running time: 54 minutes
Collection of the Artist

*Ai Weiwei in the elevator when taken
into custody by the police*, 2009
Color print
55 ⅛ × 41 ⁵⁄₁₆ in.
(140 × 105 cm)
Collection of the Artist (exhibition copy)

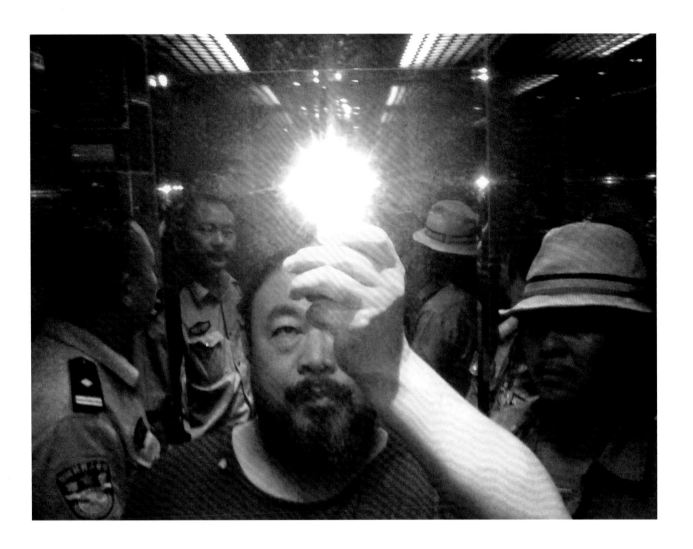

131

Brain Inflation, 2009
Color print
39 ⅜ × 78 ¾ in.
(100 × 200 cm)
Collection of the Artist (exhibition copy)

In July 2009, Ai had a physical encounter with a group of police at a hotel in Chengdu, Sichuan province, during which he was beaten on the head. Ai had gone to Chengdu to attend the trial of Tan Zuoren, a campaigner in the Citizens' Investigation project, who had been charged with "inciting subversion of state power" (Tan Zuoren was ultimately sentenced to five years' imprisonment). Later, while on a plane to Munich, Ai suffered severe headaches, and immediately upon arrival in Munich underwent emergency brain surgery. He had suffered a cerebral hemorrhage. *Brain Inflation* is an MRI image of Ai's brain showing the hemorrhage.

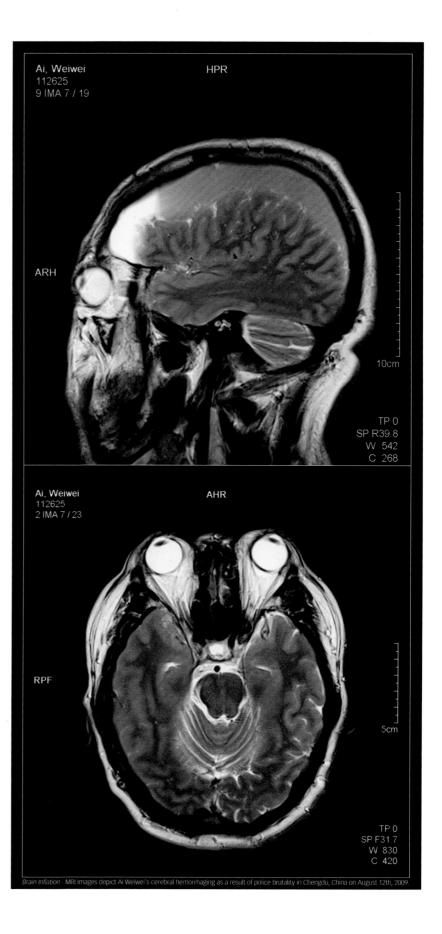

Brain Inflation - MRI images depict Ai Weiwei's cerebral hemorrhaging as a result of police brutality in Chengdu, China on August 12th, 2009.

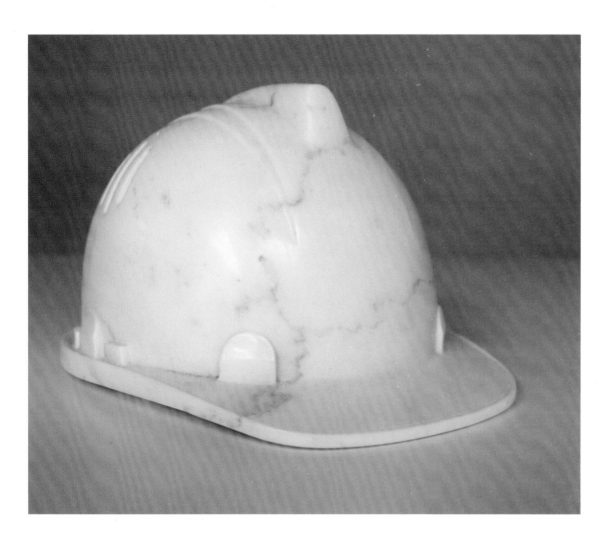

Marble Helmet, 2010
Marble
11 ¹³⁄₁₆ × 9 ¹³⁄₁₆ × 5 ⅞ in.
(30 × 25 × 15 cm)
Collection of the Artist

PAGES 134–35
He Xie, 2010–
3,000 porcelain crabs
Dimensions variable
Collection of the Artist

In *He Xie*, a new work, Ai metaphorically represents the restriction of individual expression and free speech in Chinese society. *He xie* literally means "river crab," but it is also a homophone for the word meaning "harmonious," which is used in the Chinese Communist Party slogan "the realization of a harmonious society." On the Internet, it has become a term referring to online censorship and the removal of antiestablishment views and information. In November 2010, responding to the imminent demolition of his newly constructed studio in Shanghai, Ai called for support via Twitter and invited guests to a feast of 10,000 river crabs in protest of the government's control of information. Ai was unable to attend, having been placed under house arrest as a result of his actions.

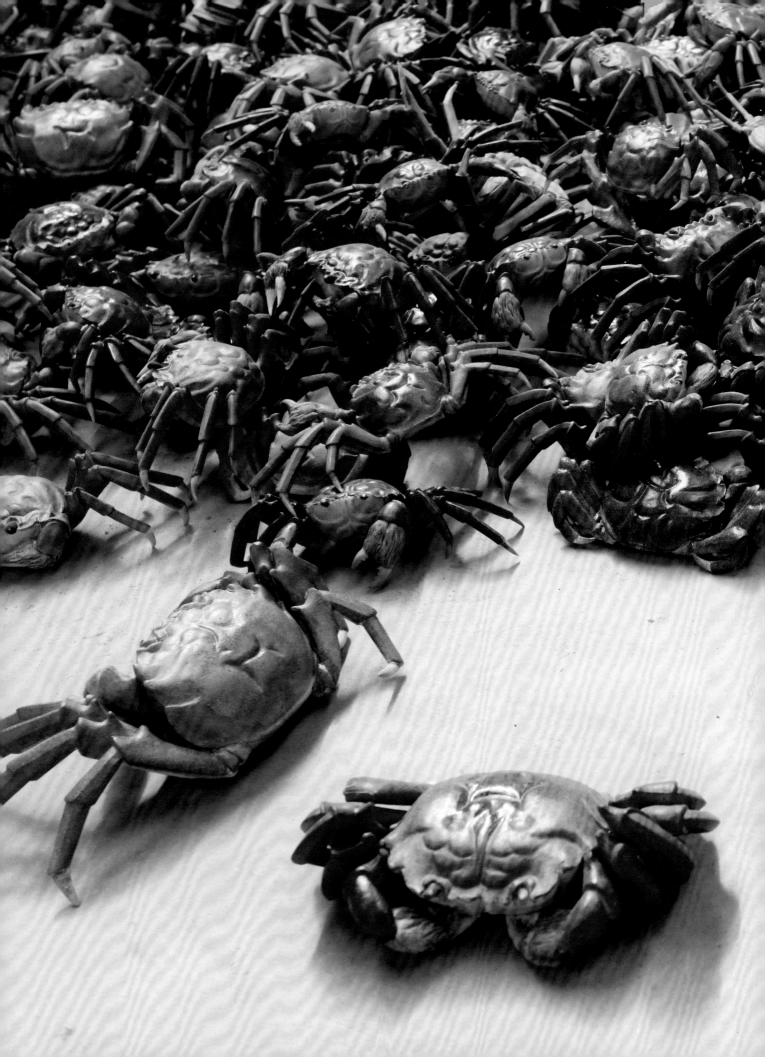

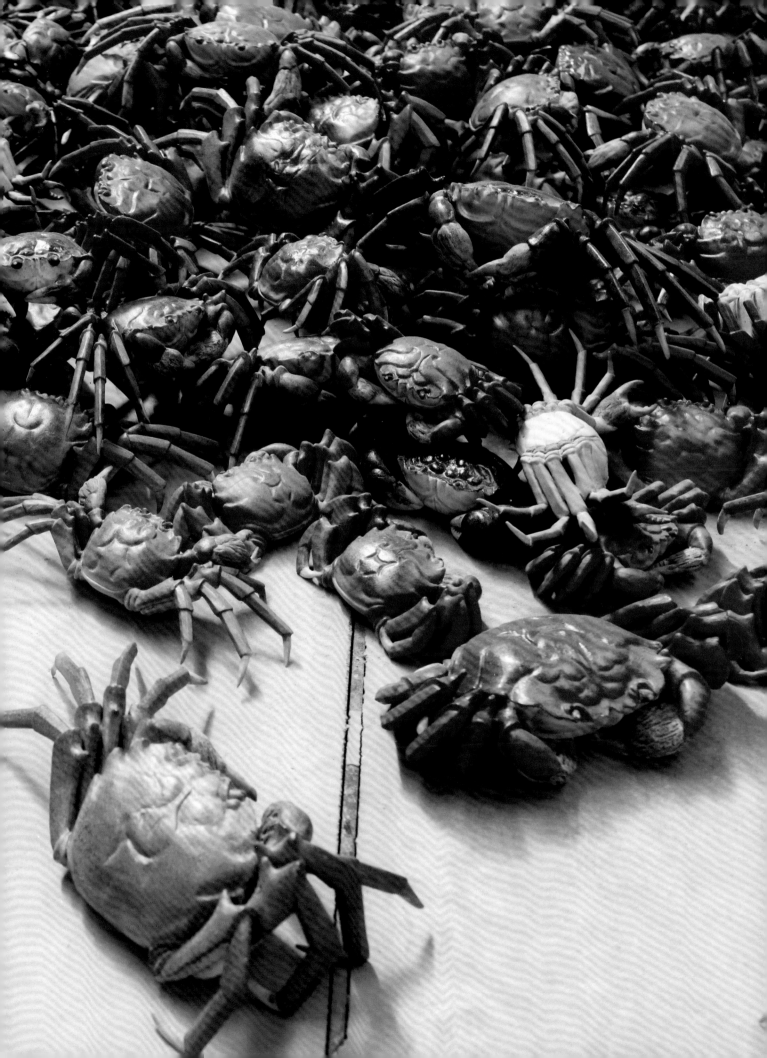

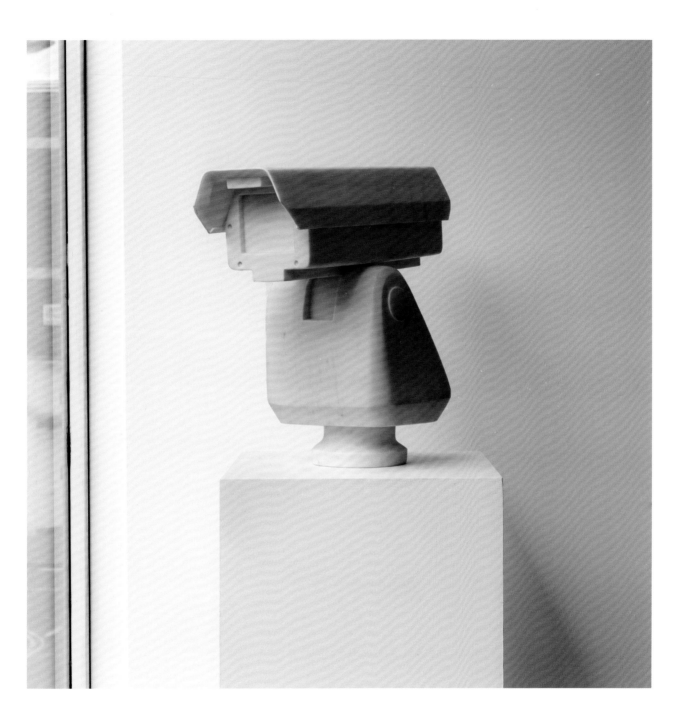

Surveillance Camera, 2010
Marble
15¾ × 15¾ × 7⅞ in.
(40 × 40 × 20 cm)
Collection of Daniel Sallick
and Elizabeth Miller,
Washington, DC

Exhibition
Checklist

New York Photographs, 1983–93
A selection of 98
black-and-white photographs
33 1/16 × 33 1/16 in.
(84 × 84 cm), each
Collection of the Artist (exhibition copy)

Beijing East Village Photographs, 1993–
A selection of 34
black-and-white photographs
33 1/16 × 33 1/16 in.
(84 × 84 cm), each
Collection of the Artist (exhibition copy)

Bowls of Pearls, 2006
A pair of porcelain bowls
and freshwater pearls
14 15/16 × 38 9/16 in.
(38 × 98 cm), each
Stockamp Tsai Collection

Cube Light, 2008
Glass crystals, lights, and metal
163 × 157 1/2 × 157 1/2 in.
(414 × 400 × 400 cm)
Hirshhorn Museum and Sculpture Garden,
Smithsonian Institution,
Washington, DC

Untitled, 2006
Huali wood
Diameter: 66 9/16 in.
(169 cm)
Collection of J. Chen

Untitled, 2011
Huali wood
Diameter: 51 3/16 in.
(130 cm)
Collection of the Artist

Cube in Ebony, 2009
Rosewood
39 3/8 × 39 3/8 × 39 3/8 in.
(100 × 100 × 100 cm)
Collection of the Artist

Small wooden box from artist's father
Wood
2 3/8 × diameter 3 9/16 in.
(6 × diameter 9 cm)

Teahouse, 2011
Compressed tea
47 1/4 × 31 1/2 × 46 7/8 in.
(120 × 80 × 119 cm), each
Collection of the Artist

Chang'an Boulevard, 2004
Video
Running time: 10 hours, 13 minutes
Collection of the Artist

Beijing: The Second Ring, 2005
Video
Running time: 1 hour, 6 minutes
Collection of the Artist

Map of China, 2008
Tieli wood (iron wood) from dismantled
temples of the Qing Dynasty (1644–1911)
63 3/8 × 84 5/8 × 66 15/16 in.
(161 × 215 × 170 cm)
Collection of the Faurschou Foundation

China Log, 2005
Tieli wood (iron wood) from dismantled
temples of the Qing Dynasty (1644–1911)
22 7/16 × 137 13/16 × 22 7/16 in.
(57 × 350 × 57 cm)
Collection of Honus Tandijono

Kippe, 2006
Tieli wood (iron wood) from dismantled
temples of the Qing Dynasty (1644–1911)
and iron parallel bars
71 5/8 × 112 5/8 × 40 15/16 in.
(182 × 286 × 104 cm)
Collection of Honus Tandijono

Table with Two Legs on the Wall, 2008
Wooden table from the Qing Dynasty
(1644–1911)
46 7/8 × 37 × 46 7/8 in.
(119 × 94 × 119 cm)
Private Collection, USA

Grapes, 2010
40 antique wooden stools from the Qing
Dynasty (1644–1911)
87 13/16 × 73 1/4 × 74 13/16 in.
(223 × 186 × 190 cm), overall
Private Collection, USA

Moon Chest, 2008
7 chests in huali wood,
126 × 63 × 31 1/2 in.
(320 × 160 × 80 cm), each
Collection of the Artist

Château Lafite, 1988
Shoes and bottle
12 3/16 × 4 5/16 × 3 9/16 in.
(31 × 11 × 9 cm)
Collection of the Artist

Coca-Cola Vase, 2007
Vase from the Neolithic age
(5000–3000 BCE) and paint
11 × 9 13/16 in.
(28 × 25 cm)
Private Collection, USA

Colored Vases, 2007–10
16 Han Dynasty (206 BCE–220 CE) vases
and industrial paint
Dimensions variable
Collection of the Artist

Dropping a Han Dynasty Urn, 1995/2009
Triptych: Lambda prints
75 3/8 × 70 7/8 in.
(191.5 × 180 cm), each
Collection of the Artist (exhibition copy)

Forever, 2003
42 bicycles
108 1/4 × 177 3/16 in.
(275 × 450 cm), overall
Courtesy of the Tiroche De Leon Collection
& Art Vantage Ltd.

Provisional Landscapes, 2002–08
Inkjet prints
Dimensions variable according
to installation
Collection of the Artist (exhibition copy)

Beijing's 2008 Olympic Stadium, 2005–08
Inkjet prints
Dimensions variable
according to installation
Collection of the Artist (exhibition copy)

Fairytale, 2008
Video
Running time: 2 hours, 32 minutes
Collection of the Artist

Sichuan Earthquake Photos, 2008–
16 black-and-white photographs
20 × 13 5/16 in.
(50.8 × 33.8 cm), each
Collection of the Artist (exhibition copy)

Snake Ceiling, 2009
Backpacks
15 3/4 × 354 5/16 in.
(40 × 900 cm)
Private Collection, USA

*Names of the Student Earthquake Victims
Found by the Citizens' Investigation*,
2008–11
Black-and-white print
Dimensions variable
Collection of the Artist

Remembrance, 2010
Voice recording listing the names of stu-
dents who died in the Sichuan earthquake
Running time: 3 hours, 41 minutes
Collection of the Artist

Wenchuan Steel Rebar, 2008–12
Steel rebar (40 tons)
236 1/4 × 472 7/16 in.
(6 × 12 m)
Collection of the Artist

So Sorry, 2011
Video
Running time: 54 minutes
Collection of the Artist

*Ai Weiwei in the elevator when taken
into custody by the police*, 2009
Color print
55 1/8 × 41 5/16 in.
(140 × 105 cm)
Collection of the Artist (exhibition copy)

Brain Inflation, 2009
Color print
39 3/8 × 78 3/4 in.
(100 × 200 cm)
Collection of the Artist (exhibition copy)

Marble Helmet, 2010
Marble
11 13/16 × 9 13/16 × 5 7/8 in.
(30 × 25 × 15 cm)
Collection of the Artist

He Xie, 2010–
3,000 porcelain crabs
Dimensions variable
Collection of the Artist

Surveillance Camera, 2010
Marble
15 3/4 × 15 3/4 × 7 7/8 in.
(40 × 40 × 20 cm)
Collection of Daniel Sallick and Elizabeth
Miller, Washington, DC

Study of Perspective, 1995–
2 black-and-white photographs
35 7/16 × 50 in.
(90 × 127 cm), each
Collection of the Artist
(exhibition copy)

Artwork by Ai Weiwei shown
concurrently in *Perspectives: Ai Weiwei*,
May 12, 2012–April 7, 2013 at the
Arthur M. Sackler Gallery, Smithsonian
Institution, Washington, DC:

Fragments, 2005
Table, chairs, parts of beams, and pillars
from dismantled temples of the Qing
Dynasty (1644–1911)
196 7/8 × 334 5/8 × 275 9/16 in.
(500 × 850 × 700 cm), overall
Sigg Collection

Selected Exhibition History

SOLO EXHIBITIONS

1982
Ai Weiwei. The Asian Foundation,
San Francisco

1988
Old Shoes—Safe Sex.
Art Waves Gallery, New York

2003
Ai Weiwei. Galerie Urs Meile, Lucerne

2004
Ai Weiwei. Caermersklooster, Provinciaal
Centrum voor Kunst en Cultuur, Ghent

Ai Weiwei. Kunsthalle Bern

Ai Weiwei. Robert Miller Gallery,
New York

2006
Fragments. Galerie Urs Meile, Beijing

2007
Ai Weiwei. Galerie Urs Meile, Lucerne

Traveling Landscapes. AedesLand, Berlin

2008
Ai Weiwei. Albion Gallery, London

Ai Weiwei. Gallery Hyundai, Seoul

Ai Weiwei: Under Construction. Sherman
Contemporary Art Foundation and
Campbelltown Arts Center, Sydney

Go China! Ai Weiwei. Groninger Museum,
Groningen, Netherlands

Illumination. Mary Boone Gallery,
New York

2009
Ai Weiwei. Friedman Benda, New York

Ai Weiwei: According to What? Mori Art
Museum, Tokyo

*Ai Weiwei: New York Photographs 1983–
1993.* Three Shadows Photography Art
Center, Beijing. Traveled to Asia Society
Museum, New York (2011); Martin-Gropius
Bau, Berlin (2011)

Ai Weiwei: Ways Beyond Art. Ivorypress
Space, London

Four Movements. Phillips de Pury & Company, London

So Sorry. Haus der Kunst, Munich

With Milk, Find Something Everybody Can Use. Pavelló Mies van der Rohe, Barcelona

World Map. Galleri Faurschou, Beijing

2010
Ai Weiwei. Galleri Faurschou, Copenhagen

Ai Weiwei. Galerie Urs Meile, Lucerne

Ai Weiwei. Haines Gallery, San Francisco

Ai Weiwei: Dropping the Urn, Ceramic Works, 5000 BCE–2010 CE. Arcadia University Art Gallery, Glenside, Pennsylvania. Traveled to Museum of Contemporary Craft, Portland, Oregon; Victoria and Albert Museum, London (2012)

Ai Weiwei: Sunflower Seeds. Tate Modern, London

Barely Something. Stiftung DKM/Galerie DKM, Duisburg, Germany

Circle of Animals/Zodiac Heads. 29th São Paulo Biennale; Los Angeles County Museum of Art (2011); Pulitzer Fountain, Grand Army Plaza, New York (2011); Somerset House, London (2011); Taipei Fine Arts Museum (2011); Hermann Park, Houston (2012); Hirshhorn Museum and Sculpture Garden, Washington, DC (2012); Princeton University, New Jersey (2012); Carnegie Museum of Art, Pittsburgh (2013); Tel Aviv Museum of Art (2013)

Cube Light. Misa Shin Gallery, Tokyo

A Few Works from Ai Weiwei. Alexander Ochs Gallery, Berlin

Hurt Feelings. Christine König Galerie, Vienna

The Mermaid Exchange. Langelinie, Copenhagen

The Unilever Series: Ai Weiwei. Turbine Hall, Tate Modern, London

2011
Ai Weiwei. Lisson Gallery, London

Ai Weiwei. Neugerriemschneider Gallery, Berlin

Ai Weiwei Absent. Taipei Fine Arts Museum

Ai Weiwei: Art/Architecture. Kunsthaus Bregenz, Austria

Ai Weiwei: Interlacing. Fotomuseum Winterthur, Switzerland; Traveled to Kunsthaus Graz, Austria; Jeu de Paume, Paris (2012); Kistefos Museum, Oslo (2012)

Ai Weiwei—Sunflower Seeds. Kunsthalle Marcel Duchamp, Cully, Switzerland

Ai Weiwei—Teehaus. Museen Dahlem, Berlin

Louisiana Contemporary: Ai Weiwei. Louisiana Museum of Modern Art, Humlebæk, Denmark; Museum De Pont, Tilburg, Netherlands (2012)

2012
A Living Sculpture. Pippy Houldsworth Gallery, London

Ai Weiwei. Galerie Urs Meile, Lucerne

Ai Weiwei. Lisson Gallery, Milan

Ai Weiwei. Magasin 3, Stockholm

Ai Weiwei: Circle of Animals/Zodiac Heads: Gold. Museum of Contemporary Art San Diego

Ai Weiwei's Five Houses. Architecture Center Houston

Perspectives: Ai Weiwei. Arthur M. Sackler Gallery, Smithsonian Institution, Washington, DC

Sunflower Seeds. Mary Boone Gallery, New York

GROUP EXHIBITIONS

1979
The first *Stars Exhibition*. Outside the National Art Museum of China, Beijing

1980
The second *Stars Exhibition*. National Art Museum of China, Beijing

1986
Avant-Garde Chinese Art. University Art Museum, University at Albany, State University of New York

China's New Expression. Municipal Gallery, New York

Seven Chinese Artists. Vorpal Gallery, San Francisco

1987
The Star at Harvard: Chinese Dissident Art. Fairbank Center for East Asian Research, Harvard University, Cambridge

1989
The Stars: Ten Years. Hanart Gallery, Hong Kong, Paris, and Taipei

1993
Chinese Contemporary Art: The Stars 15 Years. Tokyo Gallery, Tokyo

1995
Change: Chinese Contemporary Art Exhibition. Göteborgs Konstmuseum, Gothenburg, Sweden

Configura 2—Dialog der Kulturen. Angermuseum, Galerie am Fischmarkt, Erfurt, Germany

1996
Begegnung mit China [Encounter with China]. Ludwig Forum für Internationale Kunst, Aachen, Germany

1997
A Point of Contact: Korean, Chinese, Japanese Contemporary Art. Daegu Culture and Arts Center, Daegu, South Korea

1998
Double Kitsch: Painters from China. Max Protetch, New York

1999
d'Apertutto, 48th Venice Biennale

Concepts, Colors and Passions. China Art Archives and Warehouse, Beijing

Innovations Part I. China Art Archives and Warehouse, Beijing

Modern China Art Foundation Collection. Caermersklooster, Provinciaal Centrum voor Kunst en Cultuur, Ghent

2000
Fuck off. Eastlink Gallery, Shanghai

Our Chinese Friends. ACC Galerie and Galerie der Bauhaus-Universität, Weimar, Germany; Galerie Urs Meile, Beijing and Lucerne

Portraits, Figures, Couples and Groups. BizArt, Shanghai

2001

Take Part I. Galerie Urs Meile, Lucerne

Take Part II. Galerie Urs Meile, Lucerne

TU MU: Young Chinese Architecture. Aedes East Forum, Berlin

2002

1st Guangzhou Triennial. Guangdong Museum of Art, China

Art from a Changing World. Ludwig Forum für Internationale Kunst, Aachen, Germany; Henie-Onstad Kunstsenter, Høvikodden, Norway

Cement—Marginal Space in Contemporary Art. Chamber Fine Arts, New York

China—Tradition and Modernity. Ludwig Galerie Schloss Oberhausen, Oberhausen, Germany

2003

Junction: Chinese Contemporary Architecture of Art. Lianyang Architecture Art Museum, Shanghai

New Zone: Chinese Art. Zachęta National Gallery of Art, Warsaw

A Strange Heaven—Contemporary Chinese Photography. Galerie Rudolfinum, Prague. Traveled to Art Museum Tennis Palace, Helsinki (2005)

2004

9th International Architecture Exhibition, Venice Biennale

Between Past and Future: New Photography and Video from China. International Center of Photography, New York; David and Alfred Smart Museum of Art, University of Chicago. In collaboration with the Asia Society Museum, New York and the Museum of Contemporary Art, Chicago. Traveled to Seattle Art Museum (2005); Victoria and Albert Museum, London (2005); Haus der Kulturen der Welt, Berlin (2006); Nasher Museum of Art at Duke University, Durham (2006); Santa Barbara Museum of Art (2006)

Chinese Object: Dreams and Obsessions. Salvatore Ferragamo Gallery, New York

Herzog & de Meuron: No 250, An Exhibition. Schaulager, Basel. Traveled to Netherlands Architecture Institute, Rotterdam (2005); Tate Modern, Turbine Hall, London (2005); Haus der Kunst, Munich (2006)

Misleading Trails: Enrique Chagoya, Xiaoze Xie, Hai Bo, Dan Mills, Hong Hao, Ai Weiwei, Vernon Fisher. China Art Archives and Warehouse, Beijing; Samek Art Gallery, Bucknell University, Lewisburg, Pennsylvania (2006). Traveled to Hanes Art Gallery, Wake Forest University, Winston-Salem (2005); NIU Art Museum, Northern Illinois University, DeKalb (2005); University of North Texas Art Gallery, Denton (2005); Vanderbilt University Fine Arts Gallery, Nashville (2005); Boyden Gallery, St. Mary's College of Maryland, St. Mary's City (2006); Schick Art Gallery, Skidmore College, Saratoga Springs, New York (2006)

On the Edge: Contemporary Chinese Photography and Video. Ethan Cohen Fine Arts, New York

Persona 3. China Art Archives and Warehouse, Beijing

Regeneration—Contemporary Chinese Art from China and the US. Samek Art Gallery, Bucknell University, Lewisburg, Pennsylvania. Traveled to David Winton Bell Gallery, Brown University, Providence; John Paul Slusser Gallery, University of Michigan, Ann Arbor; Arizona State University Art Museum, Tempe (2005); Ben Maltz Gallery, Otis College of Art and Design, Los Angeles (2005); University Art Gallery, University of California San Diego, La Jolla (2005); Ewing Gallery of Art and Architecture, University of Tennessee, Knoxville (2006); University of Virginia Art Museum, Charlottesville (2006); Williams College Museum of Art, Williamstown, Massachusetts (2006)

Silknet: Emerging Chinese Artists. Galerie Urs Meile, Lucerne

2005

1st Montpellier Biennial of Chinese Contemporary Art

2nd Guangzhou Triennial. Guangdong Museum of Art, China

China: As Seen by Contemporary Chinese Artists. Provincia di Milano, Spazio Oberdan, Milan

Mahjong: Contemporary Chinese Art from the Sigg Collection. Kunstmuseum Bern; Hamburger Kunsthalle, Hamburg (2006); Museum der Moderne, Salzburg (2007); University of California, Berkeley

Art Museum and Pacific Film Archive (2008); Peabody Essex Museum, Salem, Massachusetts (2009)

Xianfeng! Chinese Avant-Garde Sculpture. Museum Beelden aan Zee Scheveningen, the Netherlands

2006

5th Asia-Pacific Triennial of Contemporary Art. Queensland Art Gallery, South Brisbane

2006 Beaufort Outside. Museum of Modern Art, Oostende, Belgium

Altered, Stitched and Gathered. P.S. 1 Contemporary Art Center, Long Island City

Black and Blue. Robert Miller Gallery, New York

Busan Biennale 2006. Busan Museum of Modern Art, South Korea

China Now: Art in Times of Change. Essl Museum, Kunst der Gegenwart, Klosterneuburg, Austria. Traveled to Cobra Museum voor Moderne Kunst, Amstelveen, Netherlands (2007)

China Power Station: Part I. Serpentine Gallery, at Battersea Power Station, London

Cityscapes "Beijing Welcomes You." Kunsthaus Hamburg

A Continuous Dialogue. Galleria Continua, Beijing

Detours: Tactical Approaches to Urbanization in China. Eric Arthur Gallery, University of Toronto

Inspired by China: Contemporary Furnituremakers Explore Chinese Traditions. Peabody Essex Museum, Salem, Massachusetts

MoCA Envisage/Entry Gate: Chinese Aesthetics of Heterogeneity. Museum of Contemporary Art, Shanghai

Serge Spitzer and Ai Weiwei: Territorial. Museum für Moderne Kunst, Frankfurt

THIS IS NOT FOR YOU: Sculptural Discourses. Thyssen-Bornemisza Art Contemporary, Vienna

Zones of Contact, 15th Sydney Biennale

2007

6th Shenzhen Contemporary Sculpture Exhibition, *A Vista of Perspectives*. OCT Contemporary Art Terminal, He Xiangning Art Museum, Shenzhen, China

Art from China: Collection Uli Sigg. Centro Cultural Banco do Brazil, Rio de Janeiro

Branded and on Display. Krannert Art Museum and Kinkead Pavilion, University of Illinois, Urbana-Champaign. Traveled to Ulrich Museum of Art, Wichita State University; Scottsdale Museum of Contemporary Art (2008); Tufts University Art Gallery, Medford (2008); Salt Lake City Art Center (2009)

China Welcomes You...Desires, Struggles, New Identities. Kunsthaus Graz, Austria

Chinese Video: Chord Changes in the Megalopolis. Morono Kiang Gallery, Los Angeles

Documenta 12, Kassel

Energies—Synergy. Foundation De 11 Lijnen, Oudenburg, Belgium

Metamorphosis: The Generation of Transformation in Chinese Contemporary Art. Tampere Art Museum, Finland

Origin Point: Stars Group Restrospective Exhibition. Today Art Museum, Beijing

The Real Thing: Contemporary Art from China. Tate Liverpool. Traveled to Institut Valencia d'Art Modern (2008)

Shooting Back. Thyssen-Bornemisza Art Contemporary, Vienna

The Year of the Golden Pig: Contemporary Chinese Art from the Sigg Collection. Lewis Glucksman Gallery, University College Cork, Ireland

2008

11th International Architecture Exhibition, Venice Biennale

Body Media. Tang Contemporary Art, Beijing; Duolun Museum of Modern Art, Shanghai

China: Construction/Deconstruction—Chinese Contemporary Art. Museu de Arte de São Paulo

Half-Life of a Dream: Contemporary Chinese Art from the Logan Collection. San Francisco Museum of Modern Art

Hypallage: The Post-Modern Mode of Contemporary Chinese Art. OCT Art and Design Gallery, Shenzhen, China

Liverpool Biennial International 08: Made Up. Tate Liverpool

Map Games: Dynamics of Change. Today Art Museum, Beijing

New Vista—The Phenomenon of Post-Tradition in Contemporary Art. White Space Gallery, Beijing

Reconstruction #3: The Artists' Playground. Sudeley Castle, Gloucestershire

Red Aside: Chinese Contemporary Art of the Sigg Collection. Fundació Joan Miró, Barcelona

Second Lives: Remixing the Ordinary. Museum of Arts and Design, New York

Super Fengshui: UCCA Site Commission. Ullens Center for Contemporary Art, Beijing

2009

Attitude. Shit-Art Center, Zhengzhou, China

Beg, Borrow and Steal. Rubell Family Collection/Contemporary Arts Foundation, Miami

The Big World: Recent Art from China. Chicago Cultural Project

The Making of Art. Schirn Kunsthalle, Frankfurt

Pete and Repeat: Works from the Zabludowicz Collection. Project Space 176, London

A Tribute to Ron Warren. Mary Boone Gallery, New York

United Technologies. Lismore Castle, Waterford, Ireland

2010

29th São Paulo Biennale

Acconci Studio and Ai Weiwei: A Collaborative Project. Para/Site Art Space, Hong Kong

Contemplating the Void: Interventions in the Guggenheim Museum. Solomon R. Guggenheim Museum, New York

Contemporary Chinese Photography. Oldenburger Kunstverein, Oldenburg, Germany

Lost and Found. Neugerriemschneider Gallery, Berlin

The Problem of Asia. Chalk Horse, Sydney

Radical Conceptual: Positions from the MMK Collection. Museum für Moderne Kunst, Frankfurt

Rem(a)inders. Galleria Continua, Beijing

The State of Things: Brussels/Beijing. National Art Museum of China, Beijing

Taking a Stance: 8 Critical Attitudes in Chinese and Dutch Architecture and Design. Dutch Culture Center, Shanghai. Traveled to OCT Art and Design Gallery, Shenzhen, China; Today Art Museum, Beijing; Netherlands Architecture Institute, Rotterdam (2011)

2011

The Art of Deceleration: Motion and Rest in Art from Caspar David Friedrich to Ai Weiwei. Kunstmuseum Wolfsburg

Contemporary Clay. RH Gallery, New York

I Promise to Love You: Caldic Collection. Kunsthal Rotterdam

The Last Freedom—From the Pioneers of Land Art of the 1960s to Nature in Cyberspace. Ludwig Museum, Koblenz, Germany

MMK 1991–2011, 20 Years of Presence. Museum für Moderne Kunst, Frankfurt

Shanshui: Poetry Without Sound? Landscape in Chinese Contemporary Art. Works from the Sigg Collection. Kunstmuseum Luzern, Lucerne

Staging Action: Performance in Photography Since 1960. The Museum of Modern Art, New York

2012

Art and the City. Paradeplatz, Zürich

Art + Press. Martin Gropius Bau, Berlin

Print/Out. The Museum of Modern Art, New York

Taiping Tianguo, A History of Possible encounters: Ai Weiwei, Frog King Kwok, Tehching Hsieh, and Martin Wong in New York. Para I Site Art Space, Hong Kong

Selected Bibliography

ARTIST'S BOOKS

1994
Black Cover Book. Edited by Ai Weiwei, Xu Bing, and Zeng Xiaojun. Hong Kong: Tai Tei Publishing Company Limited.

1995
White Cover Book. Edited by Ai Weiwei and Zeng Xiaojun. Hong Kong: Tai Tei Publishing Company Limited.

1997
Grey Cover Book. Edited by Ai Weiwei and Zeng Xiaojun.

LITERATURE

2003
Ai Weiwei Works: Beijing 1993–2003. Edited by Charles Merewether. Beijing: Timezone 8.

2004
Ai Weiwei: Beijing 10/2003. Edited by Ai Weiwei. Beijing: Galerie Urs Meile, Timezone 8.

2007
Ai Weiwei Beijing: Fake Design in the Village. Edited by Eduard Kögel. Berlin: AedesLand.

Ai Weiwei: Works, 2004–2007. Edited by Urs Meile. Beijing and Lucerne: Galerie Urs Meile; Zurich: JRP Ringier.

2008
Ai Weiwei. *Becoming: Images of Beijing's Air Terminal 3.* Introduction by Brendan McGetrick. London: Ivorypress; Beijing: Timezone 8.

2009
Fibicher, Bernhard, Karen Smith, and Hans Ulrich Obrist. *Ai Weiwei.* Interview by Hans Ulrich Obrist. London: Phaidon Press.

2011
Ai Weiwei and Hans Ulrich Obrist. *Ai Weiwei Speaks: with Hans Ulrich Obrist.* London: Penguin.

Ai Weiwei's Blog: Writings, Interviews, and Digital Rants, 2006–2009. Edited and translated by Lee Ambrozy. Cambridge, Massachusetts: The MIT Press.

2012
Ai Weiwei, Fairytale: A Reader. Edited by Lionel Bovier and Salome Schnetz. Beijing and Lucerne: Galerie Urs Meile; Zurich: JRPIRingier.

EXHIBITION CATALOGUES

2000
Fuck Off. Edited by Ai Weiwei, Feng Boyi, and Hua Tianxue. Shanghai: Eastlink Gallery.

2004
Ai Weiwei. Ghent: Caermersklooster, Provinciaal Centrum voor Kunst en Cultuur.

Misleading Trails: Enrique Chagoya, Xiaoze Xie, Hai Bo, Dan Mills, Hong Hao, Ai Weiwei, Vernon Fisher. Texts by Ai Weiwei and Xiaoze Xie. Beijing: China Art Archives and Warehouse; Lewisburg, Pennsylvania: Bucknell University.

2005
Mahjong: Contemporary Chinese Art from the Sigg Collection. Edited by Bernhard Fibicher and Matthias Frehner. Kunstmuseum Bern. Ostfildern: Hatje Cantz.

2006
Fragments, Beijing 2006: Ai Weiwei. Edited by Ai Weiwei and Chen Weiqun. Beijing: Galerie Urs Meile, Timezone 8.

2007
Ammer, Manuella. "Ai Weiwei: Fairytale Performance." In *Documenta Kassel 12: 16/06—23/09, 2007.* Edited by Roger M. Buergel and Ruth Noack. Cologne: Taschen.

Feng Boyi. "Ai Weiwei." In *China Now.* Amstelveen: Cobra Museum voor Moderne Kunst.

Niermann, Ingo. "Ai Weiwei: The Materials of Ai Weiwei." In *China Welcomes You... Desires, Struggles, New Identities.* Edited by Peter Pakesch. Kunsthaus Graz. Cologne: Verlag der Buchhandlung Walther König.

Smith, Karen. "Ai Weiwei." In *The Real Thing: Contemporary Art from China.* Edited by Simon Groom. Liverpool: Tate Liverpool.

2008
Ai Weiwei. Edited by Sue-an van der Zijpp and Mark Wilson. Texts by Karen Smith and Sue-an van der Zijpp. Groningen: Groninger Museum; Rotterdam: NAi Publishers.

Ai Weiwei. Edited by Kyungmin Lee and Jihyun Shin. Seoul: Gallery Hyundai.

Ai Weiwei, Herzog & de Meuron: Beijing, Venice, London. Edited by Charles Merewether and Matt Price. 2 vols. London: Albion Gallery.

Ai Weiwei: Illumination. Text and interview by Karen Smith. New York: Mary Boone Gallery.

Merewether, Charles. *Ai Weiwei: Under Construction.* Sydney: University of New South Wales Press; Paddington: Sherman Contemporary Art Foundation; Campbelltown: Campbelltown Arts Centre.

2009
Ai Weiwei: According to What? Texts by Mami Kataoka, Hironori Matsubara, and Charles Merewether. Tokyo: Mori Art Museum and Tankosha Publishing.

Ai Weiwei: Four Movements. London: Phillips de Pury & Company.

Ai Weiwei: So Sorry. Texts by Ai Weiwei and Mark Siemons. Haus Der Kunst. Munich, Berlin, London, New York: Prestel.

Ai Weiwei: Ways Beyond Art. Edited by Elena Ochoa Foster and Hans Ulrich Obrist. Ivorypress Space. London and Madrid: Ivorypress.

2010
Ai Weiwei: Dropping the Urn, Ceramic Works, 5000 BCE–2010 CE. Interview by Zhuang Hui. Glenside, Pennsylvania: Arcadia University Art Gallery; Beijing: Office for Discourse Engineering.

Ai Weiwei: New York Photographs, 1983–1993. Edited by Mao Weidong, Stephanie H. Tung. Interview by Stephanie Tung, John Tancock, and Christophe Mao. Three Shadows Photography Art Centre. Beijing: Three Shadows Press; New York: Chambers Fine Art.

Ai Weiwei: Sunflower Seeds. Edited by Juliet Bingham. London: Tate Modern.

Ai Weiwei: With Milk, Find Something Everybody Can Use. Intervention in the Mies van der Rohe Pavilion. Edited by Xavier Costa. Barcelona: Fundació Mies van der Rohe; New York: Actar.

Barely Something. Edited by Dirk Krämer and Klaus Maas. Duisburg: Stiftung DKM.

2011
Ai Weiwei: Art/Architecture. Edited by Yilmaz Dziewior. Bregenz: Kunsthaus Bregenz.

Ai Weiwei: Circle of Animals. Edited by Susan Delson. Munich and New York: Prestel.

Ai Weiwei: Interlacing. Edited by Urs Stahel and Daniela Janser. Fotomuseum Winterthur, Jeu de Paume. Göttingen: Steidl.

Ai Weiwei: Lisson Gallery 13 May – 16 July 2011. Edited by Dorothy Feaver. London: Connekt Colour.

Shanshui: Poetry Without Sound? Landscape in Contemporary Chinese Art. Edited by Peter Fischer. Texts by Ai Weiwei and Nataline Colonnello. Kunstmuseum Lucerne. Ostfildern: Hatje Cantz.

ARTICLES

2004
Colonnello, Nataline. "Beyond the Checkmate." *ArtAsiaPacific*, no. 40 (Spring): 52–58.

2005
Schindhelm, Michael. "Ai Wei Wei's [*sic*] Welt." *Cicero* (February): 118–25.

2006
Jun Jun. "No Frontiers—The Artwork of Ai Weiwei." *Artco* (May): 220–21.

Lu Heng-Zhong. "An Interview with Ai Weiwei, One of the Architects of Jinhua Architecture Park, Zhejiang." *Time + Architecture*, no. 1, 46–65.

Pollack, Barbara. "Ai Weiwei: A Bowl of Pearls, a Ton of Tea, and an Olympic Stadium." *ARTnews* 105, no. 9 (October): 162–65.

Spalding, David. "Ai Weiwei." *Artforum* 45, no. 1 (September): 395.

2007
Ai Weiwei and Jacques Herzog. "Concept and Fake." *Parkett*, no. 81, 122–45.

Coggins, David. "Ai Weiwei's Humane Conceptualism." *Art in America* 95, no. 8 (September): 118–25.

Cotter, Holland. "Asking Serious Questions in a Very Quiet Voice." *New York Times*, June 22.

Maerkle, Andrew. "The Point: In Search of the Real Thing." *ArtAsiaPacific*, no. 53 (May/June): 66–67.

Merewether, Charles. "Ai Weiwei: The Freedom of Irreverence." *ArtAsiaPacific*, no. 53 (May/June): 108–11.

Tinari, Philip. "Ai Weiwei: Some Simple Reflections on an Artist in a City, 2001–2007." *Parkett*, no. 81, 110–21.

———. "A Kind of True Living: Philip Tinari on the Art of Ai Weiwei." *Artforum* 45, no. 10 (Summer): 453–59.

2008
Danzker, Jo-Anne Birnie. "A Conversation with Ai Weiwei." *Yishu: Journal of Contemporary Chinese Art* 7, no. 4 (July/August): 10–19.

Jasper, Adam. "Critical Mass: Ai Weiwei." *Art Review*, no. 22 (May): 52–63.

Kelley, Jeff. "Look Back: Jeff Kelley on Ai Weiwei." *Artforum* 47, no. 1 (September): 107–08.

Kim, Sae-mi. "Realization of *Fairy Tale*: A Conversation with Ai Weiwei." *art in ASIA*, no. 5 (May/June): 54–57.

King, Natalie. "There is No Future: An Interview with Ai Weiwei." *Art & Australia* 45, no. 4 (Winter 2008): 546–49.

Kóvskaya, Maya. "This May Well Be the Most Intense Era for Contemporary Art in all of History: Interview with Ai Weiwei." *ART iT* 6, no. 4 (Fall/Winter): 58–65.

Lu, Carol Yinghua. "Mr. Big." *Frieze*, no. 116 (June–August): 164–71.

Thea, Carolee. "Making Everything: A Conversation with Ai Weiwei." *Sculpture* 27, no. 10 (December): 24–29.

Vine, Richard. "The Way We Were, The Way We Are: An Interview with Ai Weiwei." *Art in America* 96, no. 6 (June/July): 99–102.

2009
Frazier, David. "Ai Weiwei's Year of Living Dangerously." *Art in America*, 97, no. 8 (September): 28.

Grube, Katherine. "Ai Weiwei Challenges China's Government Over Earthquake." *ArtAsiaPacific*, no. 64 (July/August): 33–34.

———. "Ai Continues Activisim Against China; Government Responds." *ArtAsiaPacific*, no. 65 (September/October): 46.

———. "Ai Weiwei Hospitalized After Beating By Chinese Police." *ArtAsiaPacific*, no. 66 (November/December): 33–34.

Kóvskaya, Maya. "Ai Weiwei: New York Photographs 1983–1993." *Art Review*, no. 30 (March): 149.

———. "The Visual Roots of a Public Intellectual's Social Conscience: Ai Weiwei's New York Photographs." *Yishu: Journal of Contemporary Chinese Art* 8, no. 5 (September/October): 97–102.

"The Power 100: (43) Ai Weiwei." *Art Review*, no. 36 (November): 102.

Wellner, Mathieu. "Ai Weiwei: Portrait of a Critical Mind." Special issue with interview. *mono.kultur*, no. 22 (Autumn).

2010
Gill, Chris. "Artist, Activist and Social Campaigner—Meet the Man Brutally Assaulted by Chinese Police." *Art Newspaper* 19, no. 209 (January): 37.

Kelley, Jeff. "Ai Weiwei: Haus der Kunst, Munich." *Artforum* 48, no. 7 (March): 236–39.

Lu, Carol Yinghua. "The Artist as Activist." *TATE ETC.*, no. 20 (Autumn): 80–85.

McGetrick, Brendan. "Ai Weiwei: Cultural Evidence." *Flash Art* 43, no. 275 (November/December): 56–58.

Ng, David. "Artist Ai Weiwei Makes Rare U.S. Appearance to Talk About Digital Activism." *Los Angeles Times*, March 15.

Selected Bibliography, continued

Osnos, Evan. "It's Not Beautiful." *New Yorker,* May 24.

Smith, Roberta. "At Tate Modern, Seeds of Discontent by the Ton." *New York Times,* October 19.

2011
Ai Weiwei. "'Shame on Me.'" *Der Spiegel,* no. 47, November 21.

Bartlett, Voon Pow. "The Harmonization of Ai Weiwei." *Yishu: Journal of Contemporary Chinese Art* 10, no. 1 (January/February): 84–94.

Beech, Hannah, and Austin Ramzy. "Person of the Year Runners Up: Ai Weiwei, The Dissident." *Time,* December 14.

Cohen, Andrew. "Ai Weiwei." *ArtAsiaPacific,* no. 74 (July/August): 72–81.

Heartney, Eleanor. "Ai Weiwei: The Making of a Rebel." *Art in America* 99, no. 6 (June/July): 34–36.

Mason, Wyatt. "The Danger Artist." *GQ* (December): 218–30.

Millar, Iain. "Following Ai Weiwei." *Art Newspaper* 20, no. 225 (June): 64.

"The Power 100: (1) Ai Weiwei." *Art Review,* no. 54 (November): 108.

Singer, Mark. "Public Works: Gone Missing." *New Yorker,* April 18.

Smith, Roberta. "12 Heads Do the Talking for a Silenced Artist." *New York Times,* May 5.

Solway, Diane. "Enforced Disappearance." *W Magazine,* November.

Teachout, Terry. "Have Our Cultural Stewards Abandoned One of Their Own?" *Wall Street Journal,* May 27.

2012
Ai Weiwei. "China's Censorship Can Never Defeat the Internet." *The Guardian,* April 15.

Ai Weiwei. "Microblogging in China." *ArtAsiaPacific* 78 (May/June): 63.

Camille, J. J. "At Home with Ai Weiwei." *Art in America* 100, no. 1 (January): 66–69.

Crow, Kelly. "The Artist: He Pushes." *Wall Street Journal,* January 20.

Kepler, Adam. "Ai Weiwei and Herzog & de Meuron to Design Serpentine Pavilion." *New York Times,* February 7.

Osnos, Evan. "Ai Weiwei At Home, In Absentia." *New Yorker,* January 27.

INTERNET SOURCES

2006
Barboza, David and Lynn Zhang. "The Clown Scholar: Ai Weiwei." *Artzine,* no. 3 (October 16). Available from http://new.artzinechina.com/display vol aid180 en.html (accessed May 29 2012).

Blackwell, Adrian. "Ai Weiwei: Fragments, Voids, Sections and Rings." Conversation with Ai Weiwei. *Archinect* (December 5). Available from http://archinect.com/features/article/47035 (accessed January 31, 2012).

2007
Colonnello, Nataline. "1=1000." *Artnet* (August 10). Available from http://www.artnet.de/magazine/11000/ (accessed January 30, 2012).

2010
"The Judges Awards: Best new private house." *Wallpaper*.* Available from http://www.wallpaper.com/designawards/2010/tsai (accessed January 30, 2012).

2011
Brazda, Bozidar. "Ai Weiwei: I FOR AN AI." *Artnet.* Available from http://www.artnet.com/magazineus/features/brazda/ai-weiwei-4-12-11.asp (accessed January 30, 2012).

OTHER

2010
The Truth 25 Times a Second. Video of performance held February 12–13, 2010. Choreographed by Frédéric Flamand. Production Design by Ai Weiwei. 75 minutes. Ballet National de Marseille and Grand Theatre de Luxembourg. Available from http://www.ballet-de-marseille.com/-The-Truth-25-times-a-second- (accessed March 29, 2012).

2011
Ai Weiwei: Fairytale *Documentary.* DVD. Directed by Ai Weiwei. 152 minutes. Zurich: JRP Ringier.

Ai Weiwei TED Film. Available from http://blog.ted.com/2011/04/04/ai-weiwei-detained-here-is-his-ted-film/ (accessed January 30, 2012).

2012
Ai Weiwei: Never Sorry. Film. Directed by Alison Klayman. 91 minutes. Available from http://aiweiweineversorry.com/ (accessed April 3, 2012).